D

START
SAATCHI GALLERY **10-13 SEPTEMBER 2015**

PRUDENTIAL

START

SAATCHI GALLERY 10-13 SEPTEMBER 2015

edited by
Serenella Ciclitira

SKIRA

Art Director
Marcello Francone

Design
Luigi Fiore

Editorial coordination
Eva Vanzella

Copy editor
Emanuela Di Lallo

Layout
Serena Parini

First published in Italy in 2015
by Skira Editore S.p.A.
Palazzo Casati Stampa
via Torino 61
20123 Milano
Italy
www.skira.net

Printed and bound in Italy.
First edition

ISBN: 978-88-572-3010-8

Distributed in USA, Canada,
Central & South America
by Rizzoli International
Publications, Inc., 300 Park
Avenue South, New York,
NY 10010, USA.
Distributed elsewhere in the
world by Thames and Hudson
Ltd., 181A High Holborn,
London WC1V 7QX,
United Kingdom.

SAATCHI GALLERY **10-13 SEPTEMBER 2015**

Presented by

Chairman and Founder
David Ciclitira

Editor and Founder
Serenella Ciclitira

Fair Director
Niru Ratnam

Selection Committee
Serenella Ciclitira
Nigel Hurst
Niru Ratnam

Event Director
Alan Carri

Event Coordinator
Jason Oh

VIP Relations Directors
Belinda Laubi
Ben Parsons

Sponsorship and Account Director
Janice Fong

Galleries Coordinator
Michelle Uribe

Artist Coordinators
Gwendolene Koh
Jessica Ho

Eye Zone Curators
Serenella Ciclitira
Nigel Hurst
Honor Harger
Tan Boon Hui

Graphic Design
Luke Fowler

Legal Counsel
Liz Roberts

Public Relations
Rhiannon Pickles PR

START TV
Derek Hanlon
Jacques Hanlon

Photography
Alexa Horgan

Special thanks to

All at Prudential plc and
Prudential Corporation Asia

Nigel Hurst and all staff
at Saatchi Gallery

Francesco Baragiola and
all staff at SKIRA

Chang Chee Pey and the Singapore
Tourism Board

Paul Tan and the National Arts
Council, Singapore

Embassy of Japan in the
United Kingdom

Sir David Green and The Prince's
School of Traditional Arts

Ikkan Sanada from Ikkan Art
International

Honor Harger and Marina Bay Sands

Christie's

Kristin Hjellegjerde

Save the Children

All media partners

*Thank you to those who have
contributed*

All participating galleries and artists

All staff of PCA and PMG

Global Eye Programme

In 2008 Parallel Contemporary Art teamed up with the Saatchi Gallery to launch the Eye Programme. We had discovered some fantastic artists on our travels in Asia and wanted to provide a platform to contextualize their work; the first and most obvious idea we had was to publish books that would document the particular art scenes we were interested in. It was a natural step to then make exhibitions that focused on some of the artists in those books. We put together a curatorial board that was comprised of Serenella Ciclitira (co-founder of Parallel Contemporary Art and editor of the Eye Programme books), Nigel Hurst (CEO of the Saatchi Gallery) and one of Asia's most respected curators and gallerists, Chang Tsong-Zung.

In 2009 we organized *Korean Eye: Moon Generation*, an exhibition presenting 31 artists. The exhibition, like future shows in the Eye Programme, had a "home" venue in Seoul before travelling to the Saatchi Gallery (where its run was extended due to visitor figures greatly exceeding all expectations) and then to Phillips. Many of the artists in that exhibition, such as Boomoon and Lee Hyungkoo, were relatively unknown outside Korea at that time but have gone on to have significant international careers since then, which is what we hoped would happen.

We were so pleased with the response to the exhibition that it seemed a good idea to follow up. In 2010 we launched our first project, *Korean Eye: Contemporary Korean Art*. This took the form of a book of 75 artists, 12 of which were chosen for the *Korean Eye: Fantastic Ordinary* exhibition that opened at the Saatchi Gallery and showcased a younger generation of Korean artists, such as Meekyoung Shin and Dong Yoo Kim. The exhibition toured to Singapore before returning home to Korea, where it was installed at both the Seoul Museum of Art and the Korean Foundation Cultural Center.

This template of high-quality publication featuring the work of 75 artists and more focused exhibitions is one that we have been following since and it is a good sign that our curatorial board have continued their involvement, aided by local advisors from the individual scenes that the projects have focused on. In 2011, *Indonesian Eye: Contemporary Indonesian Art* featured 75 artists, with the exhibition *Indonesian Eye: Fantasies & Realities* featuring the works of 18 of these artists including Christine Ay Tjoe and Heri Dono. Again, these are artists who are now being increasingly recognized on the global stage. The exhibition opened at the Ciputra Artpreneur Center, Jakarta, before transferring to the Saatchi Gallery where 170,000 visitors viewed it.

Korean Eye: Moon Generation and *Energy and Matter* combined re-launched the Korean Eye initiative and over 2011 and 2012 showed in Seoul, New York at the Museum of Arts & Design, and Abu Dhabi, bringing together the first two Korean projects. The exhibition featured 21 emerging and established Korean artists whose work engaged with contemporary Korean society.

The series of projects on Korea culminated with a new book, *Korean Eye: Contemporary Korean Art 2* which was the largest survey of new Korean art to date. The exhibition was held over the whole 70,000 square feet of the Saatchi Gallery: it was the first time the gallery used its entire space to show work from outside its own collection. The exhibition coincided with the London Olympic Games and was seen by over half a million people.

Moving on from focusing on Korea's art scene, our curatorial team turned its gaze to a newer art scene. The book *Hong Kong Eye: Contemporary Hong Kong Art* was published and the exhibition opened at the Saatchi Gallery in December 2012, featuring the work of 24 artists. The show, which was the first major survey of Hong Kong's contemporary art scene, then travelled to ArtisTree, Hong Kong. It was seen by over 400,000 people across both venues.

With five years of making books and exhibitions behind us, we developed the second stage of the Prudential Eye Programme, in part to bring together the art scenes we had been looking at and that were in the process of researching. The inaugural edition of the Prudential Eye Awards took place in January 2014 with the simple aim of highlighting and rewarding the most interesting emerging art being made across Asia. The Awards offer both exhibiting opportunities and conventional prizes. So, along with the financial prizes that we hoped would take winning artists' careers to the next level, a key element of the Awards is that the Overall Winner gets a solo exhibition at the Saatchi Gallery. The second edition was won by the Japanese collective Chim↑Pom. For us, the group are exactly what the Awards are all about. Until recently they were mostly unknown outside Japan but in the past twelve months have taken part in a group exhibition at PS1, had their debut group exhibition in London, have been featured heavily in press including *Art Review Asia* and *i-D*, and will present their solo exhibition as one of the START Projects. Seeing them launch onto the international stage has been very satisfying. It has also been fantastic to see artists like Christine Ay Tjoe and Meekyoung Shin, who took part in Eye exhibitions, to be amongst shortlisted artists for the Prudential Eye Awards (and indeed win their respective categories).

Meanwhile, our programme continued with the book *Prudential Malaysian Eye: Contemporary Malaysian Art*. The exhibition featured the works of 21 artists chosen from the 75 who were featured in the book and took place in Kuala Lumpur in 2014. *Prudential Singapore Eye* opened in January 2015 at ArtScience Museum in Singapore. In conjunction with the book featuring 62 artists, it was the first exhibition to survey Singapore's emerging talents and was a key part of the celebrations around the young country's 50th anniversary. The synergy between our projects is demonstrated by a selection of this exhibition to form the Prudential Eye Zone at this year's START. Next on the cards is *Prudential Thailand Eye* which will open in late 2015.

The books, exhibitions and Awards gradually fulfilled our aim of gaining more understanding and appreciation for emerging artists in Asia, and in 2014 we felt that it was right to create a platform for those artists and their gallerists to exhibit alongside their peers from around the world. We believe the local and the specific can be only fully understood in relation to the global. So we set up START, presented by Prudential at the Saatchi Gallery. START is slightly different from many other fairs, as it has emerged out of the publishing and exhibition-making context of the wider Eye Programme. Ultimately, we want the Programme to enable emerging artists to take that step-up to having both a regional and an international reputation, and think that books, exhibitions, prizes and fairs all represent part of the ecology that can enable artists to do that.

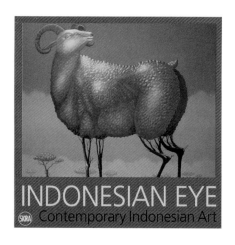

INDONESIAN EYE
SKIRA Contemporary Indonesian Art

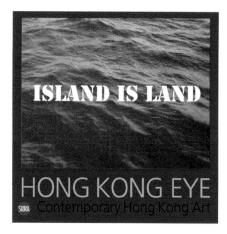

ISLAND IS LAND

HONG KONG EYE
SKIRA Contemporary Hong Kong Art

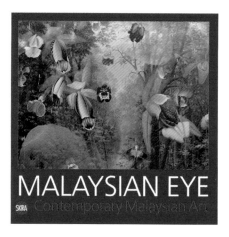

MALAYSIAN EYE
SKIRA Contemporary Malaysian Art

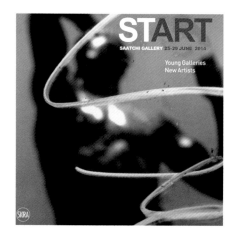

START
SAATCHI GALLERY 25-29 JUNE 2014

Young Galleries
New Artists

SKIRA

PRUDENTIAL

EYE PROGRAMME

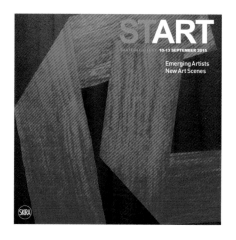

START
SAATCHI GALLERY 10-13 SEPTEMBER 2015

Emerging Artists
New Art Scenes

SKIRA

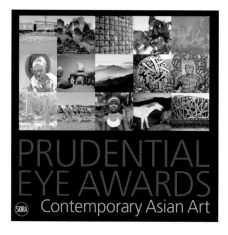

PRUDENTIAL
EYE AWARDS
Contemporary Asian Art
SKIRA

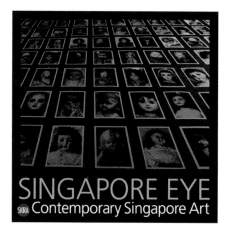

SINGAPORE EYE
SKIRA Contemporary Singapore Art

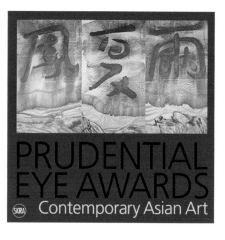

PRUDENTIAL
EYE AWARDS
Contemporary Asian Art
SKIRA

**Parallel
Contemporary
Art**

My wife Serenella and I are delighted to welcome you to the second edition of START. When we first came up with the idea of START, we asked ourselves one question: what sort of art fair would we like to visit? We have been lucky enough to travel the world and visit many exhibitions and fairs, but it seemed like there was room for something a little bit different. We wanted to create a fair that was truly international in scope, devoted to emerging art and set in a high-quality location that would really do justice to the art. We wanted a welcoming atmosphere with a family-like approach where we got to know and interact with the galleries properly. And we wanted a fair that was boutique in scale and presentation, where visitors would feel relaxed in their surroundings and eager to discover something new. And we both think that in just its second year, START fulfils our wish-list!

Discovering new artists and art scenes is something that has been very important to us and the Eye Programme, which we initiated in 2008. Travel has taken us to many places across the world where contemporary art is thriving and new galleries are constantly springing up. Artists are producing work in places that might not have had a significant contemporary art scene before. Through these activities, new art worlds are constantly being created, and this adds to the vibrancy of the contemporary art scene. It is great to bring these galleries all together into an event that places emerging artists and the galleries that support them at its heart.

Since the inaugural edition last year, START has really grown. The in-depth focus in START Projects on particular artists such as teamLab and Chim↑Pom adds an extra dimension to the exhibitors' presentations. This combination of exhibitors' presentations and START Projects gives the fair a certain vitality and reflects what we think is the dynamic nature of the Eye Programme, which includes books, exhibitions, a major set of awards and of course, START.

The exhibitors' presentations at START are a compelling survey of emerging art from around the world. The art world has grown dramatically since we first started collecting, and START enables collectors to see what is happening in cities that include Seoul, Johannesburg, Hong Kong, London, Tokyo and New York under one roof. That this "one roof" in question is Saatchi Gallery is a particular source of pleasure – we are truly fortunate to have such a wonderful location for START. We have worked in partnership with Saatchi Gallery on many projects now and share their commitment to showing art from around the world in a way that is accessible and without pretension. That commitment allows the excitement of new art scenes to be communicated to as wide an audience as possible.

We are also very grateful to our presenting sponsor Prudential, whose commitment to promoting new talent on a global stage is central to what we do. Prudential also shares our particular interest in new art scenes in Asia, thus enabling gallerists and artists from that region exhibit with their peers from around the world.

SKIRA, our Publishing Partner, plays a crucial role as we believe that the catalogues and books they issue offer a lasting legacy to events such as START and offer in-depth coverage of artists and their gallerists for audiences down the years.

We would also like to take this opportunity to thank all of our team who have worked so hard on making the second edition of START happen.

Finally, none of this would be possible without the commitment of the participating gallerists and their artists. Gallerists showing emerging artists take on a great risk. They do it because they believe in those artists and want to create the right trajectory for them to develop significant careers. They also do it because they love art. We truly respect what they are doing and hope that what we do helps them.

David Ciclitira
Founder, Global Eye Programme

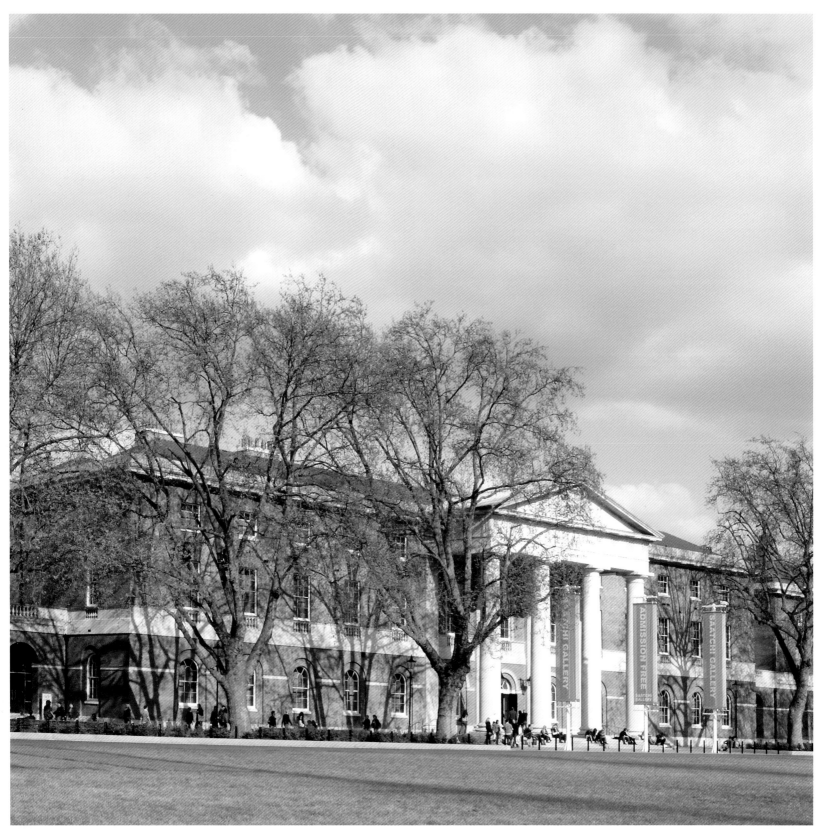

Saatchi Gallery, London

The Saatchi Gallery is proud to be hosting the second edition of START presented by Prudential. The Gallery was founded in 1985 with the aim of not only providing a highly accessible platform to bring contemporary art to the widest possible audience, but also helping to legitimize the making and collecting of art. START provides a wonderful platform for new galleries and young artists from throughout the world, so we are looking forward to seeing what this exciting initiative brings in the way of new discoveries in 2015.

START's focus on new art scenes and emerging artists worldwide dovetails very well with the Saatchi Gallery's belief that contemporary art should be available to everyone, wherever it is being made, fuel debate and become integrated into a Nation's culture.

As the world has become smaller due to advances in information technology, the art world has grown larger in inverse proportion and it is now possible to see work being made in cities across the globe in the same time scale, whereas it used to take many years for influences in different continents to filter through to each other. Yet contemporary art from different countries still retains unique qualities, often providing a visual gateway to the greater culture of a particular region.

There still remains no substitute for seeing art in the flesh and wherever you travel there is new art worth seeing, with artists absorbing many aspects of the contemporary environments in which they live while choosing to communicate these influences in very individual ways. However, it's not always possible to travel to see new work and START aims to provide an elegant environment in which to discover new art mostly being made outside more established art markets.

Since its establishment, the Gallery's audience has grown from a few art enthusiasts to over 1.5 million visitors a year. The Gallery's website has also become a global interactive meeting place for people interested in contemporary art.

Over the last five years the Saatchi Gallery has held 17 out of the top 20 most visited exhibitions in London, according to *The Art Newspaper*'s international survey of museum attendance, and is ranked among the world's top five most liked museums on Facebook and Twitter by Museum Analytics.

Through our partnership with START's co-founders Parallel Contemporary Art and Prudential over the last five years, the Saatchi Gallery has already hosted exhibitions of new art from Hong Kong, Indonesia, Malaysia and Singapore and presented the Prudential Eye Awards for emerging artists in greater Asia. All these initiatives have proven to be hugely worthwhile, popular and feed very naturally into START's goals.

We are delighted to be working again with the same partners and START in its second year presents a wonderful opportunity to bring contemporary art from around the world to a new international audience and provide the platform that these new art scenes, talented emerging artists and their young galleries richly deserve.

Nigel Hurst
Chief Executive, Saatchi Gallery

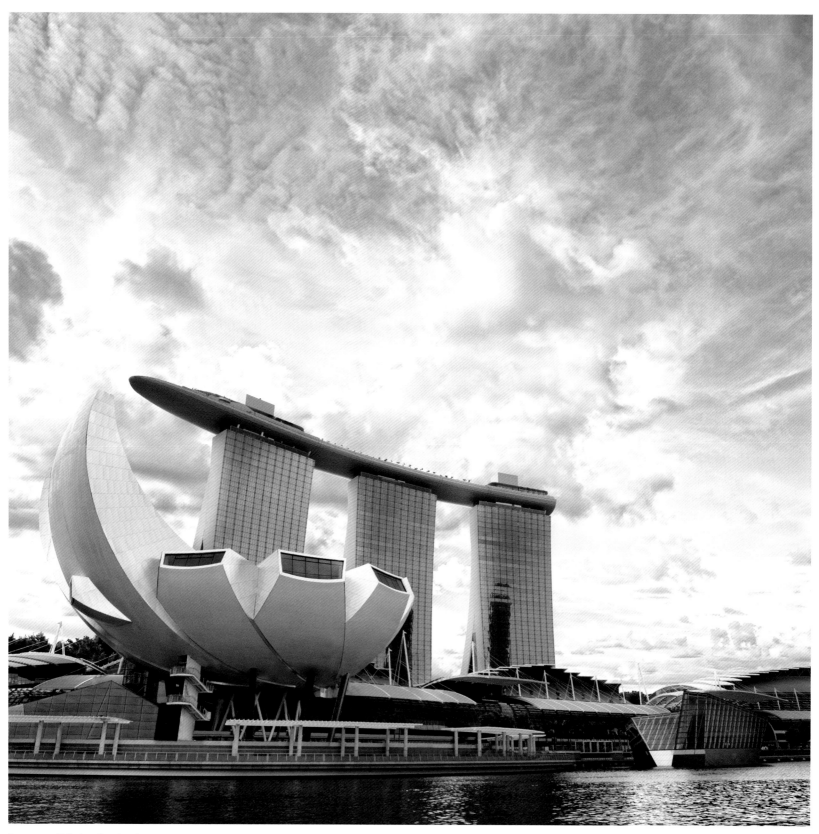

Courtesy of Marina Bay Sands

ArtScience Museum is delighted to have collaborated with Parallel Contemporary Art and the Saatchi Gallery on the presentation of *Prudential Singapore Eye*.

This exhibition marks the culmination of a journey which started at ArtScience Museum in Singapore in January 2015. *Singapore Eye* began its life as a major exhibition of contemporary art from Singapore, celebrating the nation's 50th anniversary. It showcases the vibrancy of Singapore's emerging visual art landscape, through the work of a group of exciting and innovative artists.

As a museum that sits at the intersection of arts, science and technology, ArtScience Museum is delighted to be involved in the conception of an exhibition that includes reimagined and reconfigured games, interactive sound, stunning sculptural paintings, materializations of pulsars, photographic representations of performance, and works that comment of the framing of art, the clash of popular culture, and the depiction of cities and states. The exhibition highlights the strength and diversity of contemporary practice in Singapore, as seen in the striking installations and sculptural work of Lee Wen, Chen Sai Hua Kuan, Gerald Leow and Jeremy Sharma; the exquisite photography of Chia Ming Chien, Charles Lim, and Sean Lee, and stunning painting by artists such as Justin Loke and Jane Lee.

When *Singapore Eye* opened at ArtScience Museum in January, it was held alongside an exhibition by the 18 nominees of the Prudential Eye Awards, which honours outstanding art practice from across Asia. We are thrilled that two of the nominees in the digital and video category, teamLab (Japan) and Chim↑Pom (Japan), are both presented in London, as part of START. These two exceptional art collectives represent the dynamism of contemporary art practice in Asia.

With art institutions to rival any in Southeast Asia, an emerging art market, a thriving local ecosystem, and rich and diverse cultural influences, Singapore is fast becoming an important destination for art. The distinctive confluence of a formidable science and technology sector and an emerging arts scene makes Singapore unique. These exhibitions, which showcase some of the most distinctive artists in Singapore and Asia, celebrate these qualities. ArtScience Museum is pleased to mark Singapore's 50th Jubilee by presenting this important work to a global audience.

Honor Harger
Executive Director, ArtScience Museum, Marina Bay Sands, July 2015

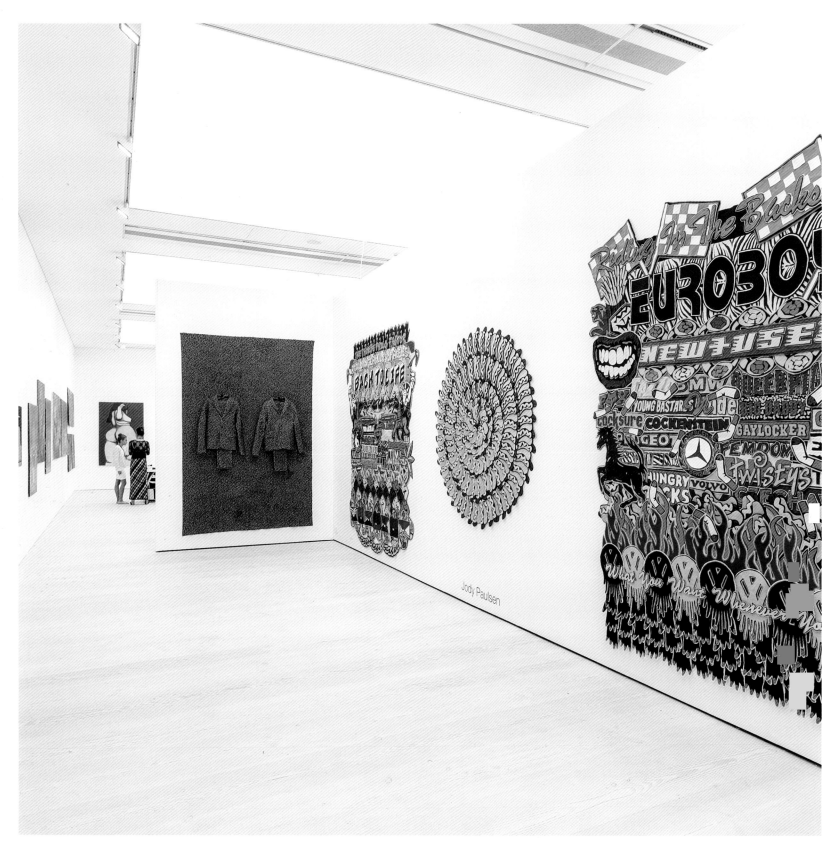

Jody Paulsen

ST**ART**

It is my great pleasure to introduce the second edition of START. I very much believe that the fair has built on the firm foundations laid by its inaugural edition to develop into a series of platforms shining a spotlight on emerging art from around the world. Emerging art is a relatively new term and one that we understand as referring not just to young artists but artists who are worth looking at again more closely or artists from the many new art scenes that are appearing around the world. I am delighted that the artist on the cover of this catalogue, who was born in Japan and trained in Europe, will be seventy-five next year. To my mind this doesn't just demonstrate the cosmopolitan nature of the contemporary art world, it also shows that the process of critical discovery (or re-discovery) can happen at any time in an artist's career.

The evolution of contemporary art continues at a great pace. When I started out in London's art world in the early 1990s, looking at contemporary art effectively meant looking at a handful of Cork Street galleries and reading about what was going on in New York. These two cities continue to be powerhouses of contemporary art, not just in terms of the artists who live there but the commercial galleries, museums, collectors, curators and critics who make up those art worlds. But they have been joined by many new scenes, artists and gallerists. What START shows is that this expansion of the art world has not led to homogeneity in the art being produced. Instead what is clear is that contemporary art is a shared language but one which is filled with local nuances and responses to specific, regional contexts.

I am particularly pleased that START has evolved this year to having a whole floor devoted to START Projects that complements the exhibitors' presentations on the Ground and First Floor. START Projects expands the fair into being a number of different platforms. It features solo presentations, an immersive environment, a solo exhibition and a group exhibition. This variety of presentations is very deliberate, trying to convey different experiences of looking at and thinking about emerging art from around the world. It was very rewarding to talk to gallerists about their proposed solo projects for "This Is Tomorrow". Chim↑Pom and teamLab are both collectives whom I have grown much more familiar with over the past twelve months; their presentations show both the strength of contemporary art and visual culture in Japan, as well as the key role that collectives have played in that country's art scene. Meanwhile, the Prudential Eye Zone looks at one particular new art scene in depth, that of Singapore, a young art world that is developing at great speed.

Finally, I would like to extend a particular word of thanks to all the artists and their gallerists whose work makes START possible. I fully believe that the more artists there are, the better place the world is, and it is very satisfying to be able to enable so many artists from around the world the opportunity to show their work together here in London.

Niru Ratnam
Fair Director of START

Contents

Galleries

A.I.
London, UK

3, 8 Princelet Street,
E1 6QJ London, UK
Phone 0203 732 7513
www.a-i-gallery.com
anne@a-i-gallery.com

Director Anne-Marie Tong
Established in 2013

Artists featured
WeiXin Chong (Singapore)
Sarah Choo Jing (Singapore)
Johan Dehlin (Sweden)
Ian David Newman (UK)
Nicole Stott (USA)
Fiona Struengmann (Germany)

Artists represented
WeiXin Chong (Singapore)
Sarah Choo Jing (Singapore)
Johan Dehlin (Sweden)
Ian David Newman (UK)
James Seow (UK)
Nicole Stott (USA)
Fiona Struengmann (Germany)

Founded in 2013 in London, A.I. is
a platform exhibiting emerging artists;
it is committed to encouraging an
East–West dialogue. A.I. runs a series
of pop-up exhibitions as well as
an online space, and works in
partnership to raise artists' profile,
value and collectability. It collaborates
with gallerists, curators and
institutions to develop the best
platform for each artist's work
and career.

Sarah Choo Jing
Nowhere Near, 2015
Digital c-type on Diasec, 35 x 200 cm
edition of 5
© Sarah Choo Jing, courtesy of A.I.

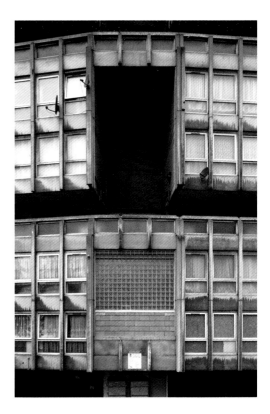

Sarah Choo Jing
Commodification III, 2013
Archival inkjet print on Hahnemühle
paper, 100 x 70 cm
edition of 3
© Sarah Choo Jing, courtesy of A.I.

WeiXin Chong
Specimen 6 (Exponential Taxonomies
series), 2014–15
Digital c-type on chromica metallica,
49 x 35.6 cm
edition of 12
© WeiXin Chong, courtesy of A.I.

Johan Dehlin
Robin Hood Gardens V, 2012
Digital c-print, 60 x 30 cm
edition of 10
© Johan Dehlin, courtesy of A.I.

WeiXin Chong
Night Panorama (Neo-Netsukes series),
2013 (detail)
Giclée print on Hahnemühle
paper, 37.5 x 80 cm
© WeiXin Chong, courtesy of A.I.

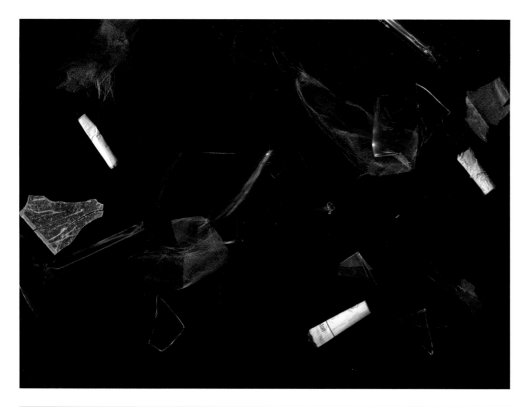

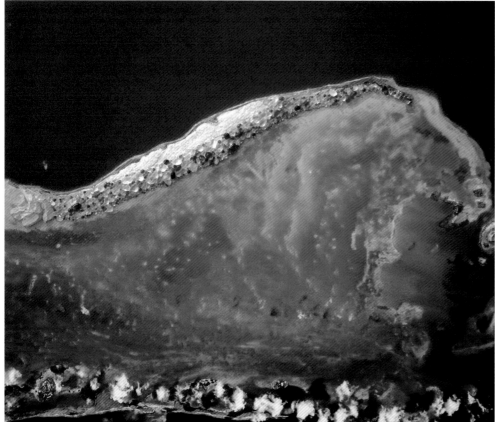

WeiXin Chong
Icarus (*Toute la nuit* series), 2015
Digital c-type on chromica metallica,
43.6 x 60 cm
edition of 8
© WeiXin Chong, courtesy of A.I.

Nicole Stott
The Wave, 2009
Digital c-print on aluminium with
mixed media, 51 x 61 cm
edition of 3
© Nicole Stott, courtesy of A.I.

Ian David Newman
Woodland / Returning Thanks
(series 4), 2009
Gouache on watercolour paper, 55 x 38 cm
© Ian David Newman, courtesy of A.I.

Fiona Struengmann
Antarctica, 2010–15
Giclée print, 100 x 120 cm
© Fiona Struengmann, courtesy of A.I.

Fiona Struengmann
White Mountain (*Articulated Silence*
series), 2012
Digital image sensor on PhotoRag
(Ultrasmooth), paper size 112 x 162 cm,
image size 110 x 160 cm
© Fiona Struengmann, courtesy of A.I.

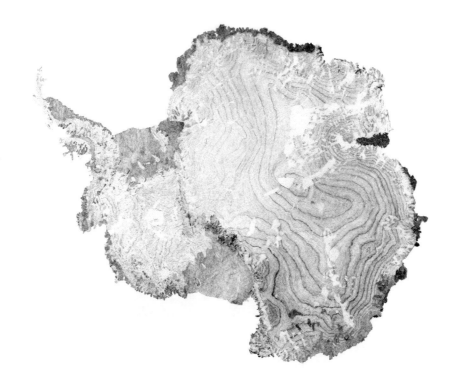

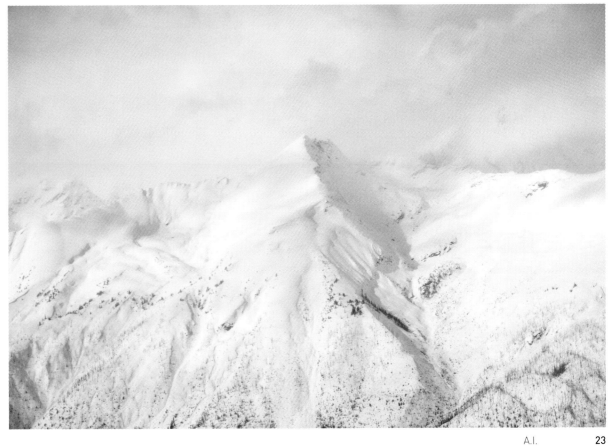

Alludo Room Gallery

Kitzbühel, Austria

Kempinski Hotel Das Tirol
Kitzbüheler Strasse 48
6373 Jochberg, Austria
Phone +39 348 3576186
www.alludoroomgallery.com
info@alludoroomgallery.com

Director Ludovica Rossi Purini
Established in 2013

Artists featured
Zsófi Barabás (Hungary)
Sabrina Dan (Italy)
Rachel Libeskind (USA)
Marton Romvari (Hungary)

Artists represented
Alessia Armeni (Italy)
Zsófi Barabás (Hungary)
Andreas Burkardt (Austria)
Sabrina Dan (Italy)
Rachel Libeskind (USA)
Barbara Luisi (Germany)
Giada Ripa (Italy)
Marton Romvari (Hungary)
Bijan Safavi (Iran)

Alludo Room Gallery, ALL-U-DO, was founded to support and promote contemporary art with a particular focus on works by innovative international artists, both emerging and already known. The gallery has its home in the charming foothills of Kitzbühel in Tyrol, Austria, a place where the magnificent surroundings of nature underscore the universal message of art and freedom of artistic creativity. The gallery is devoted to supporting, advancing and publicizing the work of artists who, regardless of their expressive means, explore the meaning of human existence in contemporary society, the relationship between art and memory and the infinite variations of European identity.

Sabrina Dan
The Lunatics, 2014
Oil on canvas, 150 x 120 cm

Sabrina Dan
Before the Battle, 2014
Oil on canvas, 130 x 90 cm

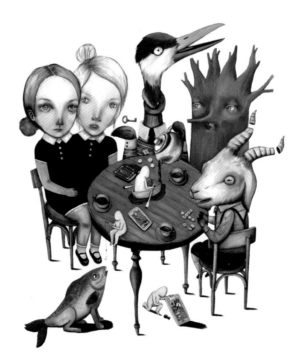

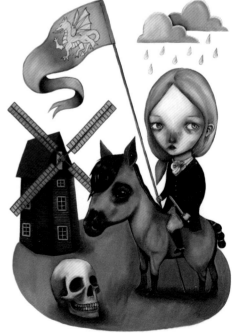

Zsófi Barabás
Close, 2015,
Acrylic on canvas, 40 x 40 cm

Zsófi Barabás
Direction, 2015
Acrylic on canvas, 40 x 40 cm

Zsófi Barabás,
ECB Frankfurt, 2013
Acrylic on canvas, 100 x 150 cm

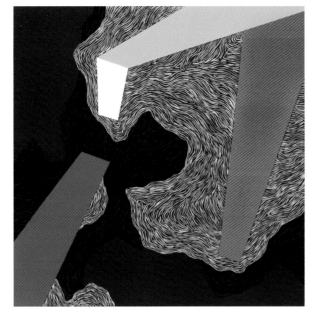
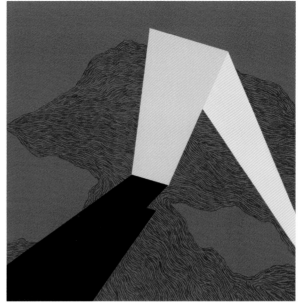

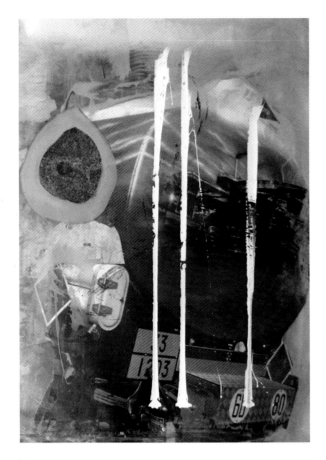

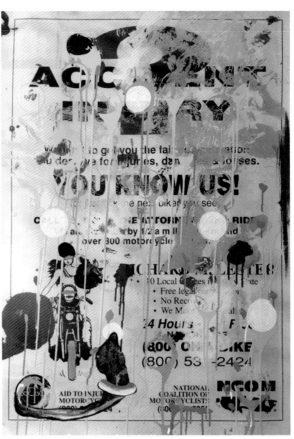

Rachel Libeskind
Breastplate, 2014
Collage and oil on paper, 106.7 x 76.2 cm

Rachel Libeskind
Accident Insurance, 2014
Collage and oil on paper, 106.7 x 76.2 cm

Rachel Libeskind
Untitled no. 1, 2014
Collage and oil on wood, 52 x 50 cm

Rachel Libeskind
Untitled no. 2, 2014
Collage and oil on wood, 52 x 50 cm

Marton Romvari
Late Baroque, 2012
Oil and lacquer on canvas, 100 x 70 cm

Marton Romvari
Shine Balls 12, 2012
Acrylic and lacquer on canvas,
140 x 100 cm

ALMA GALLERY

Riga, Latvia

Rūpniecības iela 1
Riga, LV-1010, Latvia
Phone +371 67322311
http://www.galerija-alma.lv
alma@galerija-alma.lv

Director Astrida Riņķe
Established in 2005

Artists featured
Krišs Salmanis (Latvia)
Aija Zariņa (Latvia)

Artists represented
Kristians Brekte (Latvia)
Andris Breže (Latvia)
Ivars Drulle (Latvia)
Andris Eglītis (Latvia)
Barbara Gaile (Latvia)
Ernests Kļaviņš (Latvia)
Verners Lazdāns (Latvia)
Zenta Logina (Latvia)
Krišs Salmanis (Latvia)
Aija Zariņa (Latvia)

ALMA GALLERY was founded by artist Astrida Riņķe and art historian Ilva Krišane with the goal of promoting new Latvian contemporary art that emphasizes dialectical engagement between what is perceived as local and what is perceived as global.

Krišs Salmanis
Scourge, 2015
Photograph, 42 x 52 cm
Courtesy of ALMA GALLERY

Krišs Salmanis
Scourge (series) 10, 2015
Burnt gingerbread on pedestal,
150 x 22 x 30 cm each
Courtesy of ALMA GALLERY

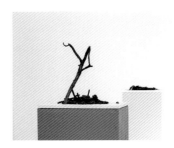

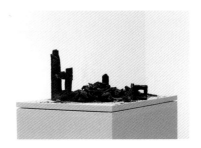

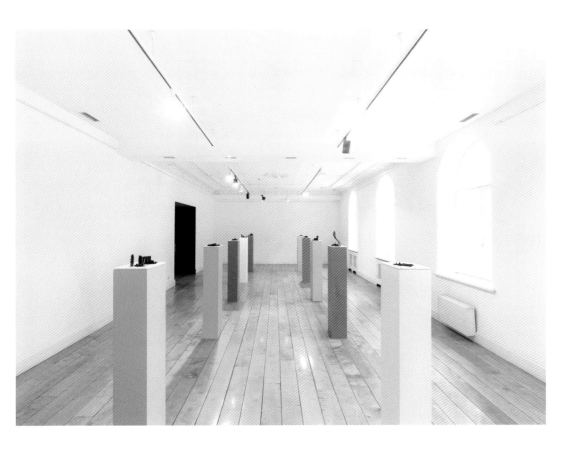

Krišs Salmanis
Tide, 2011
Stop-motion animation, loop
Courtesy of ALMA GALLERY

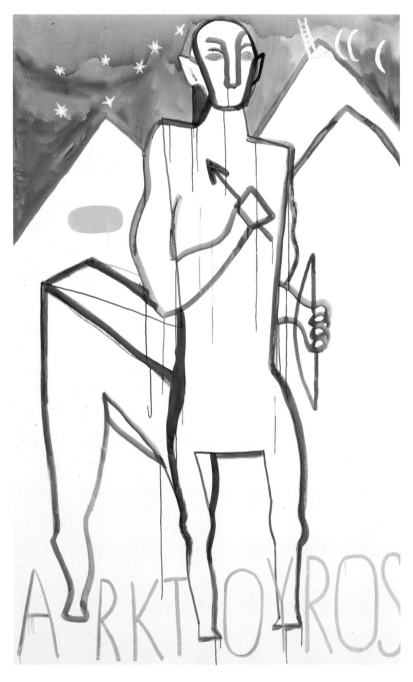

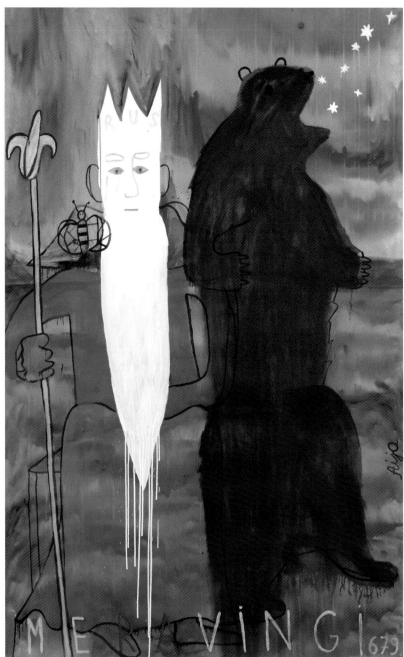

Aija Zariņa
The Sun Kingdom, 2015
Oil and acrylic on canvas, 240 x 150 cm
Courtesy of ALMA GALLERY

Aija Zariņa
The Russ Kings, 2015
Oil and acrylic on canvas, 245 x 150 cm
Courtesy of ALMA GALLERY

Aija Zariņa
Mage of the Sun, 2015
Oil and acrylic on canvas, 166.5 x 152 cm
Courtesy of ALMA GALLERY

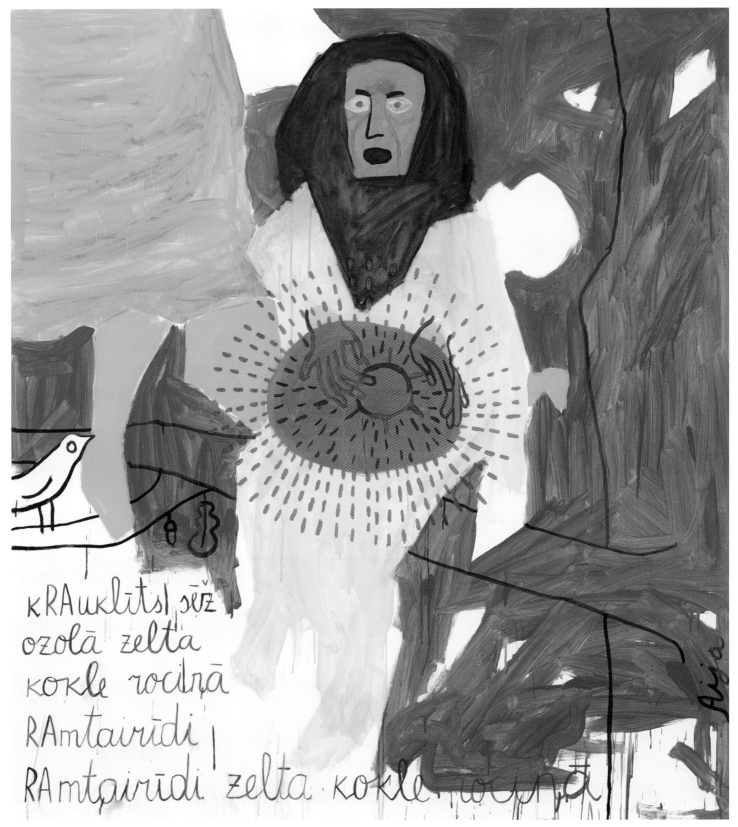

kRAuklīts| sēž
ozolā zelta
kokle rocirā
RAmtairīdi |
RAmtairīdi zelta kokle rocirā

ARTCO Gallery
Aachen, Germany

Seilgraben 31
D-52062 Aachen, Germany
Phone +49 (0) 241 401 267 50
Fax +49 (0) 241 401 267 52
www.artco-art.com
info@artco-ac.de

Director Joachim Melchers
Established in 2003

Artists featured
Daniel Blom (South Africa)
Marion Boehm (Germany/
South Africa)
Oliver Czarnetta (Germany)
Richard Mudariki (Zimbabwe/
South Africa)
Marcin Owczarek (Belgium/Poland)
Alice Smeets (Belgium)
Ransome Stanley (Germany)

Artists represented
Tété Azankpo (Togo)
Norman Catherine (South Africa)
Bruce Clarke (France)
Dilomprizulike (Nigeria)
Godfried Donkor (Ghana/UK)
EL Loko (Togo/Germany)
George "Afedzi" Hughes (Ghana/USA)
Owusu-Ankomah (Ghana)
Manuela Sambo (Angola/Germany)
Gary Stephens (South Africa)

ARTCO Gallery was founded in 2003
by Joachim and Jutta Melchers and
is located in the very heart of Europe,
close to Cologne, Düsseldorf and
bordering Belgium and The
Netherlands. Representing a selection
of local and international artists,
the gallery's main focus is the
presentation of established and
emerging artists with an African
background. The gallery participates
in a number of international fairs,
seeking to bring art from the continent
to the widest possible audience.
In addition to its programme of
solo shows and group exhibitions,
ARTCO Gallery publishes exhibition
catalogues and printed matter.

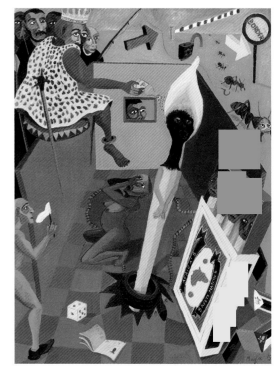

Richard Mudariki
Only in South Africa, 2015
Acrylic on canvas, 160 x 120 cm
Courtesy of the artist

Ransome Stanley
Another Place III, 2015
Oil on canvas, 97 x 95 cm
Courtesy of ARTCO Gallery

Marcin Owczarek
The Last Drop of Water, 2013
Photographic print on dibond, 66 x 100 cm
edition of 7 + 2 AP
Courtesy of the artist

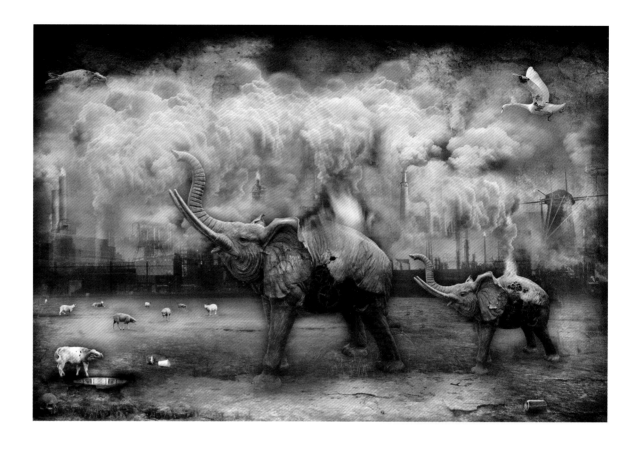

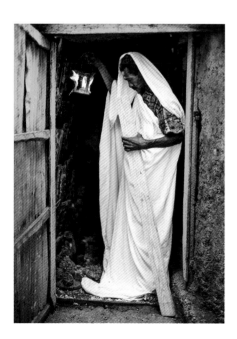

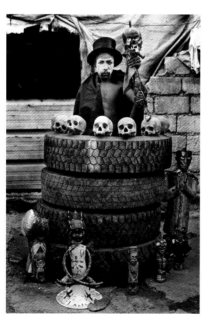

Alice Smeets
Ghetto Tarot / The Hermit, 2015
Archival pigment print, 58 x 42 cm
edition of 10 + 2 AP
Courtesy of the artist

Alice Smeets
The Ghetto Tarot, 2015
Photographic print on dibond, 100 x 72 cm
Courtesy of the artist

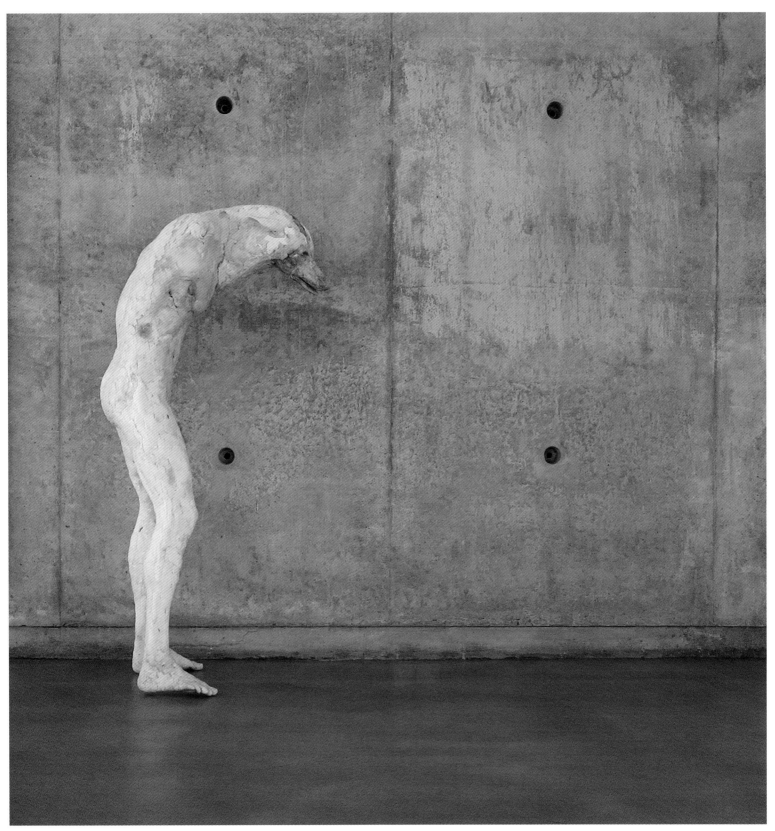

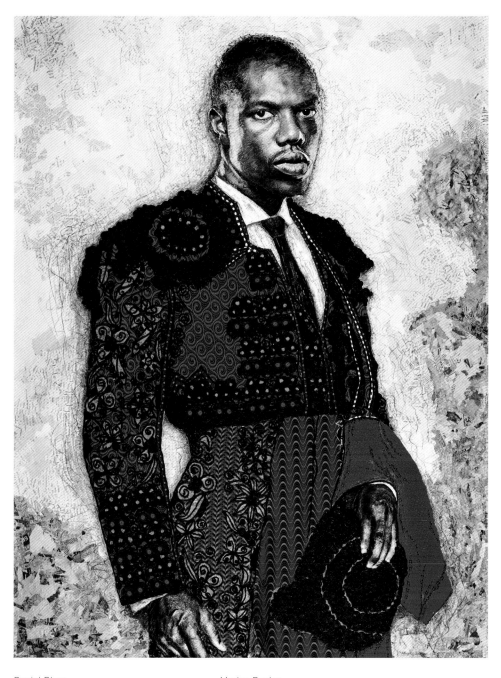

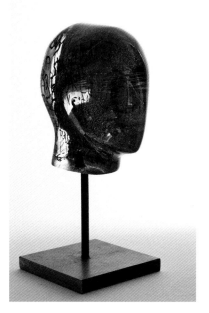

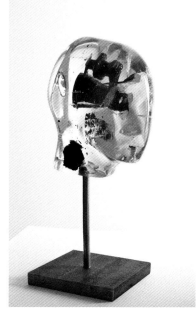

Oliver Czarnetta
Spectrum, 2015
Head poured in resin, height 28 cm
Courtesy of ARTCO Gallery

Daniel Blom
Wolf, 2006
Plastic and steel, 157 x 50 x 65 cm
Courtesy of the artist

Marion Boehm
Urban Torero, 2015
Collage and mixed media, 156 x 119 cm
Courtesy of ARTCO Gallery

art ON Istanbul

Istanbul, Turkey

Sair Nedim Cad. No:4
34307 Besiktas, Istanbul, Turkey
Phone 0090 212 259 1543
Fax 0090 212 259 1556
info@artonistanbul.com

Director Goksen Bugra
Established in March 2011

Artists featured
Firat Engin (Turkey)
Ilgin Seymen (Turkey)

Artists represented
Firat Engin (Turkey)
Ulrich Erben (Germany)
Murat Germen (Turkey)
Gereon Krebber (Germany)
Renée Levi (Switzerland)
Kemal Seyhan (Turkey/Austria)
Ilgin Seymen (Turkey)
Tunca Subasi (Turkey)
Sencer Vardarman (Turkey/Germany)
Iskender Yediler (Germany)

art ON Istanbul, a leading Turkish contemporary art gallery, concentrates on three major art concepts: abstract studies, explorations on figures and digital imagery. The gallery has been redesigned to be an interdisciplinary platform where works of creative thinking are exhibited and art discussions are held. Developing a programme that enables both young Turkish and international artists to present and exhibit their work, art ON Istanbul aims to provide an experimental area for artists with different tendencies while creating an open-ended dialogue between the Turkish and the global contemporary art world.

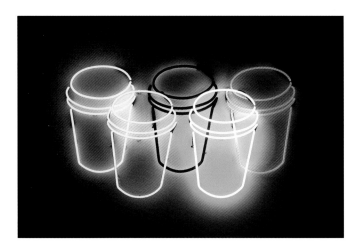

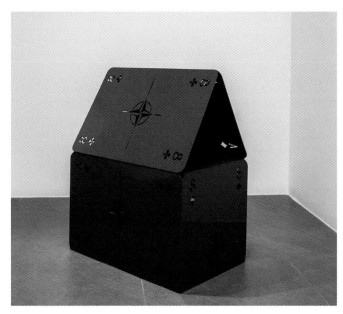

Firat Engin
Istanbul 2024, 2014
Neon installation, 100 x 140 x 20 cm
Courtesy of art ON Istanbul

Firat Engin
Nato House, 2013
CNC cut metal, 73 x 60 x 40 cm
Courtesy of art ON Istanbul

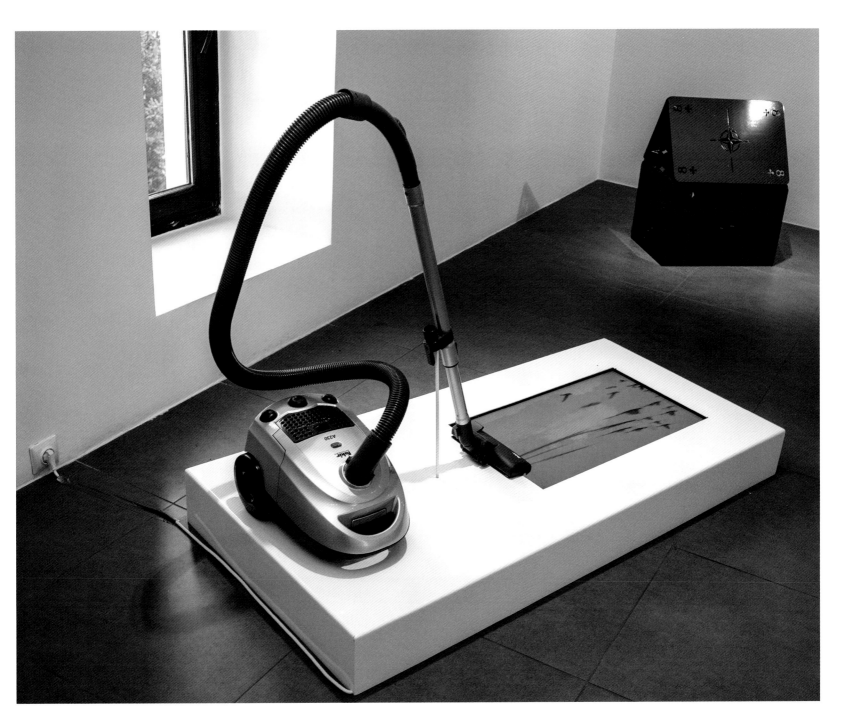

Firat Engin
Authority, 2013
Vacuum cleaner, DVD player, metal,
100 x 155 x 75 cm
Courtesy of art ON Istanbul

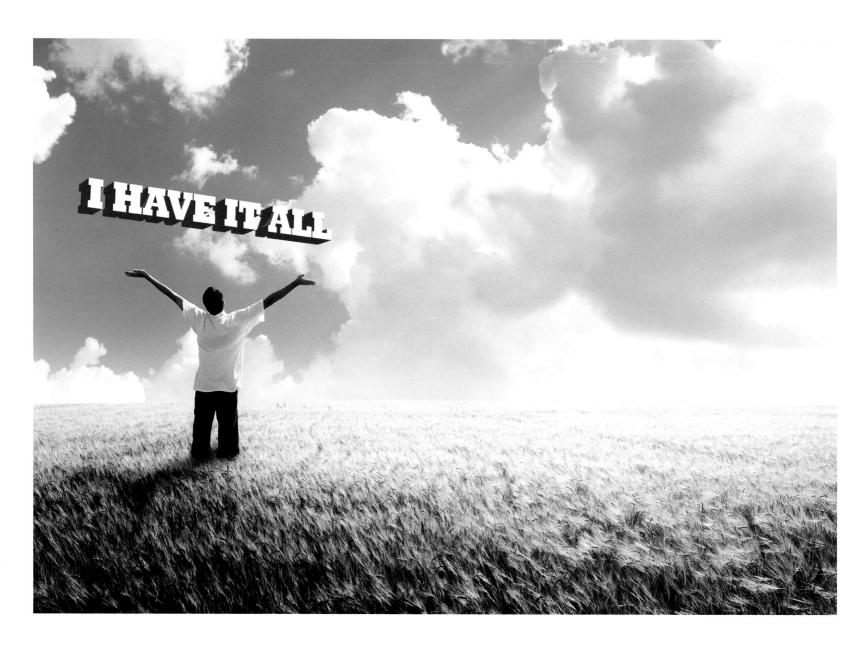

Ilgin Seymen
I Have It All, 2014
Digital print in lightbox, 50 x 70 cm
Courtesy of art ON Istanbul

Ilgin Seymen
Daily Chemistry, 2015
Mixed media, 93 x 160 x 11 cm
Courtesy of art ON Istanbul

Ilgin Seymen
Recycle Logo Collection III, 2015
Lightbox, 58 x 58 cm
Courtesy of art ON Istanbul

Ilgin Seymen
Future is Yours, 2014
Mixed media, 61 x 20 x 71 cm
Courtesy of art ON Istanbul – Chroma

Ilgin Seymen
Cosmostic Powder, 2014
Mixed media, 43 x 21 x 27 cm
Courtesy of art ON Istanbul

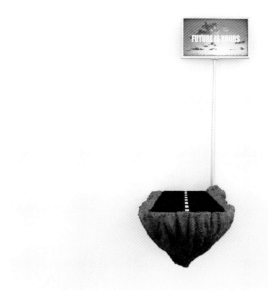

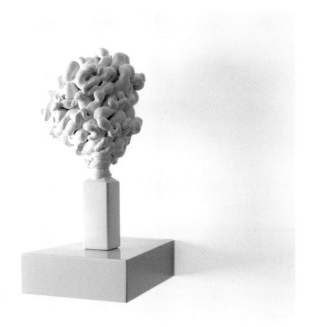

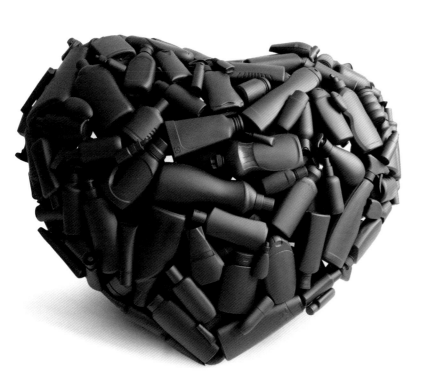

Ilgin Seymen
Blind Love, 2014
Mixed media, 70 x 100 x 70 cm
Courtesy of art ON Istanbul

atelier aki

Seoul, South Korea

Galleria Foret 1F 685–696
Seongsu-dong 1ga Seongdong-gu
Seoul, South Korea 133-110
Phone 84 (0)2 464 7710
Fax 84 (0)2 466 7710
www.atelieraki.com
aki@atelieraki.com

Director Eunkyung Kim
Established in 2010

Artists featured
Kim Nam-Pyo (South Korea)
Kang Jun Young (South Korea)
Kang Yeh Sine (South Korea)

Artists represented
Kim Nam-Pyo (South Korea)
Kang Jun Young (South Korea)
Kang Yeh Sine (South Korea)

Established in 2010, atelier aki has
always challenged new realms as a
young and promising gallery in South
Korea. It builds cultural exchanges,
has developed a stream of new
contemporary art and has encouraged
diversity and variety in the Korean art
world. As well as showing established
Korean masters, in its short existence
atelier aki has also been committed
to presenting new works by emerging
artists. atelier aki has organized solo
exhibitions of the most notable Korean
artists known throughout the world
like Kim Nam-Pyo, Myungho Lee
and Kwon Kisoo.

Kim Nam-Pyo
Instant Landscape – Traveler #29, 2014
Artificial fur and charcoal on corrugated
cardboard, 130.3 x 190 cm

Kim Nam-Pyo
Instant Landscape – Androgynous #3, 2014
Artificial fur and charcoal on corrugated
cardboard, 130.3 x 162.2 cm

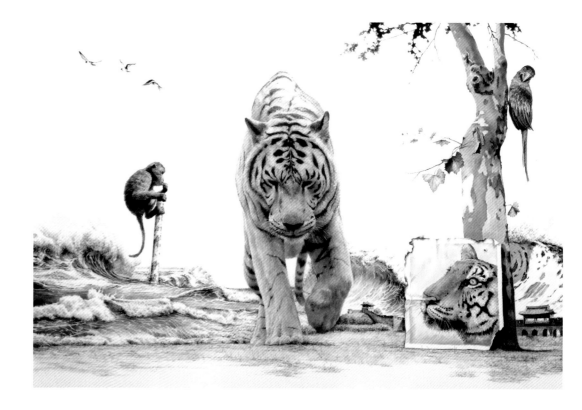

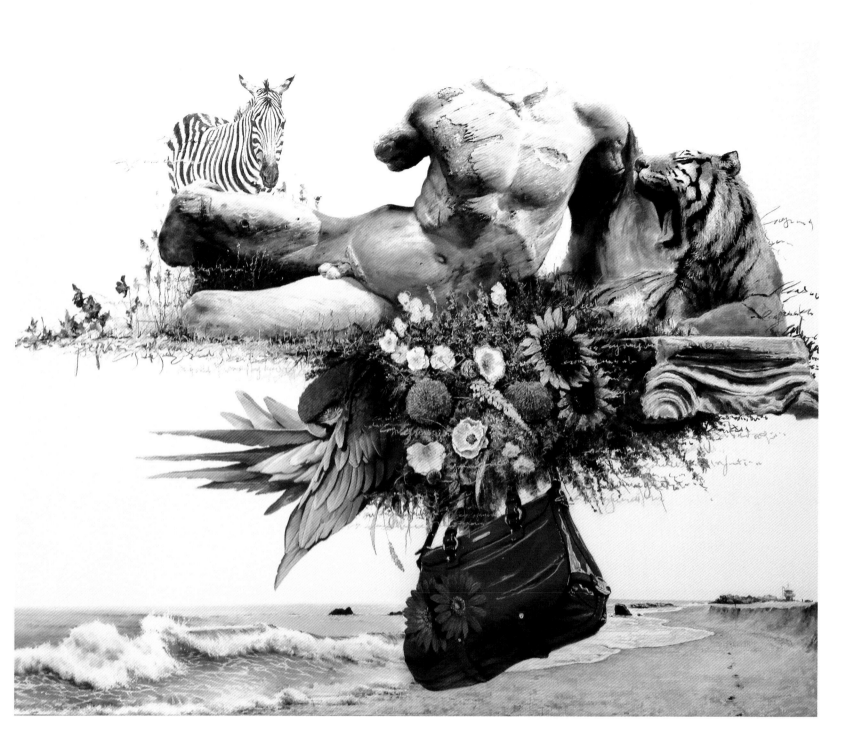

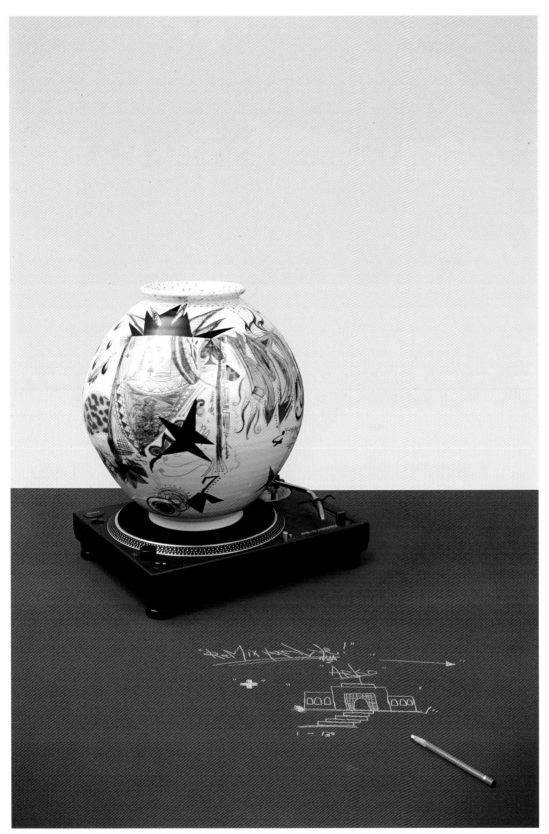

Kang Jun Young
Nostalgia + This is it!, 2010
Glazed ceramic, turntable, 50 x 50 x 52 cm

Kang Jun Young
I was born to love you, 2013
Glazed ceramic, 50 x 50 x 52 cm

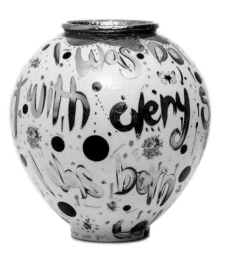

Kang Jun Young
The first duty of love is to listen, 2014
Mixed media, dimensions variable

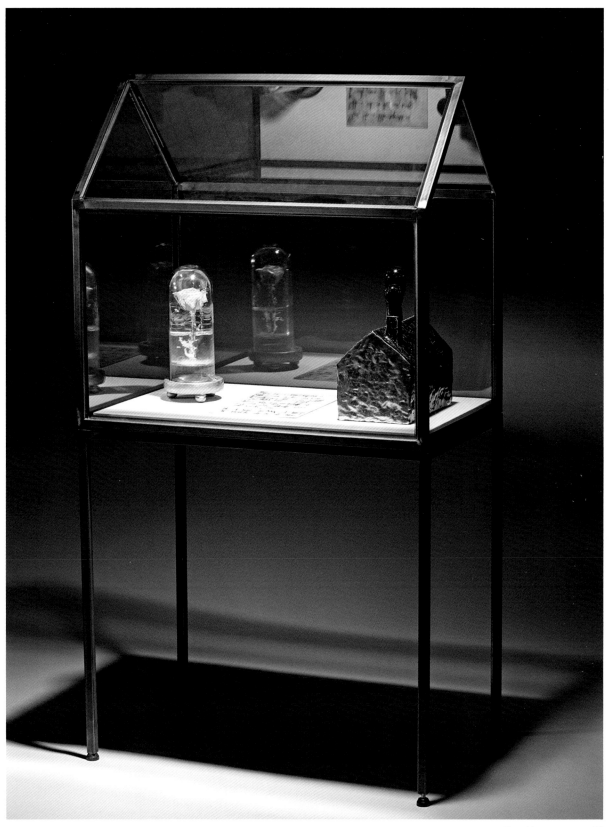

Atelier Alen

Munich, Germany

Baaderstrasse 34
80469 Munich, Germany
Phone +49 89 2020 1899
Fax +49 89 20201898
info@atelieralen.de

Director Elena Fedorova
Established in 2012

Artists featured
Candido Baldacchino (Italy)
Raimund Feiter (Germany)
Beate Rose (Germany)
Anatoly Rudakov (Russia)

Artists represented
Candido Baldacchino (Italy)
Sherif Elhage (France)
Raimund Feiter (Germany)
Costin Irimia (Romania)
Beate Rose (Germany)
Anatoly Rudakov (Russia)

Atelier Alen is based in the heart of Munich and was founded in 2012 by Elena Fedorova, a former CEO of German TV channel Das Vierte. She provides work and exhibition space for aspiring and established artists and offers them an opportunity to get international exposure. Since 2012 Atelier Alen held solo and group exhibitions of Anatoly Rudakov, Costin Irimia, Raimund Feiter, Sherif Elhage, Beate Rose and others. Atelier Alen participated in various international art fairs and art projects including City Cinemas Munich, the DOK.fest and the BOX – Space for Art, which expanded the reach of this young gallery.

Beate Rose
Housewife, 34. Merchant for oversea timber, 44, 1971/2015
C-print on Kodak Pro Endura paper, 40 x 30 cm
Courtesy of the artist

Beate Rose
Student, 19. Goldsmith, 19, 1971/2015
C-print on Kodak Pro Endura paper, 40 x 30 cm
Courtesy of the artist

Beate Rose
Vagabond, 63. Vagabond, 63, 1971/2015
C-print on Kodak Pro Endura paper, 40 x 30 cm
Courtesy of the artist

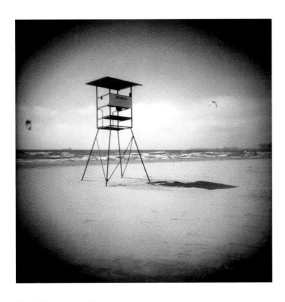

Candido Baldacchino
La vedetta, 2011
Black and white digital print on cotton
paper, 60 x 60 cm
Courtesy of the artist

Candido Baldacchino
Sand Castles, 2011
Black and white digital print on cotton
paper, 60 x 60 cm
Courtesy of the artist

Candido Baldacchino
The Rolling Stone, 2005
Black and white digital print on cotton
paper, 60 x 60 cm
Courtesy of the artist

Raimund Feiter
Untitled (cactus), 2012
Archival pigment print on Hahnemühle
paper, 90 x 120 cm
Courtesy of the artist

Raimund Feiter
Untitled (magno), 2012
Archival pigment print on Hahnemühle
paper, 90 x 120 cm
Courtesy of the artist

Raimund Feiter
Untitled (trees), 2013
Archival pigment print on Hahnemühle
paper, 90 x 120 cm
Courtesy of the artist

Anatoly Rudakov
Landscape #2, 2014
C-print on Alu Dibond under matte
acrylic glass, 100 x 150 cm
Courtesy of the artist

Anatoly Rudakov
Landscape #3, 2013
C-print on Alu Dibond under matte
acrylic glass, 100 x 150 cm
Courtesy of the artist

Anatoly Rudakov
Landscape #8, 2013
C-print on Alu Dibond under matte
acrylic glass, 100 x 150 cm
Courtesy of the artist

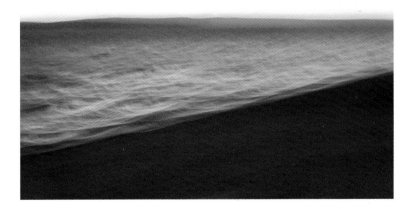

BAIK ART

Los Angeles, USA

2600 S. La Cienega Blvd.
Los Angeles, CA 90034
Phone 310-842-3892
www.baikart.com
baik@baikart.com

Director Susan Baik
Established in 2014

Artists featured
Laura Menz (USA)
Wiyoga Muhardanto (Indonesia)
Christine Nguyen (USA)
Park Kyung-Ryul (South Korea)

Artists represented
Ahn Young-Il (USA)
Ahmad Zakii Anwar (Malaysia)

BAIK ART is a contemporary art
gallery dedicated to growing with its
artists. International residencies,
travelling exhibits, and transpacific
collaborations: these are just a few
ways in which we support the cross-
fertilization of our artists' cultural
values and ideas. Grounded with
a clear vision of contributing to the
contemporary art world, we encourage
our artists to continually test and
evolve the boundaries of their
practices.

Christine Nguyen
Rockets, 2008
Acrylic inks with salt crystals on
unprocessed Fujicolor Crystal archive
paper, 70 x 50.8 cm

Christine Nguyen
Millusk's Dust, 2008
Acrylic inks with salt crystals on
unprocessed Fujicolor Crystal archive
paper, 70 x 50.8 cm

Christine Nguyen
Atmosphere, 2015
Acrylic inks with salt crystals on
unprocessed Fujicolor Crystal archive
paper, 70 x 50.8 cm

Christine Nguyen
Cosmiccactus, 2015
Acrylic inks with salt crystals on
unprocessed Fujicolor Crystal archive
paper, 70 x 50.8 cm

Christine Nguyen
Sea Moon, 2015
Acrylic inks with salt crystals on
unprocessed Fujicolor Crystal archive
paper, 2 sheets, 70 x 50.8 cm each

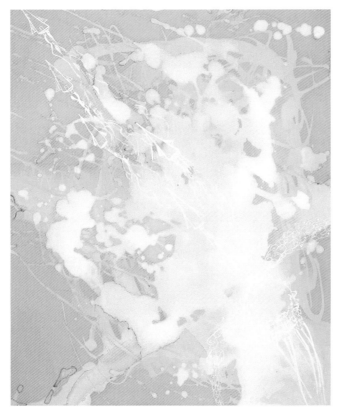
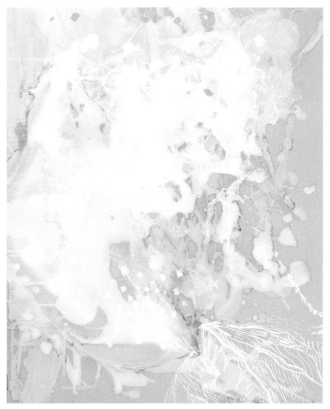
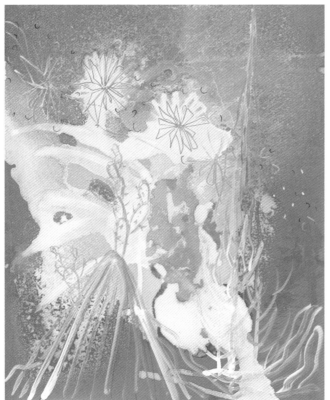
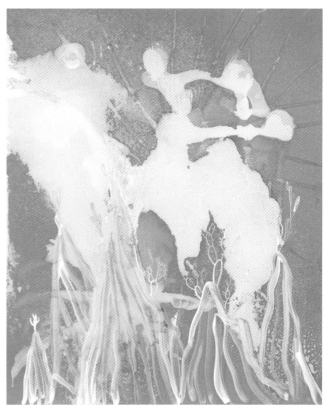

Park Kyung-Ryul
Vulnerable Drawing No. 650, 2013
Oil on pencil, oil on pastel acrylic on terra,
240 x 650 cm

Park Kyung-Ryul
Untitled, 2014
Oil on canvas, 30 x 30 cm

Park Kyung-Ryul
Vulnerable Drawing No. 170, 2013
Acrylic and colour pencil on terra paper,
21 x 22 cm

Park Kyung-Ryul
Floating A, 2014
Oil on canvas, 170 x 170 cm

Park Kyung-Ryul
Untitled, 2014
Oil on canvas, 112 x 146 cm

Park Kyung-Ryul
Drama of C, 2014
Oil on canvas, 170 x 180 cm

Park Kyung-Ryul
Fall Bud, 2014
Oil on canvas, 60 x 60 cm

GALLERY BASTEJS

Riga, Latvia

Alksnaja Str. 7, Riga
LV-1050, Latvia
Phone +37129136840
www.bastejs.com
bastejs@latnet.lv
baiba.morkane@gmail.com

Director Baiba Morkane
Established in 2005

Artists featured
Kristians Brekte (Latvia)
Sigita Daugule (Latvia)
Ritums Ivanovs (Latvia)
Henrijs Preiss (Latvia/USA)

Artists represented
Kristians Brekte (Latvia)
Sigita Daugule (Latvia)
Ritums Ivanovs (Latvia)
Henrijs Preiss (Latvia/USA)

GALLERY BASTEJS, led and owned by Baiba Morkane, has focused on the cultural exchange between Baltic states, representing artists from Estonia, Latvia and Lithuania. The gallery works closely with its represented artists, providing artworks for private collections and institutions, as well as organizing various cultural events. Currently GALLERY BASTEJS is located in the old quarter of Latvia's capital city Riga.

Kristians Brekte
Pink bird, 2013
Mummified bird, alkyd on canvas,
35 x 43 cm
Courtesy of the artist and
GALLERY BASTEJS

Kristians Brekte
The end, 2013
Crow roadkill, alkyd on canvas,
40 x 50 cm
Courtesy of the artist and
GALLERY BASTEJS

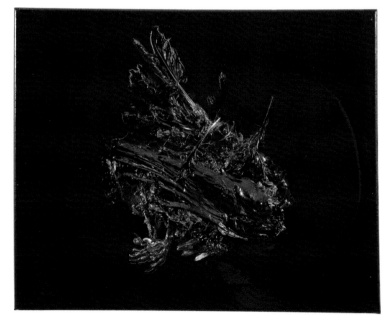

Sigita Daugule
Family pet, 2014
Oil on canvas, 120 x 150 cm
Courtesy of the artist and
GALLERY BASTEJS

Sigita Daugule
The wall, 2014
Oil on canvas, 100 x 100 cm
Courtesy of the artist and
GALLERY BASTEJS

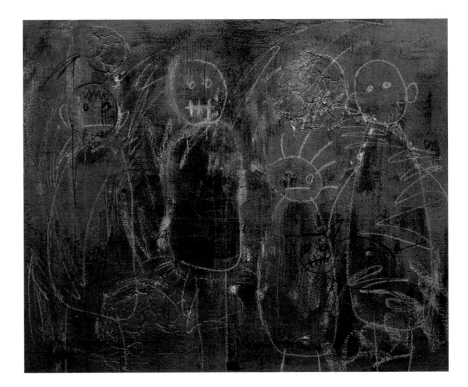

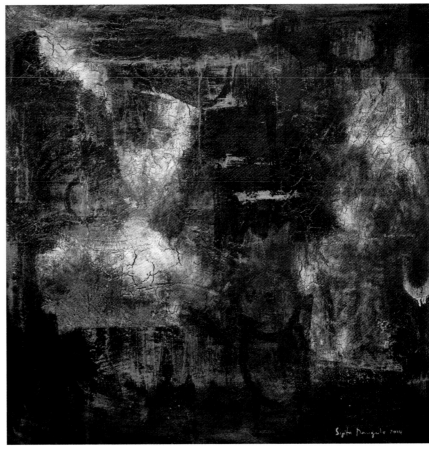

Ritums Ivanovs
City girl, 2014
Oil on canvas, 80 x 60 cm
Courtesy of the artist and
GALLERY BASTEJS

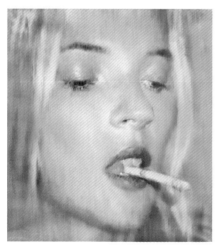

Ritums Ivanovs
Erotic movie, frame 06, 2014
Oil on canvas, 100 x 105 cm
Courtesy of the artist and
GALLERY BASTEJS

Ritums Ivanovs
Model with the cigarette (Kate), 2014
Oil on canvas, 80 x 73 cm
Courtesy of the artist and
GALLERY BASTEJS

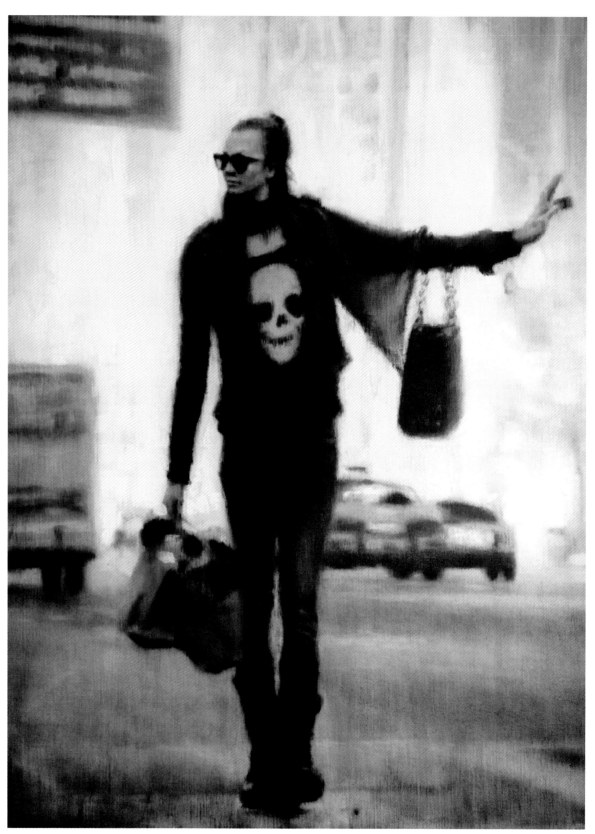

Henrijs Preiss
N 387, 2015
Acrylic on board, 116 x 102 cm
Courtesy of the artist and
GALLERY BASTEJS

Henrijs Preiss
N388, 2015
Acrylic on canvas, 116 x 102 cm
Courtesy of the artist and
GALLERY BASTEJS

CES Gallery

Los Angeles, USA

711 Mateo St.
Los Angeles, CA 90021
www.carlesmithgallery.com
info@carlesmithgallery.com
Phone +1 213 880 5474

Director Carl E. Smith
Established in 2014

Artists featured
Scott Anderson (USA)
Doty/Glasco (USA)
Robert Larson (USA)
Kenton Parker (USA)

Artists represented
Scott Anderson (USA)
Doty/Glasco (USA)
Lola Dupré (France)
Stephen Eichhorn (USA)
Ashkan Honarvar (Iran)
Robert Larson (USA)
Mike Parillo (USA)
Zin Helena Song (South Korea)
Ira Svobodová (Czech Republic)

CES Gallery specializes in local and international contemporary fine art. The gallery pursues and supports the development of young, emerging artists. Our mission is to encourage accessible works that are progressive, challenging and cutting edge.
A multitude of traditional and new artistic mediums is exhibited at CES with an emphasis on concept-driven, interdisciplinary works that maintain integrity in design and attention to detail. CES Gallery was founded in 2014 by Carl E. Smith in downtown Los Angeles. Smith has directed and produced other eponymous projects since 2010.

Doty/Glasco
The White Place, 2015
Archival pigment print on silk, poplar and acrylic paint, 134.6 x 91.4 cm
Courtesy of CES Gallery

Doty/Glasco
Fountain of Four Rivers
(Southern Comfort), 2015
Matte archival pigment print
and archival varnish, 71 x 53 cm
Courtesy of CES Gallery

Doty/Glasco
Fountain of Four Rivers
(Upper Canopy), 2015
Matte archival pigment print
and archival varnish, 71 x 53 cm
Courtesy of CES Gallery

Robert Larson
White Tessellation, 2014
Discarded cigarette packaging on canvas,
165.1 x 114.3 cm
Courtesy of CES Gallery

Robert Larson
White Honey, 2012
Discarded cigarette packaging on linen,
66 x 66 cm
Courtesy of CES Gallery

Scott Anderson
Mall Huffers (Nightschool), 2015
Oil and coloured pencil on canvas,
101.5 x 81 cm
Courtesy of CES Gallery

Scott Anderson
Holding Food Court, 2014
Oil, oil crayon and graphite on canvas,
152 x 122 cm
Courtesy of CES Gallery

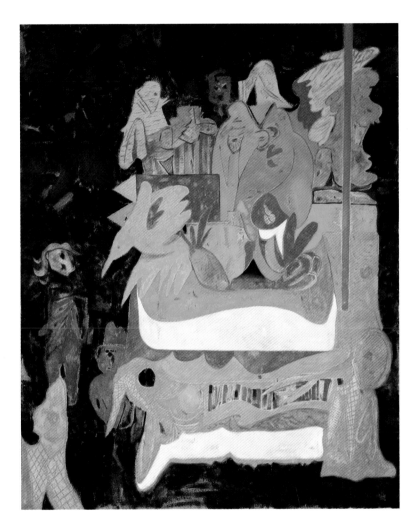

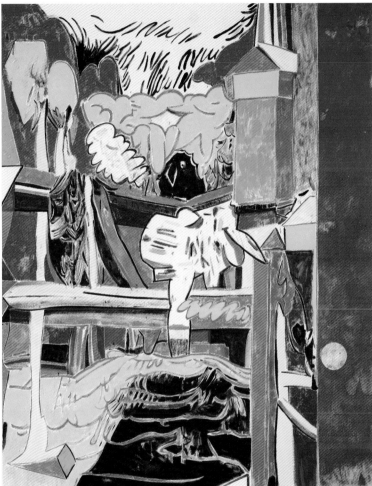

Galeri Chandan

Kuala Lumpur, Malaysia

Lot 24 & 25, Level G4, Block C5,
Publika Shopping Gallery,
Jalan Dutamas 1, 50480
Kuala Lumpur, Malaysia
Phone +603 62015360
Fax +603 62018360
galerichandan@gmail.com

Director Nazli Aziz
Established in 2008

Artists featured
Haris Abadi Abdul Rahim (Malaysia)
Awang Damit Ahmad (Malaysia)
Chong Siew Ying (Malaysia)
Umibaizurah Ismail@Mahir (Malaysia)
Kow Leong Kiang (Malaysia)
Phuan Thai Meng (Malaysia)
Zulkifli Yusoff (Malaysia)

Artists represented
Haris Abadi Abdul Rahim (Malaysia)
Awang Damit Ahmad (Malaysia)
Chong Siew Ying (Malaysia)
Umibaizurah Ismail@Mahir (Malaysia)
Kow Leong Kiang (Malaysia)
Phuan Thai Meng (Malaysia)
Zulkifli Yusoff (Malaysia)

Galeri Chandan is dedicated to
Malaysian contemporary artists.
In addition to commercial exhibitions,
the gallery fostered the *Kembara Jiwa*
(Travelling Soul) project in order to
introduce Malaysian contemporary art
to the global art community. It also
pioneered the *Malaysian Emerging
Artist* biennial award and Nafa's
Residensi, an artist-in-residence
programme based in Yogyakarta,
Indonesia to promote collaboration
among artists in the Southeast
Asian region.

Umibaizurah Ismail@Mahir
Dinner with Someone...?, 2014
Ceramic, metal flower, silicon fish, wooden
round blocks, wood cabinet and wheels,
142 x 37 x 37 cm each
Courtesy of the artist

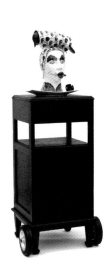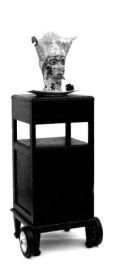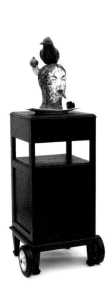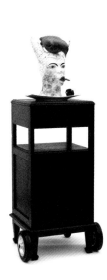

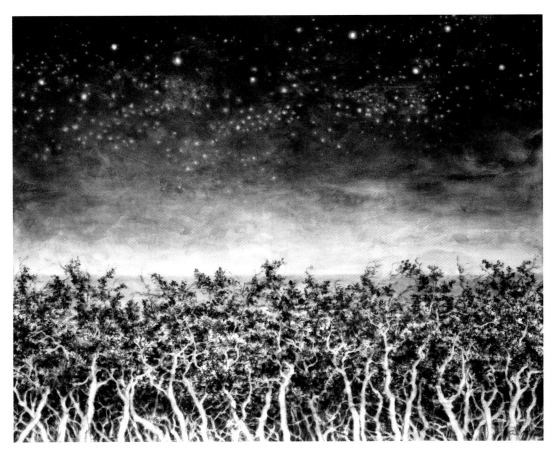

Chong Siew Ying
A Starry Night, 2014
Charcoal and acrylic emulsion on paper-mounted canvas, 114 x 146 cm
Courtesy of the artist

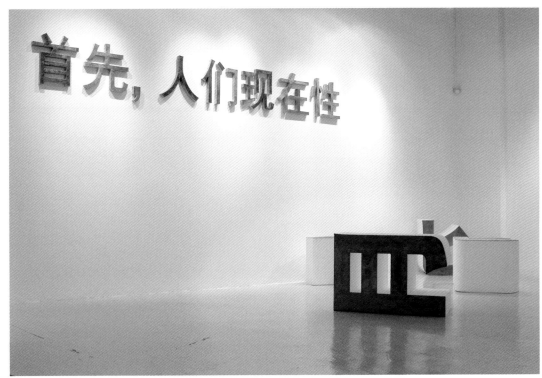

Detail of artworks: Attitude & Vision

Malaysia is a developing country, with problems and challenges similar to other nations in Southeast Asia. By re-visiting images of rapid urbanization and infrastructure development, in this piece of work I aim to provoke various questionings of the social environment on both a local and regional level.

This piece of work was inspired by some social issues which happen in Malaysia, such water lacking in our high court, used inappropriate material in the infrastructure, wrong Chinese translation for the welcoming banner during the ceremony to welcome the leader from foreign country. I try to re-looking and make an awareness for myself as well as the public toward the attitude of the authority on leading the country, and what actually they looking for, self benefit, serving people or ...

The artwork was constructed by a Chinese sentence (首先，人们现在性能). This sentence was a resulted of Google translate the 1 Malaysia's slogan "RAKYAT DIDAHULUKAN, PENCAPAIAN DIUTAMAKAN".

Those Chinese words were design to install on wall and floor as well. Those words install on the wall were made by plywood and "fake" gold leaf was glued on the front surface. The last word in the sentence "能" was made by poly-foam and top part of the word was covered with cement. The word was deconstructed and place on the floor. In this work the gold leaf was intentionally to let it continually to oxide.

** "能" in English mean CAN and in Malay is "BOLEH".

Phuan Thai Meng
Attitude & Vision, 2011
Plywood, gold leaf, polyfoam and cement, dimensions variable
Courtesy of the artist

Zulkifli Yusoff
Mari Kita ke Ladang, 2015
Mixed media (fibreglass, epoxy resins
and fabrics), 122 x 488 cm
Courtesy of the artist

Awang Damit Ahmad
Marista "Saging dan Sebabat Keringat II"
Mixed media on canvas, 122 x 91.5 cm
Courtesy of the artist

Haris Abadi Abdul Rahim
Yellow Dancer, 2013
Digital frame, plastic and video,
53 x 8 x 30 cm
Courtesy of the artist

Kow Leong Kiang
Sea Breeze, 2015
Oil on canvas, 120 x 120 cm
Courtesy of the artist

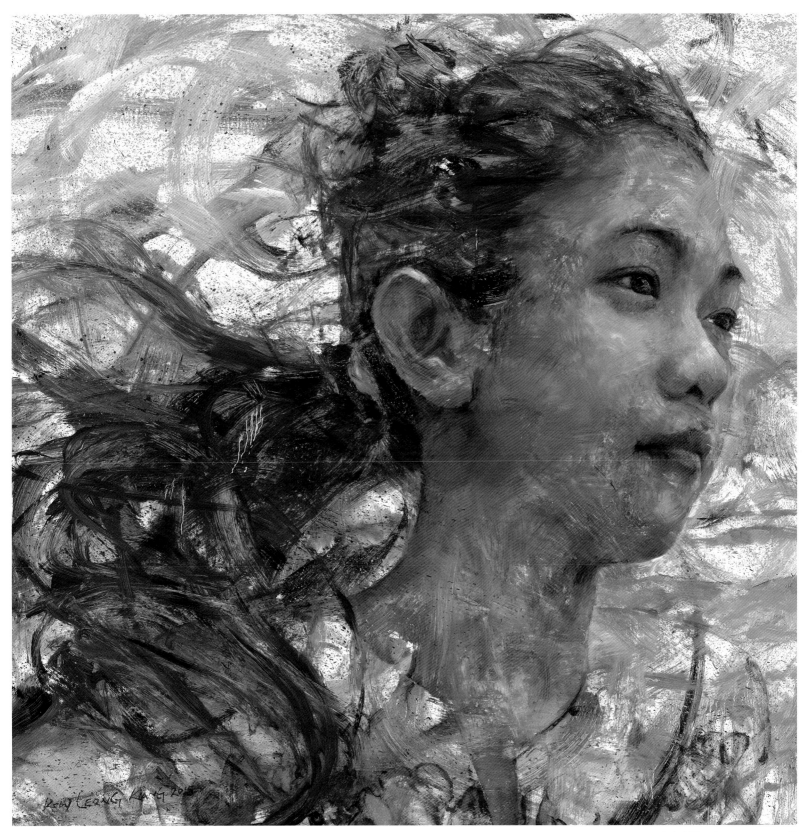

CUC Gallery

Hanoi, Vietnam

A4703, Keangnam Tower A
E6 Pham Hung, Cau Giay,
Hanoi, Vietnam
Phone +84462523111
Fax +84462582111
contact@cucgallery.vn

Director Pham Phuong Cuc
Established in 2012

Artists featured
Do Hoang Tuong (Vietnam)
Ly Tran Quynh Giang (Vietnam)
Nguyen Son (Vietnam)
Nguyen Trung (Vietnam)
Nguyen Van Phuc (Vietnam)

Artists represented
Do Hoang Tuong (Vietnam)
Lai Dieu Ha (Vietnam)
Ly Tran Quynh Giang (Vietnam)
Nau (Vietnam)
Nguyen Son (Vietnam)
Nguyen Trung (Vietnam)
Nguyen Van Phuc (Vietnam)

CUC Gallery is located in the new financial area of Hanoi, Vietnam. It launched its first exhibition in November 2012. The gallery aims to present Vietnamese, regional and international art and to promote contemporary art to the Vietnamese and regional audiences.

Nguyen Van Phuc
Courtship, 2009
Oil on canvas, 80 x 100 cm
Courtesy of CUC Gallery

Nguyen Van Phuc
Sacrifice, 2008
Oil on canvas, 120 x 150 cm
Courtesy of CUC Gallery

Nguyen Trung
Alexandra beige, 2014
Acrylic on canvas, 100 x 100 cm
Courtesy of CUC Gallery

Nguyen Trung
Creamy beige, 2014
Acrylic on canvas, 100 x 100 cm
Courtesy of CUC Gallery

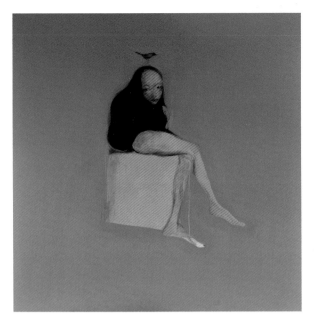

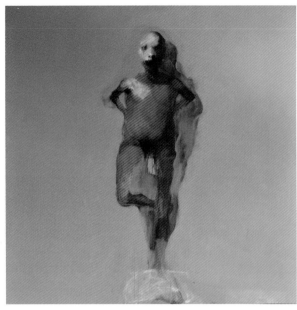

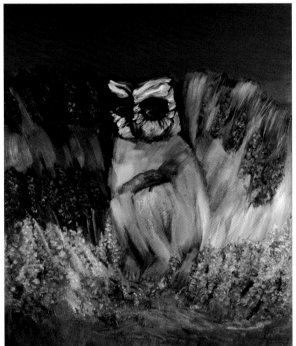

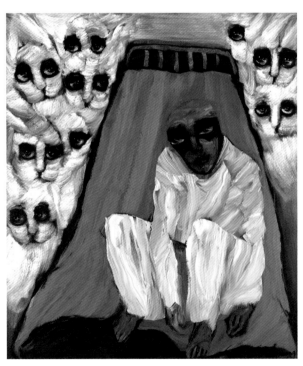

Do Hoang Tuong
Red bird, 2014
Oil on canvas, 145 x 145 cm
Courtesy of CUC Gallery

Do Hoang Tuong
Untitled, 2014
Oil on canvas, 145 x 145 cm
Courtesy of CUC Gallery

Ly Tran Quynh Giang
Where they turn to 5, 2013
Oil on canvas, 155 x 135 cm
Courtesy of CUC Gallery

Ly Tran Quynh Giang
Where they turn to 9, 2014
Oil on canvas, 155 x 135 cm
Courtesy of CUC Gallery

Nguyen Son
Nine 15, 2012
Ink on Xuyen chi paper, 65 x 150 cm
Courtesy of CUC Gallery

Nguyen Son
Nine 17, 2012
Ink on Xuyen chi paper, 65 x 150 cm
Courtesy of CUC Gallery

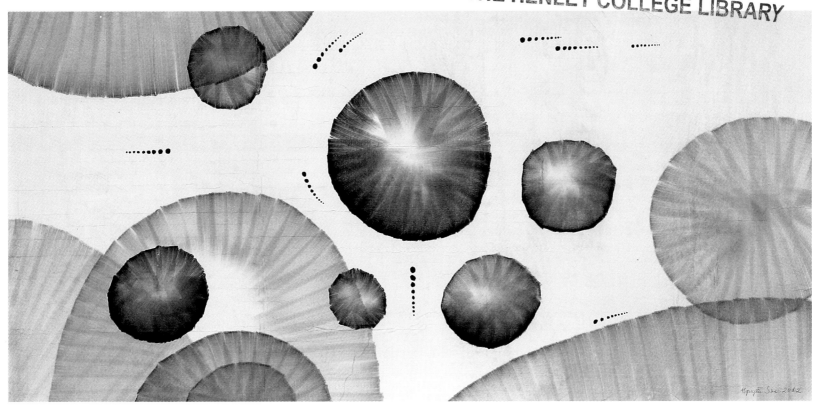

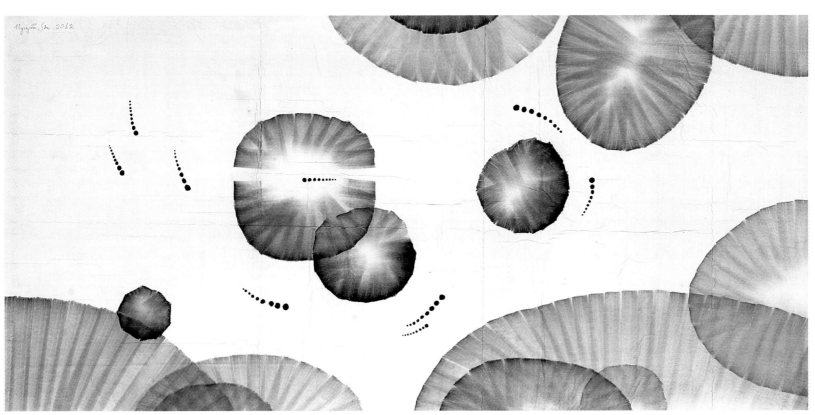

Denny Gallery
New York, USA

261 Broome Street
New York, NY 10002
Phone +1 212 226 6753
www.dennygallery.com
email@dennygallery.com

Director Elizabeth Denny
Established in 2013

Artists featured
Nikolai Ishchuk (UK/Russia)
Emily Noelle Lambert (USA)
Lauren Seiden (USA)

Artists represented
Sean Fader (USA)
Nadja Frank (USA/Germany)
Nikolai Ishchuk (UK/Russia)
Emily Noelle Lambert (USA)
Ole Martin Lund Bø (Norway)
Liz Nielsen (USA)
Lauren Seiden (USA)
Jordan Tate (USA)
Russell Tyler (USA)
Amanda Valdez (USA)

Denny Gallery is a contemporary fine
art gallery opened by Elizabeth Denny
in January 2013 on the Lower East
Side of New York City. The gallery
specializes in work by emerging and
mid-career artists whose practices
are interdisciplinary, process-oriented,
aware of their social and institutional
contexts, and engaged with
contemporary issues, materials
and technologies.

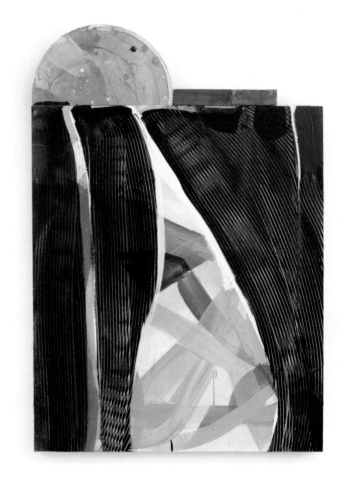

Emily Noelle Lambert
Veil, 2014
Acrylic on panel, 95 x 66 cm
Courtesy of the artist and Denny Gallery

Emily Noelle Lambert
Tangle, 2015
Acrylic on panel, 122 x 122 cm
Courtesy of the artist and Denny Gallery

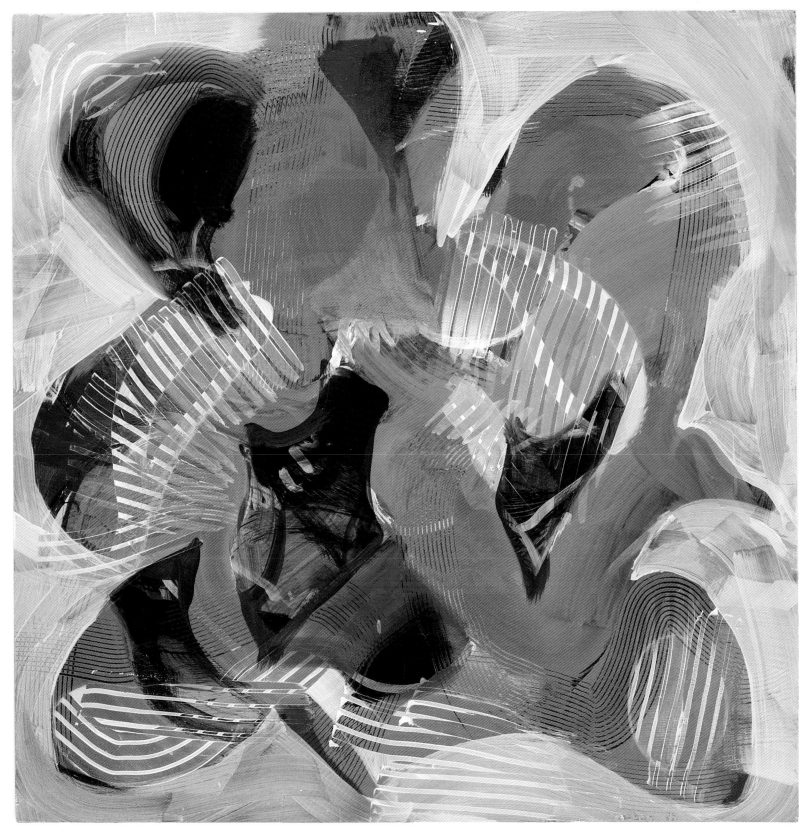

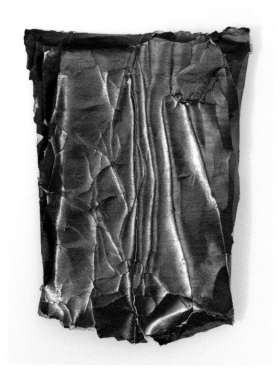

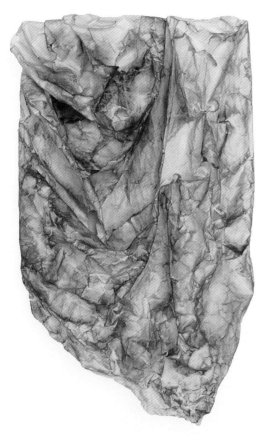

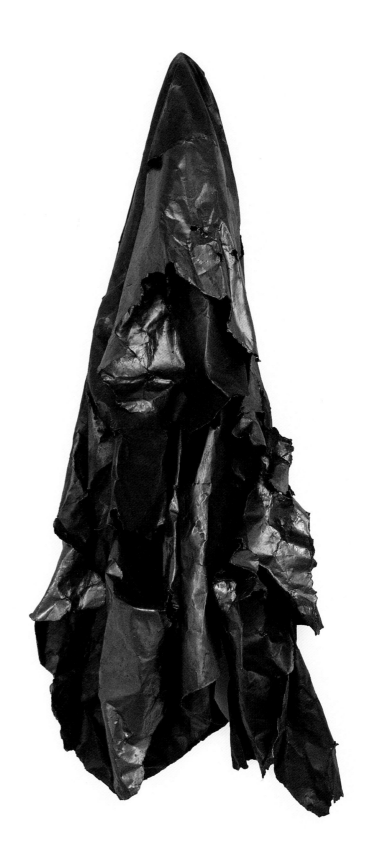

Lauren Seiden
Untitled (Burst 2), 2015
Graphite on paper wrapped on wood,
30 x 20 x 6 cm
Courtesy of the artist and Denny Gallery

Lauren Seiden
Blue Raw Wrap 3, 2015
Graphite and pigment on paper,
140 x 90 x 23 cm
Courtesy of the artist and Denny Gallery

Lauren Seiden
Cloaked, 2015
Graphite on paper, 124 x 56 x 23 cm
Courtesy of the artist and Denny Gallery

Nikolai Ishchuk
Untitled (Spill 6), 2014
Silver gelatin print, cyanotype, acrylic
and polymer spray, 61 x 51 cm
Courtesy of the artist and Denny Gallery

Nikolai Ishchuk
Untitled (Sedimentation 7), 2015
Silver gelatin print, cyanotype, acrylic, oil,
printing ink, cement wash and polymer
spray, 61 x 51 cm
Courtesy of the artist and Denny Gallery

Nikolai Ishchuk
Leak XII, 2015
Silver gelatin print, cyanotype,
acrylic, concrete, epoxy and lacquer,
60.5 x 22 x 6 cm
Courtesy of the artist and Denny Gallery

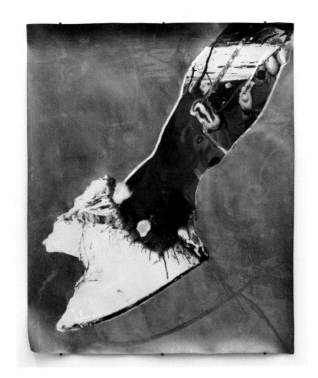
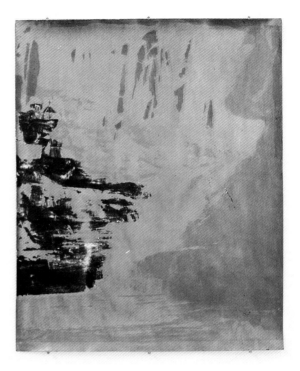
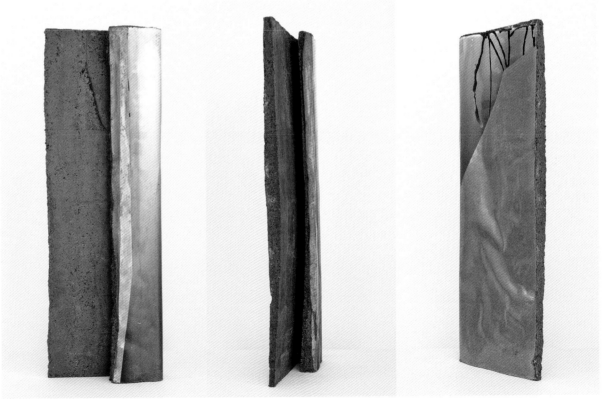

dvorak sec contemporary

Prague, Czech Republic

Dlouhá 5, Prague 1, 110 00,
Czech Republic
Phone +420 723 818 480
info@dvoraksec.com

Directors Olga Trčková and Petr Šec
Established in 2008

Artists featured
David Černý (Czech Republic)
Viktor Frešo (Slovakia)
Michal Gabriel (Czech Republic)
Ašot Haas (Slovakia)
Martin Krajc (Czech Republic)
Jakub Matuška (Czech Republic)
Pasta Oner (Czech Republic)

Artists represented
Jiří Černický (Czech Republic)
David Černý (Czech Republic)
Jiří David (Czech Republic)
Viktor Frešo (Slovakia)
Ašot Haas (Slovakia)
Martin Krajc (Czech Republic)
Jakub Matuška (Czech Republic)
Tomáš Smetana (Czech Republic)
Richard Stipl (Czech Republic)
Roman Týc (Czech Republic)

dvorak sec contemporary is a leading Prague-based gallery that offers Czech and international art, with a quality portfolio of artists whom they exclusively represent. The full spectrum of services the gallery offers includes assistance to clients in the purchase of contemporary art, development and management of fine art collections and navigation through the contemporary art market. Thanks to its knowledge and international network, DSC provides expert advice and personalized consultation in an intimate gallery setting to a wide range of clients, including private collectors, corporations and institutions that are interested in building and developing noteworthy art collections.

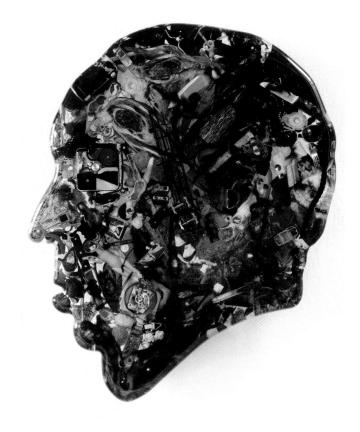

David Černý
Hitchcock, 2013
Mixed media, 100 x 95 cm
Courtesy of dvorak sec contemporary

David Černý
Guns, 2015
Mixed media, 41 x 55 x 17 cm
Courtesy of dvorak sec contemporary

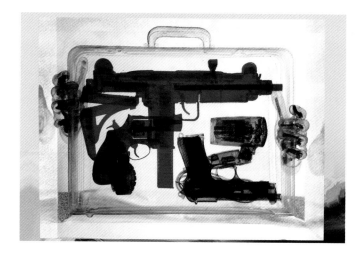

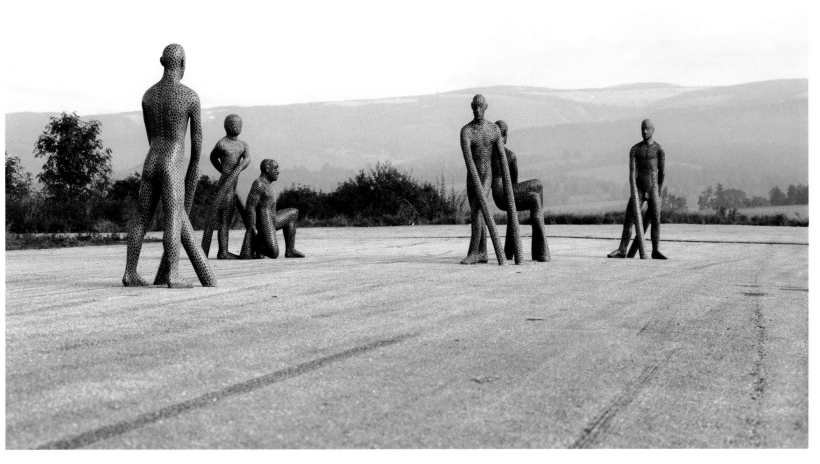

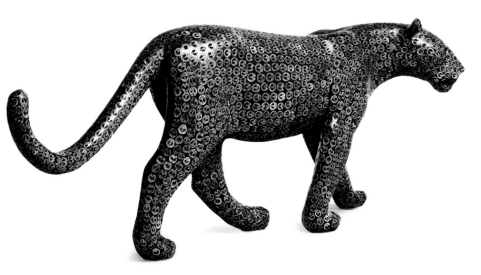

Michal Gabriel
Blue player (1), 2007–10
Blue fibreglass and sliced peach
nutshells, height 150/210 cm
Courtesy of dvorak sec contemporary

Michal Gabriel
Animal, 2006–10
Coloured resin and sliced peach
nutshells, height 60 cm
Courtesy of dvorak sec contemporary

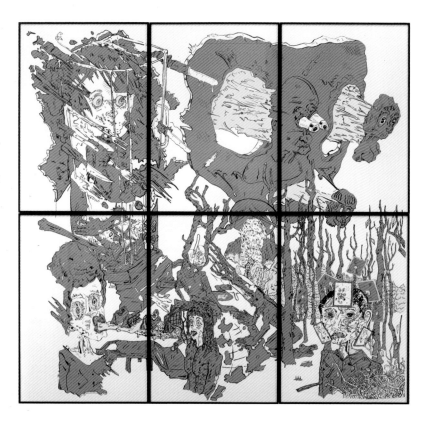

Jakub Matuška aka Masker
Mysterious Universe, 2013
Framed print, 200 x 212 cm
Courtesy of dvorak sec contemporary

Ašot Haas
Light object, 2015
Light object, graphics on Plexiglas
and aluminium, Ø190 cm
Courtesy of dvorak sec contemporary

Ašot Haas
Sixtimes, 2013
Light object, graphics on Plexiglas
and aluminium, 300 x 85 cm
Courtesy of dvorak sec contemporary

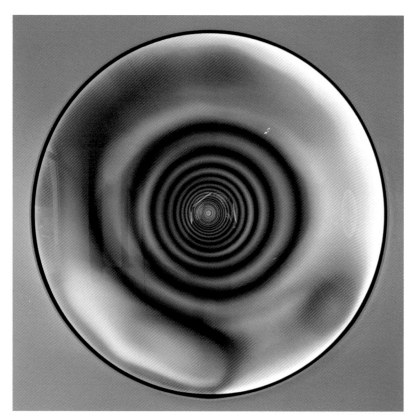

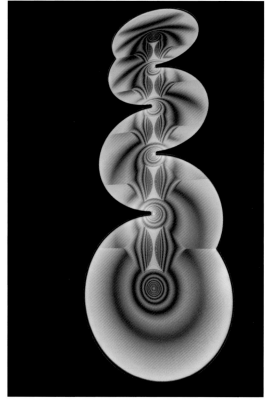

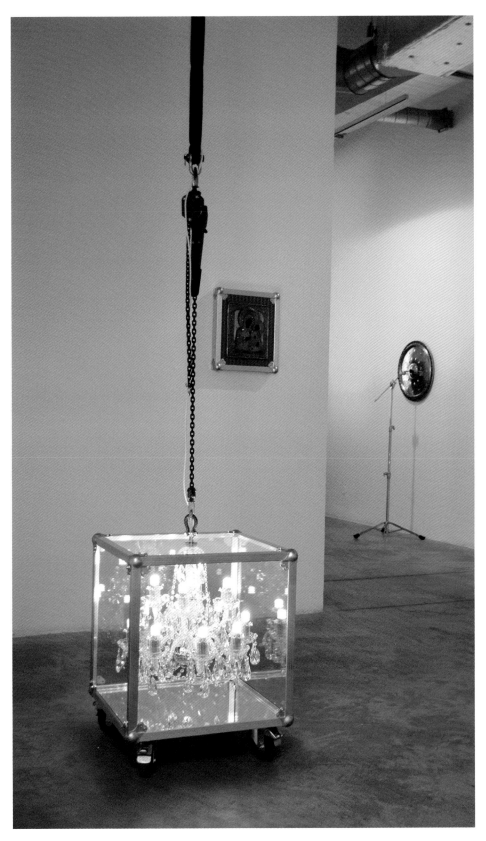

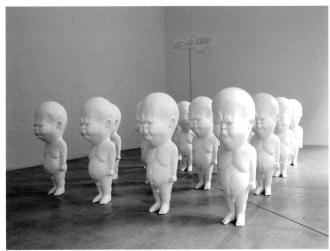

Viktor Frešo
Chandelier Box, 2013
Mixed media, 65 x 55 x 55 cm
Courtesy of dvorak sec contemporary

Viktor Frešo
Niemand, 2013
Epoxy, 90 x 30 x 30 cm each
Courtesy of dvorak sec contemporary

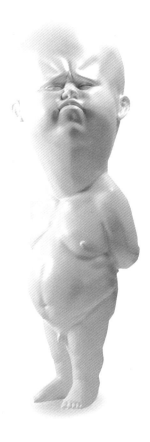

Faur Zsófi Gallery

Budapest, Hungary

Bartók Béla út 25
H-1114, Budapest, Hungary
Phone 0036203590551
http://www.galeriafaur.hu/
info@galeriafaur.hu

Director Zsófia Faur
Established in 2010

Artists featured
Katerina Belkina (Russia/Germany)
Ádám Magyar (Hungary/Germany)
Áron Majoros (Hungary)

Artists represented
Zsófi Barabás (Hungary)
Alfredo Barsuglia (Austria)
Katerina Belkina (Russia/Germany)
BOLDI (Hungary)
Csilla Bondor (Hungary)
Béla Dóka (Hungary)
Gábor Arion Kudász (Hungary)
Ádám Magyar (Hungary/Germany)
Áron Majoros (Hungary)
Gergely Szatmári (Hungary)

The gallery's mission is to promote the area's emerging contemporary artists and to integrate them into the international art scene by continuing its increasingly active presence at foreign art fairs and by forging partnerships with other international players in the field. The gallery's newly created Panel Contemporary (project room) aims to provide an innovative platform for independent artworks and focus on new tendencies.
The gallery is constantly in search of the latest international trends, as well as foreign artists of emerging significance to introduce them to the domestic audience and to promote their work among discriminating Hungarian art collectors. In addition to painting and sculpture, the Faur Zsófi Gallery has become an indispensable player in the market for contemporary photography over the past four years. Employing its professional printing background, which is unique in the contemporary art scene of the CEE region, the gallery issues erudite publications and monographs about the latest developments and insights in contemporary art history in several languages. The Faur Zsófi Gallery aspires to cultivate an extensive and dedicated audience attracted to the important artworks on display in a vibrant, vital and contemplative environment.

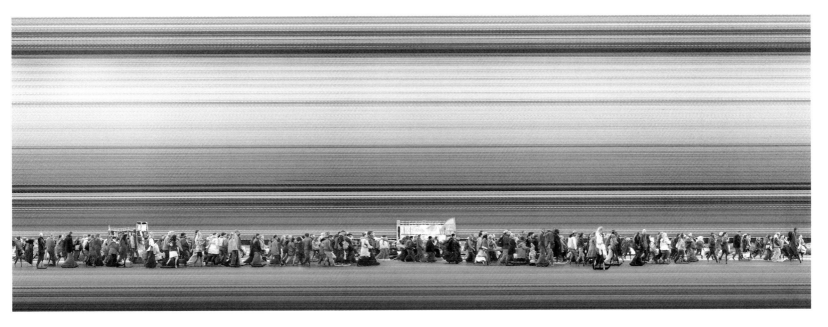

Ádám Magyar
Urban Flow #1865 (New York), 2015
Archival inkjet print, 60 x 170 cm
Courtesy of the artist and Faur Zsófi Gallery

Ádám Magyar
Squares – Tokyo I, 2007–09
Archival inkjet print, 120 x 180 cm
Courtesy of the artist and Faur Zsófi Gallery

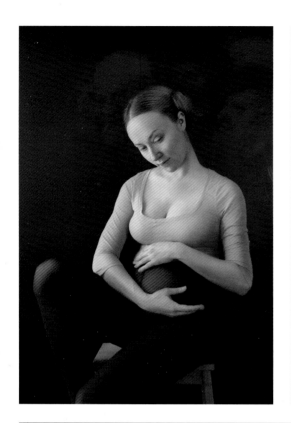 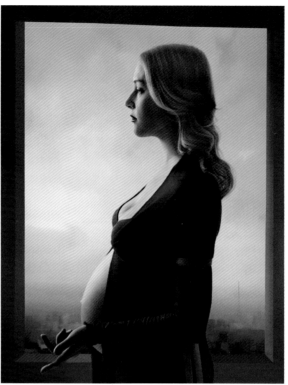

Katerina Belkina
The Sinner, 2014
C-print on Alu Dibond under diasec,
100 x 70 cm
Courtesy of the artist and Faur Zsófi Gallery

Katerina Belkina
Entreaty, 2015
C-print on Alu Dibond under diasec,
100 x 78 cm
Courtesy of the artist and Faur Zsófi Gallery

Katerina Belkina
Red Moscow, 2010
C-print on Alu Dibond under diasec,
93 x 130 cm
Courtesy of the artist and Faur Zsófi Gallery

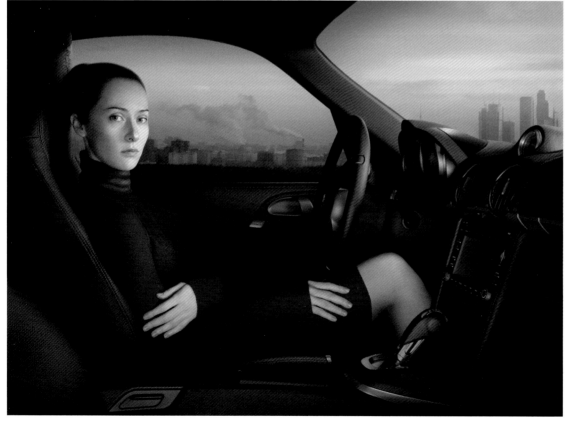

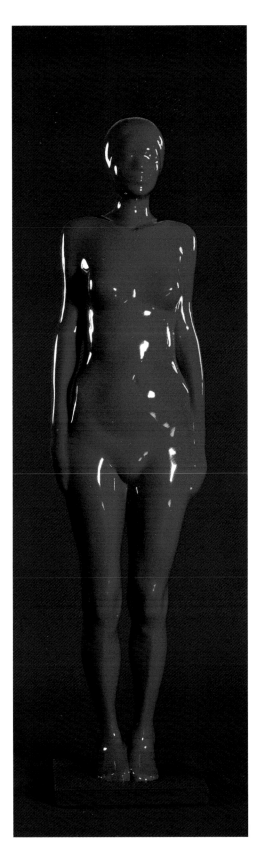

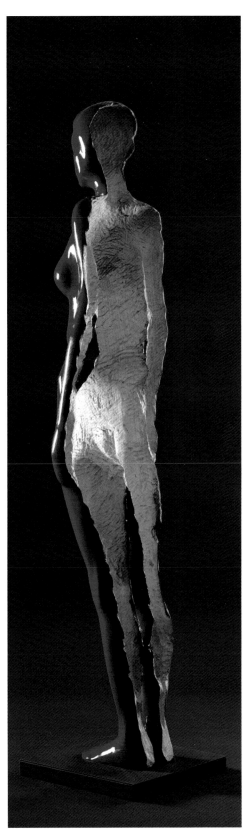

Áron Majoros
Venus, 2012–15
Linden, 180 x 40 x 40 cm
Courtesy of the artist and Faur Zsófi Gallery

Áron Majoros
Woman Portrait, 2015
Steel, 170 x 36 x 30 cm
Courtesy of the artist and Faur Zsófi Gallery

Áron Majoros
Liminal Spaces, 2015
Steel, 40 x 30 x 20 cm
ed. 2/8
Courtesy of the artist and Faur Zsófi Gallery

FIUMANO PROJECTS

London, UK

27 Connaught Street,
W2 2AY London, UK
Phone 0797 4092993
www.fiumanoprojects.com
francesca@fiumanoprojects.com

Director Francesca Fiumano
Established in 2013

Artists featured
Sam Burford (UK)
Roger Holtom (UK/Italy)
Takefumi Hori (Japan/USA)

Artists represented
Sam Burford (UK)
Roger Holtom (UK/Italy)
Takefumi Hori (Japan/USA)
Kent Karlsson (Sweden)
Beth Nicholas (UK)
Tanya Tier (UK)
Tindr (Italy)
Nicole Wassall (UK)

FIUMANO PROJECTS was launched in 2013 by Francesca Fiumano, with a focus on presenting the work of artists who do not necessarily "fit" into the traditional preconception of an artist/gallery relationship.
The central philosophy of FIUMANO PROJECTS is a commitment to supporting artists and their creative visions. This allows for a dynamic relationship where creative projects often transgress the initially staked-out path.

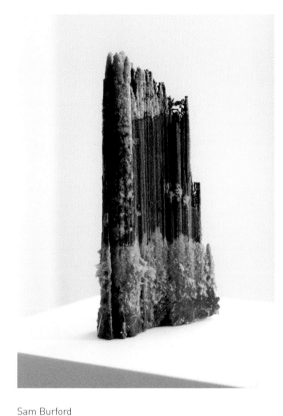

Sam Burford
Blue Emerald Castle, 2015
Polylactic acid and copper sulphate,
17 x 10 x 4 cm
Courtesy of the artist and
FIUMANO PROJECTS

Sam Burford
Blue Movie Negative in 336 Brushes, 2015
Oil on specially treated perspex
and alumiunium, 83 x 144 cm
Courtesy of the artist and
FIUMANO PROJECTS

Sam Burford
Top Films of the 20th Century –
Number 57, 2012
C-type metallic print, diasec, perspex
and aluminium, 101 x 183 cm
Courtesy of the artist and
FIUMANO PROJECTS

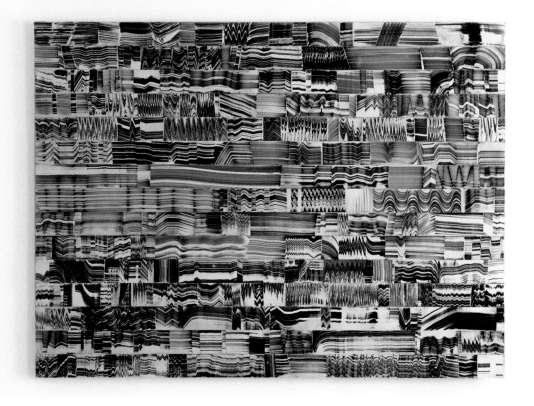

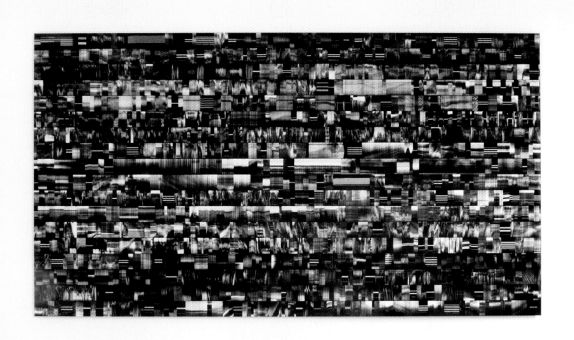

Roger Holtom
Self Portrait, 2015
Mixed media on board, 100 x 100 cm
Courtesy of the artist and
FIUMANO PROJECTS

Roger Holtom
Deep Blue, 2015
Mixed media on board, 206 x 106 cm
Courtesy of the artist and
FIUMANO PROJECTS

Roger Holtom
La Divina Commedia, 2015
Mixed media on board, 98 x 240 cm
Courtesy of the artist and
FIUMANO PROJECTS

Takefumi Hori
Silver XIII, 2015
Gold and silver leaf and acrylic
on canvas, 70 x 70 cm
Courtesy of the artist and
FIUMANO PROJECTS

Takefumi Hori
Gold XLII, 2015
Gold and silver leaf and acrylic on canvas,
70 x 70 cm
Courtesy of the artist and
FIUMANO PROJECTS

Takefumi Hori
Circle LXIII, 2015
Gold and silver leaf and acrylic
on canvas, 90 x 90 cm
Courtesy of the artist and
FIUMANO PROJECTS

Hafez Gallery

Jeddah, Saudi Arabia

Bougainvillea Centre, 3rd floor, King
Abdulaziz Road, Jeddah, Saudi Arabia
Phone +966 12 6134111
Mobile +966 555517000
info@hafezgallery.com Gallery

Director Qaswra Hafez
Established in 2014

Artists featured
Sara Al Abdali (Saudi Arabia)
Nora Alissa (Saudi Arabia)
Ghada Da (Saudi Arabia)
Tarfa Fahad (Saudi Arabia)
Filwa Nazer (Saudi Arabia)

Artists represented
Hend Adnan (Egypt)
Sara Al Abdali (Saudi Arabia)
Mohammed Al Ghamdi (Saudi Arabia)
Mohammad Al Resayes (Saudi Arabia)
Taha Al Sabban (Saudi Arabia)
Abdullah Al Shaikh (Saudi Arabia)
Abdulrahman Al Soliman (Saudi Arabia)
Oudah Al Zahrani (Saudi Arabia)
Nora Alissa (Saudi Arabia)
Abdulaziz Ashour (Saudi Arabia)
Raeda Ashour (Saudi Arabia)
Ibrahim El Dessouki (Egypt)
Osama Esid (Syria)
Tarfa Fahad (Saudi Arabia)
Abdullah Hammas (Saudi Arabia)
Yousef Jaha (Saudi Arabia)
Faisel Laibi (Iraq)
Maha Malluh (Saudi Arabia)
Ahmed Nawar (Egypt)
Filwa Nazer (Saudi Arabia)

Launched in 2014, Hafez Gallery
engages the art community to visually
converse with and explore Saudi and
Middle Eastern modern and
contemporary art. Hafez Gallery
serves as a space to nurture the
discovery of a Saudi visual identity
and participate in the international
art dialogue.

Ghada Da
Lip Sync For Your Life, The Crisco Disco,
2014
3 channel video performance, 4'47''
Courtesy of the artist

Nora Alissa
Untitled 5 "from Epiphamania series", 2012
Inkjet print, 40 x 176 cm
Courtesy of the artist

Nora Alissa
Untitled 14 "from Epiphamania series",
2013
Inkjet print, 60 x 140 cm
Courtesy of the artist

Nora Alissa
Untitled 16 "from Epiphamania series",
2013
Inkjet print, 60 x 106 cm
Courtesy of the artist

Nora Alissa
Untitled 15 "from Epiphamania series",
2013
Inkjet print, 40 x 131 cm
Courtesy of the artist

Filwa Nazer
Micro Chat, 2014
Archival inkjet print on somerset paper,
35 x 50 cm
Courtesy of the artist

Filwa Nazer
Untitled from the children series, 2014
Archival inkjet print on somerset paper,
35 x 50 cm
Courtesy of the artist

Filwa Nazer
Soulmates, 2014–15
Archival inkjet print on somerset paper,
52.5 x 34 cm (unframed)
Courtesy of the artist

Filwa Nazer
Untitled from the children series, 2014
Archival inkjet print on somerset paper,
50 x 35 cm
Courtesy of the artist

Sara Al Abdali
The Storyteller's Den, 2015
Gouache on paper, 59.5 x 84 cm
Courtesy of the artist

Tarfa Fahad
Epiphany 8, 2014
Mixed media on canvas, 100 x 150 cm
Courtesy of the artist

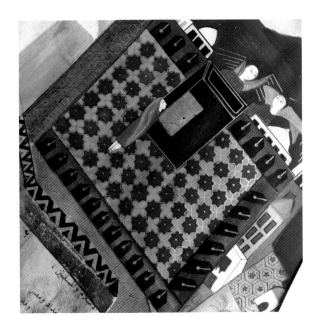

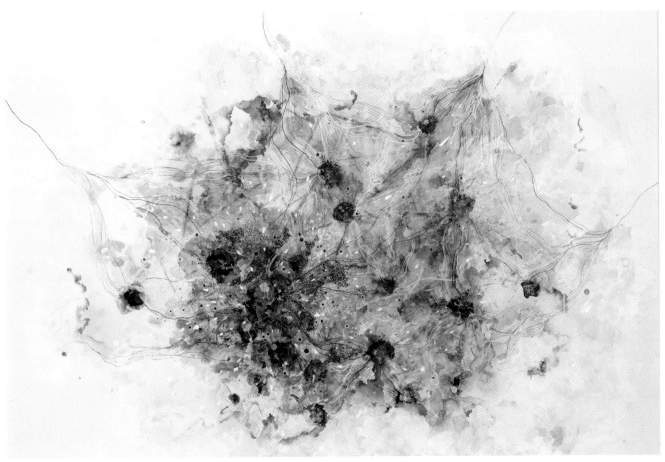

Galerie Huit

Hong Kong

G/F & 1/F, Shop 2, SOHO 189,
No. 189 Queen's Road West,
Sheung Wan, Hong Kong
Phone 852 2803 2089
www.galeriehuit.com.hk
info@galeriehuit.com.hk

Directors Mrs. Ali Yeh-Cheng,
Mrs. Jane Chao-Lee, Mrs. Yas
Mostashari-Chang, Mrs. Yvette Ma-Ho
Established in 2010

Artists featured
Ahmad Zakii Anwar (Malaysia)

Artists represented
Ahmad Zakii Anwar (Malaysia)
Nogah Engler (UK)
Ali Esmaeilipour (Iran)
Darvish Fakhr (Iran)
Makoto Fujimura (USA/Japan)
Ge Yan (China)
Lu Song (China)
Kate MccGwire (UK)
Troika (UK)
Wang Yabin (China)

Established in 2010, Galerie Huit was
founded by Jane Chao-Lee to promote
emerging and established artists in
Asia. Owing to the success of its initial
four years, the gallery has acquired a
larger space in the newly launched
building SOHO 189. The new gallery
will provide the scope for a wider
range of exhibitions and projects.
The relocation heralds a new
development in the exhibition
programme with the aim of
showcasing important new positions
in international contemporary art
by a wide range of artists from across
the globe.

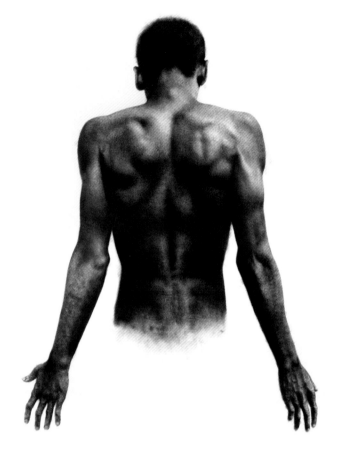

Ahmad Zakii Anwar
Standing Figure 17, 2011
Charcoal on paper, 135 x 101.6 cm
Courtesy of the artist

Ahmad Zakii Anwar
Reclining Figure 12, 2011
Charcoal on paper, 81.3 x 223.5 cm

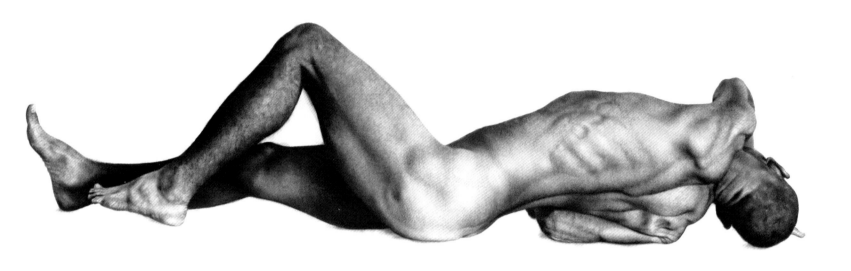

Ahmad Zakii Anwar
Profane, 2008
Charcoal on paper, 119 x 223 cm
Courtesy of the artist

Ahmad Zakii Anwar
Warthog, 2011
Acrylic on jute, 147 x 294 cm
Courtesy of the artist

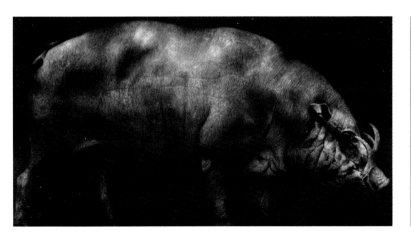

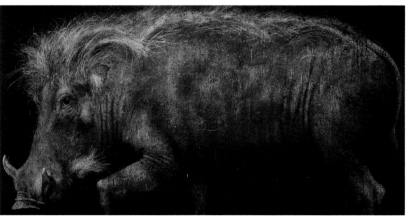

Ahmad Zakii Anwar
Strange Tale from Jeju 3, 2014
Charcoal on paper, 76 x 224 cm
Courtesy of the artist

Ahmad Zakii Anwar
Strange Tale from Jeju 6, 2014
Charcoal on paper, 76 x 224 cm
Courtesy of the artist

Ahmad Zakii Anwar
Pear and Nails, 2014
Acrylic on linen, 41 x 69 cm
Courtesy of the artist

Ahmad Zakii Anwar
Mango and Banana, 2015
Acrylic on linen, 41 x 69 cm
Courtesy of the artist

Ahmad Zakii Anwar
Brinjai and Chilli, 2014
Acrylic on linen, 41 x 69 cm
Courtesy of the artist

Ahmad Zakii Anwar
Bokchoi and Garlic, 2015
Acrylic on linen, 41 x 69 cm
Courtesy of the artist

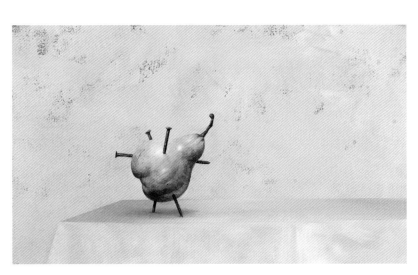

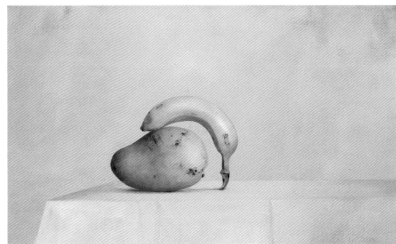

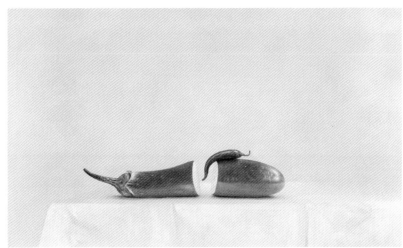

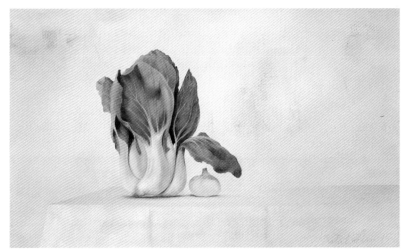

Julian Page

London, UK

24 Pembridge Villas,
W11 3EL London, UK
Phone +44 7939 501 552
www.julianpage.co.uk
julian@julianpage.co.uk

Director Julian Page
Established in 2011

Artists featured
Victoria Burge (USA)
Stephen Gill (UK)
Elizabeth Hayley (UK)
Alexander Massouras (UK)

Artists represented
Giacomo Brunelli (Italy)
Victoria Burge (USA)
Marcelle Hanselaar (The Netherlands)
Elizabeth Hayley (UK)
Alexander Massouras (UK)
Kate McCrickard (UK)

Julian Page deals in contemporary works of art. We represent emerging artists and specialize in publishing and dealing in prints. We are also the sole authorized agent for Bridget Riley's print sales worldwide. Previous exhibitions have included solo shows by Alexander Massouras and Giacomo Brunelli and a group show entitled *Mapping Time*. In September, immediately after START, we will open a group show around the theme of repetition. Alternative ways of showing our artists' work include solo and two-artist presentations at art fairs and the publication of group portfolios and artist books. Artists that we represent include Giacomo Brunelli, Victoria Burge, Marcelle Hanselaar, Elizabeth Hayley, Alexander Massouras and Kate McCrickard.

Elizabeth Hayley
Rainbow, 2014
Silver gelatin print on brass, 75 x 100 cm
edition of 5
Courtesy of the artist

Stephen Gill
#27 from *Talking to Ants*, 2009–13
Pigment print, 120 x 120 cm
Courtesy of the artist

Victoria Burge
319, 2015
Ink, acrylic and pencil on paper,
107 x 122 cm
Courtesy of the artist

Alexander Massouras
Landing, 2015
Oil on linen, 125 x 95 cm
Courtesy of Julian Page

Alexander Massouras
Swan Dive, 2014
Oil on linen, 90 x 75 cm
Courtesy of the artist

Alexander Massouras
Two and a half somersaults...
bbbbackwards with tuck, 2015
Oil on linen, 125 x 95 cm
Courtesy of Julian Page

Kalman Maklary Fine Arts
Budapest, Hungary

Falk Miksa út 10
H-1055 Budapest, Hungary
Phone +36 1 374 07 74
http://www.kalmanmaklary.com/
kalmanmaklaryfinearts@gmail.com

Director Kalman Maklary
Established in 2005

Artists featured
Sam Havadtoy (Hungary)
Hur Kyung-Ae (South Korea)
Lim Dong-Lak (South Korea)
Judit Reigl (Hungary)
Suh Jeong-Min (South Korea)

Artists represented
Sam Havadtoy (Hungary)
Hur Kyung-Ae (South Korea)
Lim Dong-Lak (South Korea)
Judit Reigl (Hungary)
Suh Jeong-Min (South Korea)

The Kalman Maklary Fine Arts gallery
is dedicated to both contemporary
artists and the Post-War School of
Paris. Through its exhibitions outside
the Budapest-based gallery and the
publication of books and catalogues,
Kalman Maklary Fine Arts works
with museums and art collectors,
developing with them long-term
relationships of trust. Today, some
of the gallery's artists have already
rightfully found their place in the
major modern art museums around
the world. It also handles and
represents works by László Moholy-
Nagy, Paul Kallos, Geza Szobel,
Étienne Sandorfi, Tibor Csernus,
Sam Havadtoy, Kamill Major,
Hur Kyung-Ae and Suh Jeong-Min.

Lim Dong-Lak
Point–Gate of Space XII, 2013
Mixed media, lace and acrilyc,
62 x 30 x 52 cm
Courtesy of Kalman Maklary Fine Arts

Lim Dong-Lak
Point–Blue Bird, 2008
Stainless steel, 36 x 57 x 50 cm
Courtesy of Kalman Maklary Fine Arts

Suh Jeong-Min
Lines of travel 27, 2014
Acrylic on canvas, 110 x 110 cm
Courtesy of Kalman Maklary Fine Arts

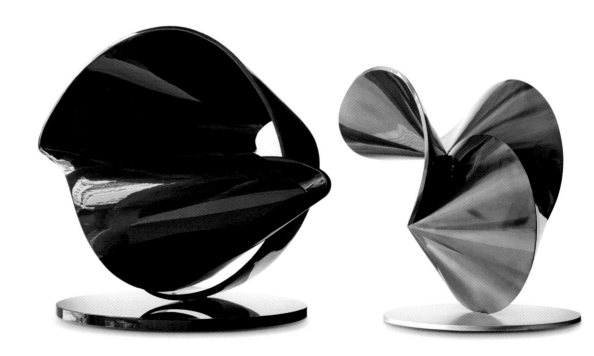

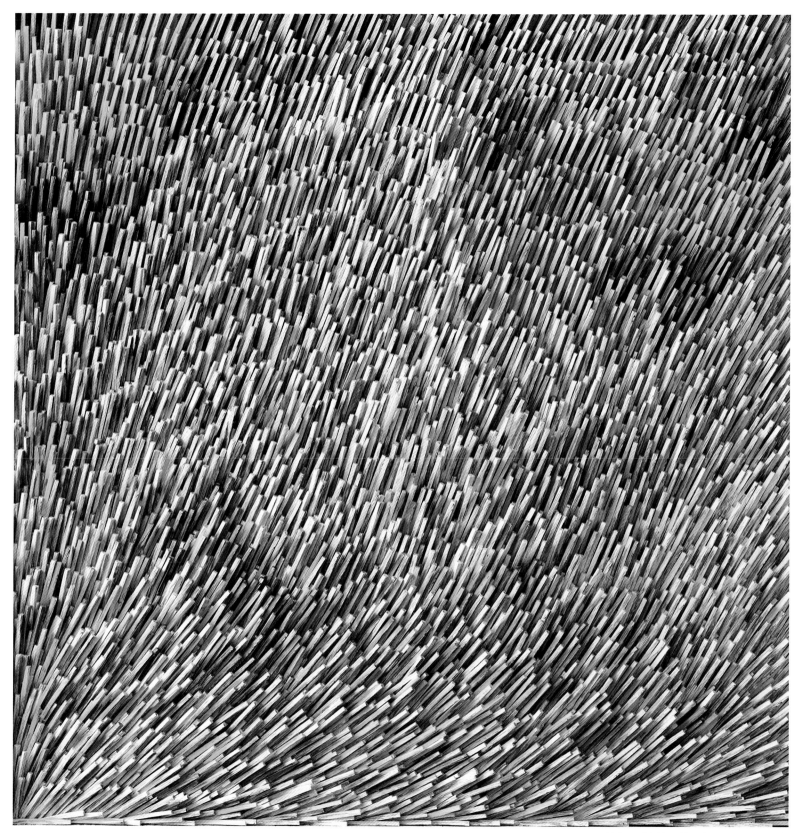

Hur Kyung-Ae
RP0515BP, 2015
Acrylic on canvas, 150 x 200 cm
Courtesy of Kalman Maklary Fine Arts

Hur Kyung-Ae
VP0515B, 2015
Acrylic on canvas, 60 x 80 cm
Courtesy of Kalman Maklary Fine Arts

Judit Reigl
Man, 1966
Oil on canvas, 236 x 206 cm
Courtesy of Kalman Maklary Fine Arts

Judit Reigl
Mass Writing, 1959
Oil on canvas, 148 x 123 cm
Courtesy of Kalman Maklary Fine Arts

Kristin Hjellegjerde Gallery
London, UK

533 Old York Road
SW18 1TG London, UK
Phone + 44 (0) 20 8875 0110
www.kristinhjellegjerde.com
Info@kristinhjellegjerde.com

Director Kristin Hjellegjerde
Established in 2012

Artists featured
Dawit Abebe (Ethiopia)
Martine Poppe (Norway)
Fredrik Raddum (Norway)

Artists represented
Dawit Abebe (Ethiopia)
Chris Agnew (UK)
Andrea Francolino (Italy)
Sebastian Helling (Norway)
Daniel Malva (Brazil)
Martine Poppe (Norway)
Richard Schur (Germany)
Soheila Sokhanvari (Iran)
Richard Stone (UK)
Sinta Tantra (UK)
Celina Teague (UK)
Muhammad Zeeshan (Pakistan)

Named among the "Top 500 most influential galleries in the world" by Blouin (2015), "Independent gallery of the year in London" by the Londonist (2014) and Wandsworth Council's Best New Business (commended) of 2014, Kristin Hjellegjerde Gallery, beginning its third year, prides itself on representing a core group of cutting-edge international contemporary artists. Founded in 2012 by Norwegian-born Kristin Hjellegjerde following her move from New York, the gallery seeks to develop new talents by creating a platform through which artists can present a focused, coherent body of work in an intimate environment, engage in artistic and cultural exchange with other creatives and be exposed to local and international audience.

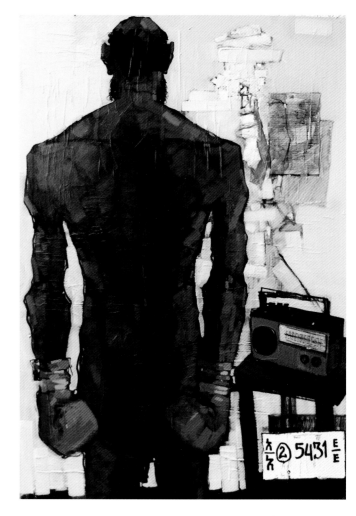

Dawit Abebe
No. 2 Background 32, 2015
Acrylic and collage on canvas, 200 x 140 cm
Courtesy of Kristin Hjellegjerde Gallery

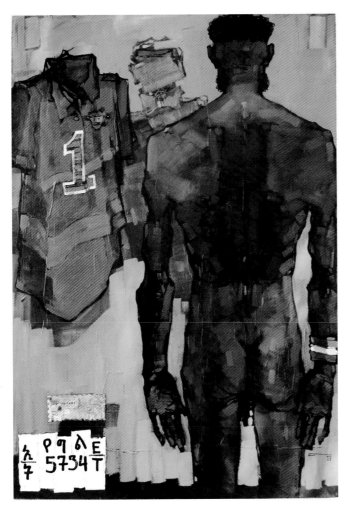

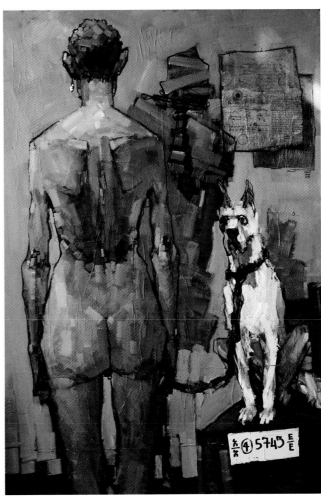

Dawit Abebe
No. 2 Background 33, 2015
Acrylic and collage on canvas, 200 x 140 cm
Courtesy of Kristin Hjellegjerde Gallery

Dawit Abebe
No. 2 Background 16, 2015
Acrylic and collage on canvas, 200 x 140 cm
Courtesy of Kristin Hjellegjerde Gallery

Fredrik Raddum
Lady with drapery, 2015
Bronze, 170 x 70 x 50 cm
Courtesy of Kristin Hjellegjerde Gallery

Fredrik Raddum
Male Habitus, 2014
Bronze, 52 x 50 x 50 cm
Courtesy of Kristin Hjellegjerde Gallery

Fredrik Raddum
Female Habitus, 2014
Bronze, 38 x 60 x 29 cm
Courtesy of Kristin Hjellegjerde Gallery

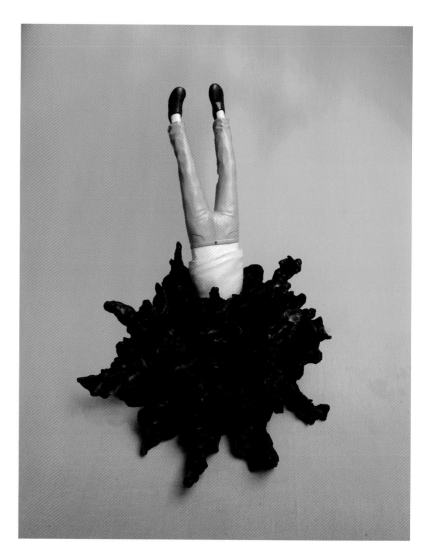

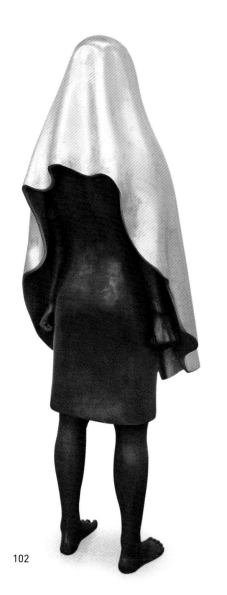

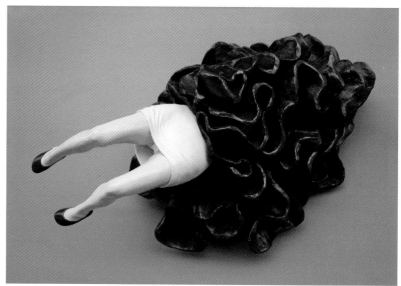

Martine Poppe
11.43 04.23.2015, 2015
Oil on polyester restoration fabric,
160 x 266 cm
Courtesy of Kristin Hjellegjerde Gallery

Martine Poppe
15.37 04.25.2015, 2015
Oil on polyester restoration fabric,
160 x 296 cm
Courtesy of Kristin Hjellegjerde Gallery

Martine Poppe
14.08 05.23.2015, 2015
Oil on polyester restoration fabric,
160 x171 cm
Courtesy of Kristin Hjellegjerde Gallery

L153 Art Company
Seoul, South Korea

Seodaemun-gu, Yeonhee ro 11ba gil 2,
Seoul, South Korea
Phone 82 2 322 5827
Fax 82 2 322 5827
http://L153art.co.kr
L153art@naver.com

Director Sangjeong Laurence Lee
Established in 2012

Artists featured
Bae Jin Sik (South Korea)
Koo Sung Soo (South Korea)
Lee Seung Hee (South Korea)

Artists represented
Heo Wook (South Korea)
Kang Il Goo (South Korea)
Park Sung Soo (South Korea)
Tak No (South Korea)
Yoon Ji Sun (South Korea)

L153 Art Company was founded in Seoul in 2012. The exhibitions started through a collaboration between the company and artists. Beyond providing opportunities to artists entering the art market, L153 Art Company promotes their work and provides guidance to each artist presented. The company introduces their work to a wider audience including businesses, communities, the local and global art markets; increases their opportunities of further exhibitions; and helps them develop their career.

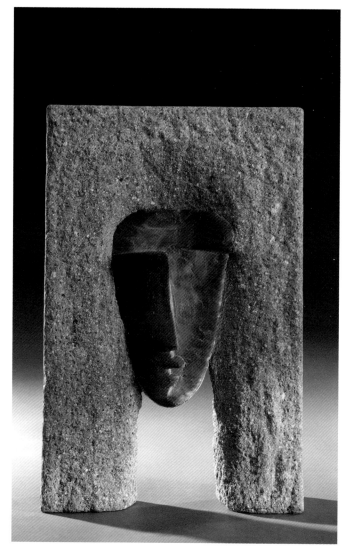

Bae Jin Sik
Girl, 2014
Glass and mixed media, 45 x 30 x 10 cm
Courtesy of the artist

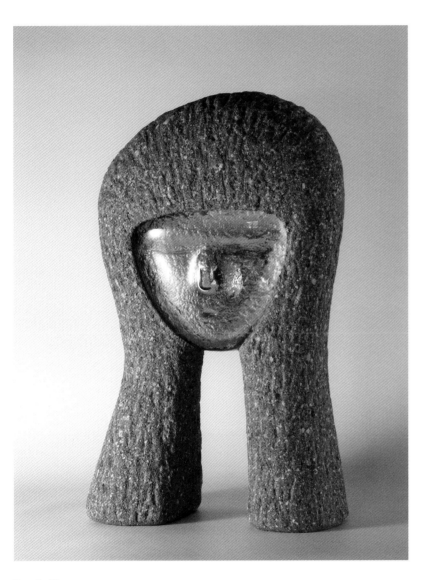

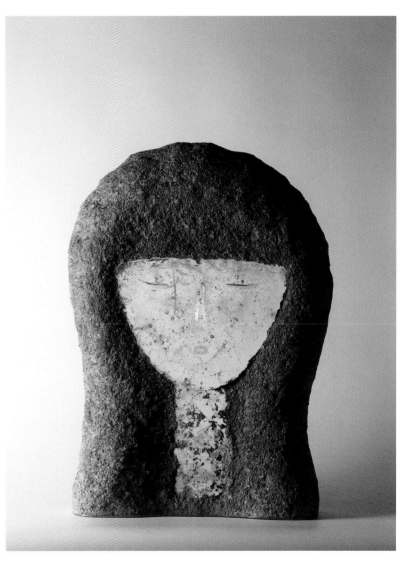

Bae Jin Sik
Girl 2, 2015
Glass, mirror and mixed media,
42 x 25 x 13 cm
Courtesy of the artist

Bae Jin Sik
Girl 4, 2015
Glass and mixed media, 39 x 26 x 9 cm
Courtesy of the artist

Lee Seung Hee
Tao LB422013, 2013
Ceramics, 100 x 83 cm
Courtesy of Lim Jang Hwal

Lee Seung Hee
Tao LB432013, 2013
Ceramics, 102 x 83 cm
Courtesy of Lim Jang Hwal

Lee Seung Hee
Tao LB452013, 2013
Ceramics, 74 x 102 cm
Courtesy of Lim Jang Hwal

Koo Sung Soo
Rose, 2012
C-print, 75 x 55 cm / 1840 x 1540 cm
Courtesy of the artist

Koo Sung Soo
Anthurium, 2012
C-print, 75 x 55 cm / 1840 x 1540 cm
Courtesy of the artist

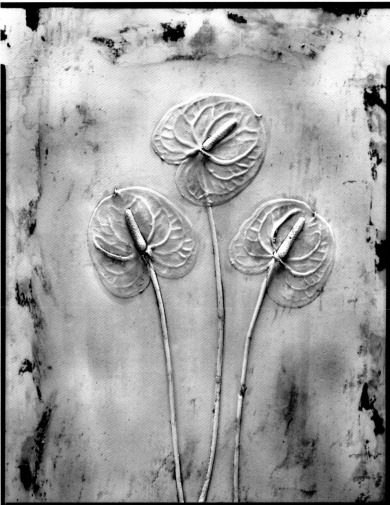

+MAS Arte Contemporáneo

Bogotá, Colombia

Calle 62 n 3-09, Chapinero Alto
Bogotá DC, Colombia
Phone +571 3133122556
Fax 2172979
contacto@masartecontemporaneo.com

Director Carlos Vargas
Established in 2011

Artists featured
Franklin Aguirre (Colombia)
Sergio Jiménez (Colombia)
Roberto Lombana (Colombia)
Guillermo Londoño (Colombia)
Álvaro Pérez (Colombia)
Piedad Tarazona (Colombia)

Artists represented
Franklin Aguirre (Colombia)
Hermes Berrio (Colombia)
Nicolas Cardenas (Colombia)
Antonio Castañeda (Colombia)
Rafael Gómezbarros (Colombia)
Guillermo Londoño (Colombia)
Álvaro Pérez (Colombia)
Piedad Tarazona (Colombia)
Toxicómano (Colombia)

+MAS Arte Contemporáneo is a gallery specializing in Colombian contemporary art with an emphasis on emerging artists. The gallery opened in 2011 and has established itself thanks to the top quality of the works it has exhibited. We understand the power that art has both as documentation of a particular historical moment and as a subtle critique of society. Together with our artists, we seek a level of academic rigour combined with the creative process.

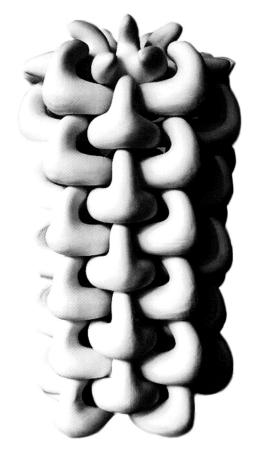

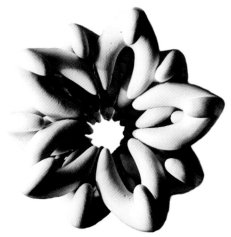

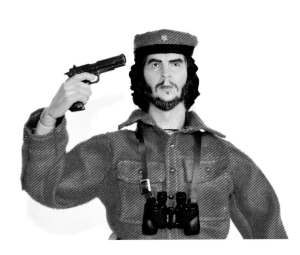

Álvaro Pérez
Soft CHE GUEVARA, 2015
Mixed media, dimensions variable
Courtesy of +MAS Arte Contemporáneo

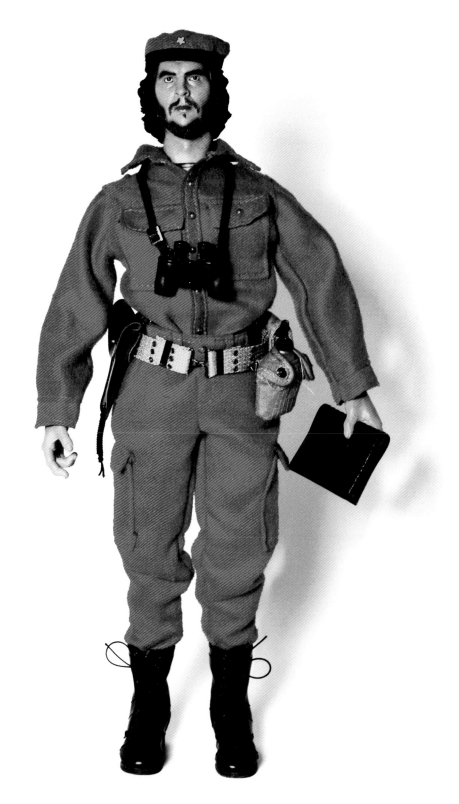

Piedad Tarazona
Pillar, 2015
Ceramics, dimensions variable
Courtesy of +MAS Arte Contemporáneo

Guillermo Londoño
Untitled, 2014
Oil on canvas, 180 x 130 cm
Courtesy of +MAS Arte Contemporáneo

Sergio Jiménez
DOWRY, 2014
Goat skins suspended, dimensions variable
Courtesy of +MAS Arte Contemporáneo

Franklin Aguirre
Pantocrator of Light, 2015
Light box, Ø 120 cm
Courtesy of +MAS Arte Contemporáneo

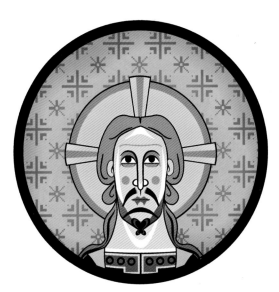

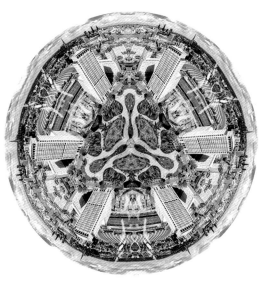

Roberto Lombana
LONDON 2 Mandala, 2015
Digital print on Hahnemühle canvas,
Ø 140 cm
Courtesy of +MAS Arte Contemporáneo

mc2gallery

Milan, Italy

Via Malaga 4, 20143 Milan, Italy
Phone +39 0287280910
Fax +39 0287280911
mc2gallery@gmail.com

Directors Claudio Composti
and Vincenzo Maccarone
Established in 2009

Artists featured
Tiffany Chung (Vietnam)
Julia Fullerton-Batten (Germany)
Liu Xiaofang (China)
Yang Yongliang (China)

Artists represented
Michael Ackerman (USA)
Jacob Aue Sobol (Denmark)
Chan-Hyo Bae (South Korea)
Renato D'Agostin (Italy)
Kate Fichard (France)
Trong Gia Nguyen (Vietnam/USA)
Roberto Kusterle (Italy)
Susanna Majuri (Finland)
Erica Nyholm (Finland)
Simon Roberts (UK)
Lamberto Teotino (Italy)

mc2gallery was founded in 2009 by Vincenzo Maccarone and Claudio Composti. Located in the heart of Milan, near the fashion district of Via Tortona and the Navigli, mc2gallery has become known as the place where you can discover the most interesting Italian and international photographers. The gallery represents young photographers such as Renato D'Agostin, Lamberto Teotino, Susanna Majuri, Yang Yongliang, Jacob Aue Sobol, Simon Roberts, Chan-Hyo Bae, Kate Fichard and Erica Nyholm.

Tiffany Chung
Purple Puddle and Bubble Shooter, 2008
Digital c-print, 100 x 150 cm
Courtesy of the artist and mc2gallery

Liu Xiaofang
I remember II_01, 2012
Ultra giclée, 100 x 100 cm
Courtesy of the artist and mc2gallery

Liu Xiaofang
I remember_02, 2008
Ultra giclée, 60 x 60 cm
Courtesy of the artist and mc2gallery

Julia Fullerton-Batten
Portrait, Chae-eun Son, 2013
C-type colour print, 63.5 x 76 cm
Courtesy of the artist and mc2gallery

Julia Fullerton-Batten
Present, 2013
C-type colour print, 65 x 80 cm
Courtesy of the artist and mc2gallery

Yang Yongliang
Broken Bridge, 2011
Epson Ultra giclée, 90 x 260 cm
Courtesy of the artist and mc2gallery

Yang Yongliang
A Scorpion and Missile, 2012
Epson Ultra giclée, 66 x 118 cm
Courtesy of the artist and mc2gallery

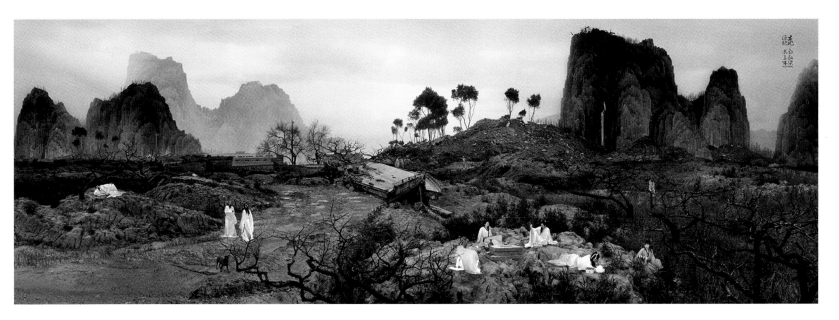

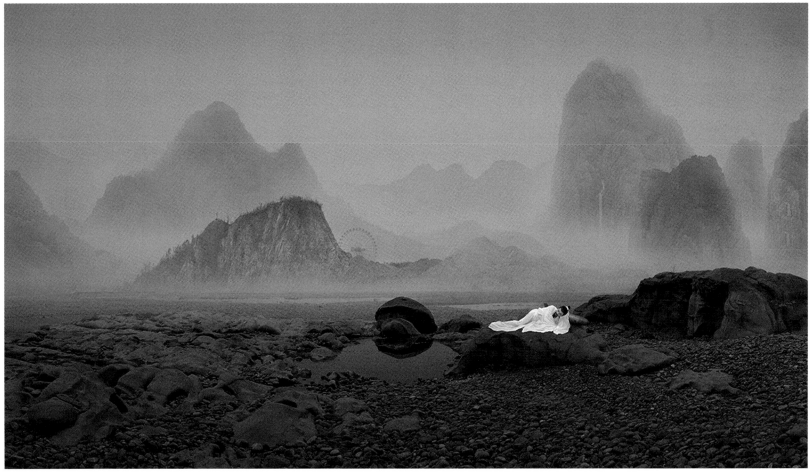

Gallery MOMO
Johannesburg, South Africa

52 7th Avenue, Parktown North,
Johannesburg, South Africa, 2193
www.gallerymomo.com
info@gallerymomo.com
Phone +27 11 327 3247

Director Monna Mokoena
Established in 2003

Artists featured
Mohau Modisakeng (South Africa)
Blessing Ngobeni (South Africa)
Mary Sibande (South Africa)

Artists represented
Vitshois Mwilambwe Bondo
(Democratic Republic of Congo)
Florine Demosthene (Ghana)
Kimathi Donkor (UK)
Patricia Driscoll (South Africa)
Ayana V Jackson (USA)
Blessing Ngobeni (South Africa)
Mary Sibande (South Africa)
Ransome Stanley (Germany)
Andrew Tshabangu (South Africa)

Gallery MOMO is a contemporary art gallery with spaces in Johannesburg and Cape Town, South Africa. We represent a growing number of international and locally based contemporary artists with a focus on African art and art from the diaspora. The Johannesburg gallery is known for its lectures, panel discussions and seminars, such as last year's "Regarding Woman". In addition to its residency programme, which provides opportunities to collaborate with artists from around the world, Gallery MOMO has succeeded in bringing the work of artists such as David Adjaye, Koto Bolofo and Yinka Shonibare to South Africa for the first time. In the Cape Town space, Gallery MOMO has adopted a focus on video artworks and features a dedicated video room that accompanies the three large exhibition spaces. Gallery MOMO takes part in international art fairs and the gallery's artists are frequently featured in exhibitions and biennales (Venice Biennale, Johannesburg Art Fair, Cape Town Art Fair and Lyon Biennale) and are included in private and public collections across the globe.

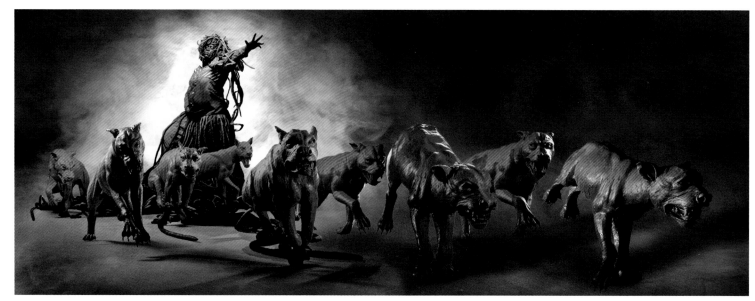

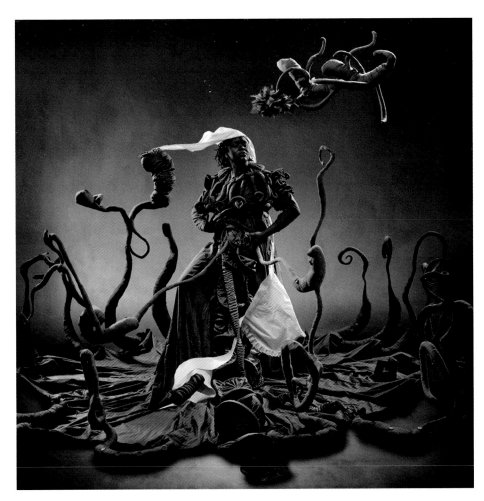

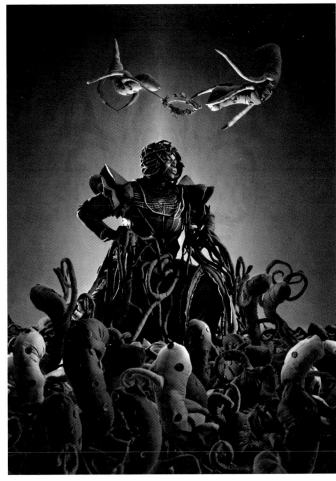

Mary Sibande
A Terrible Beauty, 2013
Archival print, 118 x 113 cm
edition of 10 + 3 AP
Courtesy of the artist and Gallery MOMO

Mary Sibande
Right Now!, 2015
Archival pigment print, 101.16 x 235.57 cm
edition of 10 + 3 AP
Courtesy of the artist and Gallery MOMO

Mary Sibande
Admiration of the Purple Figure, 2013
Archival print, 150 x 110.5 cm
edition of 10 + 3 AP
Courtesy of the artist and Gallery MOMO

Blessing Ngobeni
Race Against Time, 2014
Mixed media on canvas, 140 x 109 cm
Courtesy of the artist and Gallery MOMO

Blessing Ngobeni
Satisfaction, 2014
Mixed media on canvas, 154 x 113.5 cm
Courtesy of the artist and Gallery MOMO

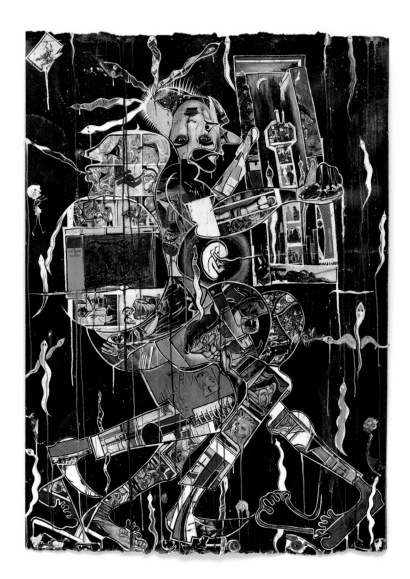

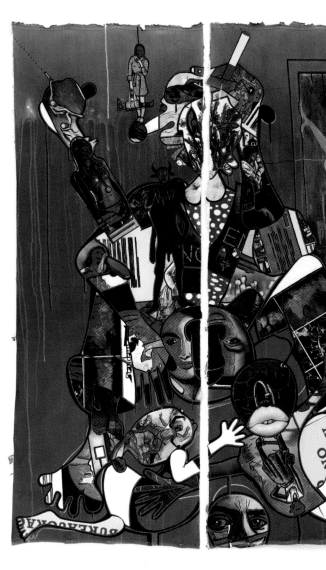

Blessing Ngobeni
Leftover Eaters, 2014
Mixed media on canvas, 190 x 270 cm
Courtesy of the artist and Gallery MOMO

Blessing Ngobeni
Bellies of Freedom II, 2015
Mixed media on canvas, 130 x 207 cm
Courtesy of the artist and Gallery MOMO

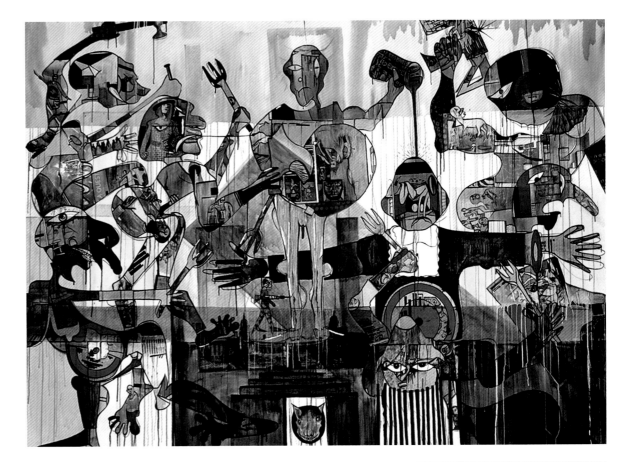

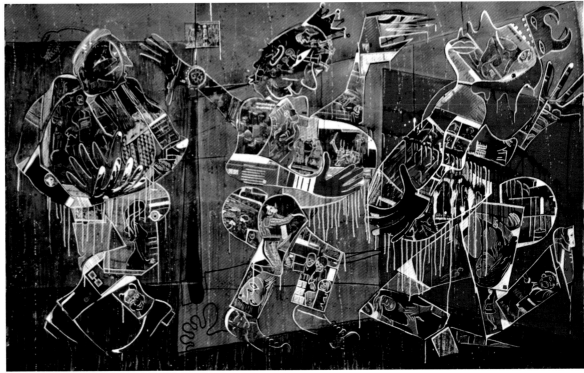

Montoro12 Contemporary Art
Rome, Italy

Via di Montoro, 12
00186 Rome, Italy
Phone +39 3929578974
www.m12gallery.com
info@montoro12.it

Director Ursula Hawlitschka
Established in 2012

Artists featured
Faig Ahmed (Azerbaijan)
Emmanuele De Ruvo (Italy)
Dmitri Obergfell (USA)
Larissa Sansour (Palestine)

Artists represented
Faig Ahmed (Azerbaijan)
Emmanuele De Ruvo (Italy)
Pietro Fortuna (Italy)
Federico Guerri (Italy)
Dmitri Obergfell (USA)
Simone Pellegrini (Italy)
Alessandro Procaccioli (Italy)
Virginia Ryan (Australia)
Larissa Sansour (Palestine)
Franklin Wilkinson (UK)

Montoro12 Contemporary Art was founded in 2012 by contemporary art historian Ursula Hawlitschka with the goal to exhibit young Italian artists and to bring international contemporary artists to Rome. Located in the city centre, the gallery stages about six exhibitions a year, often solo or two-artist shows. The gallery has participated in numerous art fairs in order to bring its featured artists to a wider public. The gallery promotes artists who exhibit profound concepts as well as powerful techniques in their work. Montoro12 believes art to be an excellent means of communication to further understanding between different cultures.

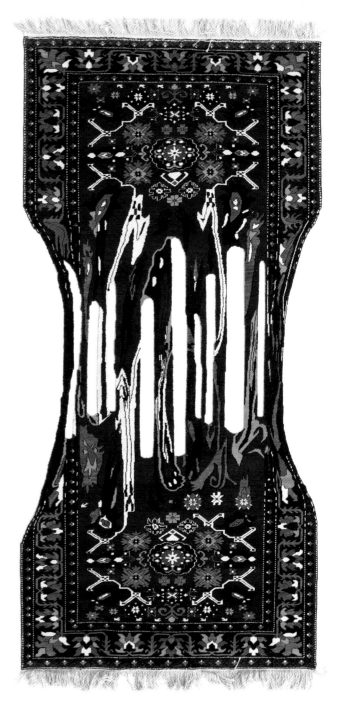

Faig Ahmed
Stickiness, 2013
Handmade woolen carpet and natural colours, 150 x 120 cm
Courtesy of the artist and Montoro12 Contemporary Art

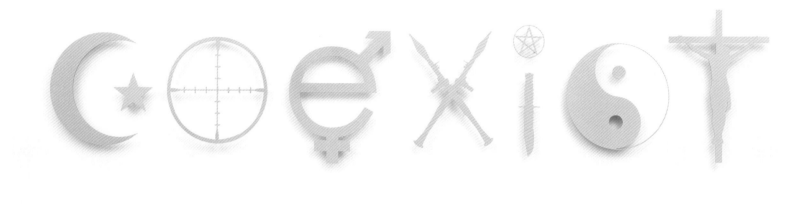

Dmitri Obergfell
Coexist, 2015
Chameleon paint on aluminium,
25 x 150 x 8 cm
Courtesy of the artist and Montoro12
Contemporary Art

Emmanuele De Ruvo
Anatomia aureonumerica, 2014
Bronze, iron, steel, brass, lead, glass and
marble; forces: compression, traction,
cut and gravity, 120 x 40 x 25 cm
Courtesy of the artist and Montoro12
Contemporary Art

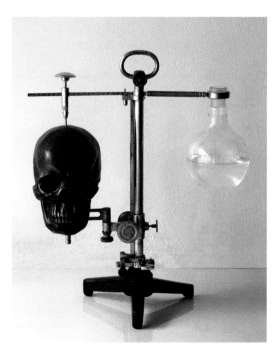

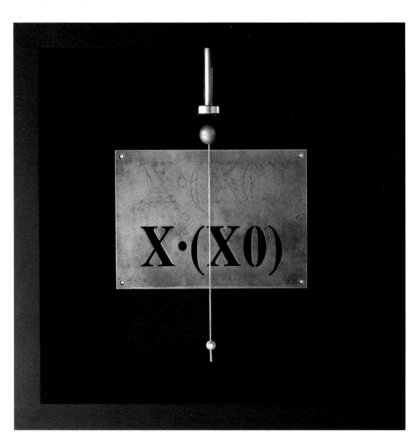

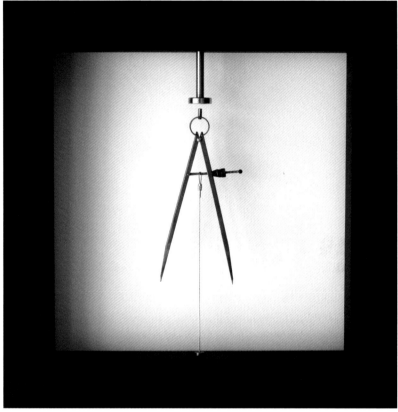

Emmanuele De Ruvo
Building Theater, 2014
Wood, iron, steel, aluminium and
neodymium magnet; forces: magnetism
and gravity, 30 x 20 cm
Courtesy of the artist and Montoro12
Contemporary Art

Emmanuele De Ruvo
Alchemy, 2015
Wood, iron, steel and neodymium
magnet, 50 x 50 cm
Courtesy of the artist and Montoro12
Contemporary Art

Larissa Sansour
Jerusalem Floor, 2012
C-print (diasec on aluminium), 75 x 150 cm
ed. 3 of 3
Courtesy of the artist and Montoro12
Contemporary Art

Larissa Sansour
Main Lobby, 2012
C-print (diasec on aluminium), 75 x 150 cm
ed. 3 of 3
Courtesy of the artist and Montoro12
Contemporary Art

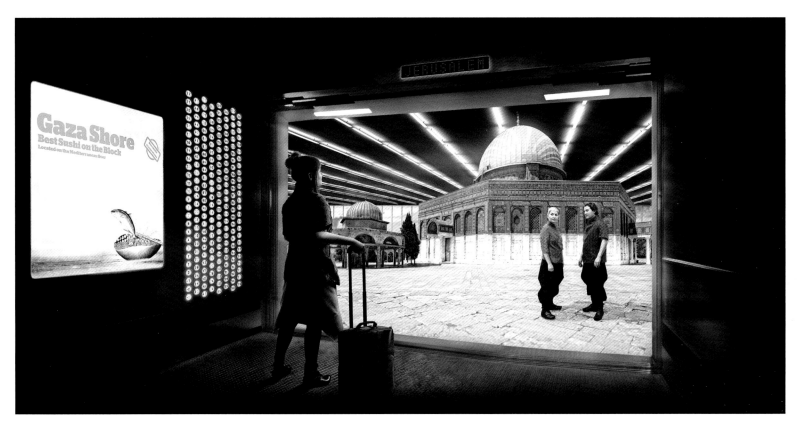

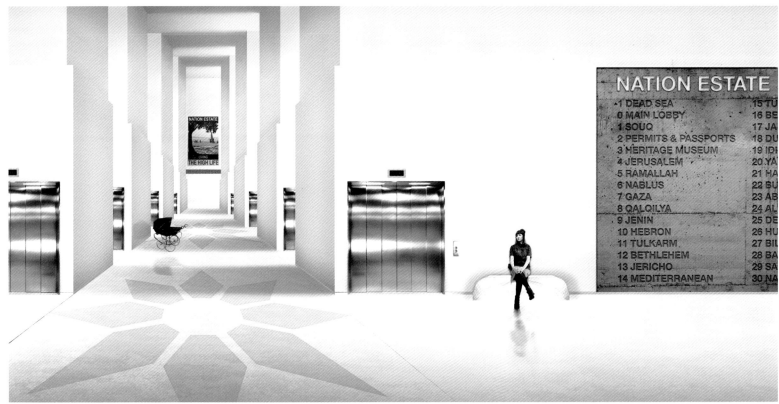

Ncontemporary

London, UK

52 Prince of Wales Road
London, UK
Phone 07588442800
norsa@ncontemporary.com

Director Emanuele Norsa
Established in 2014

Artists featured
Jonny Briggs (UK)
Daniele Galliano (Italy)
Nadir Valente (Italy)

Artists represented
Jonny Briggs (UK)
Ruben Brulat (France)
Daniele Galliano (Italy)
Motoko Ishibashi (Japan)
Erez Rimon (Israel)
Nadir Valente (Italy)

Ncontemporary is a London-based project launched by Italian-born collector Emanuele Norsa. Having started its activities in 2014, Ncontemporary currently represents international young global artists, while supporting and developing new projects with more established names. Ncontemporary operates from London, but since its opening has also organized exhibitions in Milan, Rome, Turin and Tel Aviv. The aim of the gallery is to expand further its reach in order to give a global support to the artists represented.

Nadir Valente
Albero, 2014
Paper, 60 x 50 cm
Courtesy of the artist and Ncontemporary

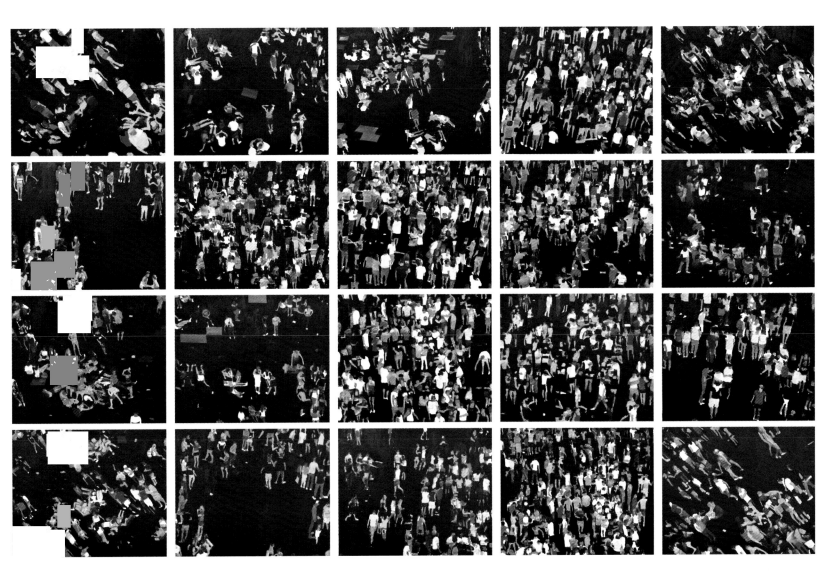

Daniele Galliano
Constellations, 2013
Polyptych, oil on canvas,
40 x 50 cm each
Courtesy of the artist and Ncontemporary

Jonny Briggs
Trompe l'œil, 2012
Photograph, 85 x 65 cm
Courtesy of the artist and Ncontemporary

Jonny Briggs
The Cage, 2013
Photograph, 126 x 128 cm
Courtesy of the artist and Ncontemporary

Osage Gallery
Hong Kong

4/F, 20 Hing Yip Street, Kwun Tong,
Kowloon, Hong Kong
Phone +852 2389 8332
Fax +852 3007 2988
www.osagegallery.com
info@osagegallery.com

Director Agnes Lin
Established in 2004

Artists featured
Au Hoi Lam (Hong Kong)

Artists represented
Au Hoi Lam (Hong Kong)
Leung Mee Ping (Hong Kong)
Li Xinping (China)
Liang Quan (China)
Ma Shuqing (China)
Ng Joon Kiat (Singapore)
Kingsley Ng (Hong Kong)
Wilson Shieh (Hong Kong)
Sarah Tse (Hong Kong)
Tintin Wulia (Indonesia)

Osage Gallery was established in Hong Kong in 2004 and currently operates an exhibition space in Hong Kong and another one in Shanghai. Osage Gallery is devoted to the exhibition and promotion of international contemporary visual arts with a focus on the Asian region. It aims to be a catalyst for the creative expression of artists and the active engagement of audiences by embracing a global, multidisciplinary approach to the creation, presentation and interpretation of the arts of our time. It examines the questions that shape and inspire us as individuals, cultures and communities through high-quality exhibition and publication programmes.

* The Artist will do a new version of this installation of paintings and photographs according to the exhibition space.

Au Hoi Lam
Full-Stop, 2013
Pencil and acrylic on canvas (copper nails),
acrylic on wall, 35 x 35 cm each
Courtesy of the artist and Osage Gallery

Au Hoi Lam
Souvenir (At the End), 2013
Digital image, gloss photographs, wooden
frame with glass, acrylic on wall,
18 x 24 cm each
Courtesy of the artist and Osage Gallery

Au Hoi Lam
*Memorandum (To Love Someone
Once Again)*, 2014
Pencil, colour pencil and acrylic on linen,
153 x 122 cm
Courtesy of the artist and Osage Gallery

Au Hoi Lam
Reminder Oblivion (2015002), 2015
Pencil, colour pencil and acrylic on linen,
153 x 122 cm
Courtesy of the artist and Osage Gallery

Au Hoi Lam
Memo: Screw, 2004
Acrylic and pencil on canvas, 213 x 122 cm
Courtesy of the artist and Osage Gallery

Au Hoi Lam
Moving the Mountain, 2004
Acrylic on linen, 213 x 122 x 5 cm
Courtesy of the artist and Osage Gallery

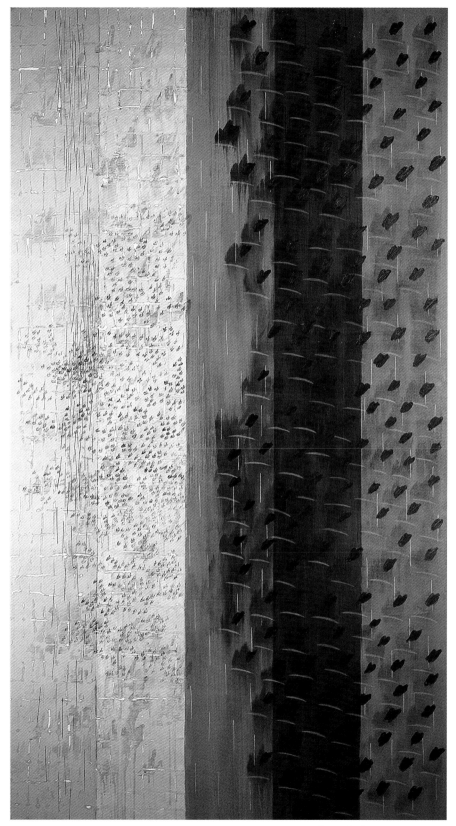

Project ArtBeat
Tbilisi, Georgia

T. Tabidze Street 106
Tbilisi, Georgia
Phone 00995 322 971716
www.projectartbeat.com
elenea@projectartbeat.com
salome@projectartbeat.com

Directors Natia Bukia, Salome
Vakhania and Natia Chkhartishvili
Established in 2014

Artists featured
Tato Akhalkatsishvili (Georgia)
Maka Batiashvili (Georgia)
Irakli Bugiani (Germany)
Thea Gvetadze (Georgia/Germany)

Artists represented
Tato Akhalkatsishvili (Georgia)
Maka Batiashvili (Georgia)
Irakli Bugiani (Germany)
Sopho Chkhikvadze (UK)
Giorgi Gagoshidze (Georgia)
Sopho Kirtadze (Georgia)
Konstantin Mindadze (Georgia)
Levan Mindiashvili (USA)
Gio Sumbadze (Georgia)
Maya Sumbadze (Georgia)
Beso Uznadze (UK)

Project ArtBeat is an innovative start-up in the Georgian art scene. Our aim is to offer carefully selected Georgian and Caucasian artists and their works to the international community through our online platform projectartbeat.com and pop-up exhibition programme. Project ArtBeat also aims to make the information about Georgian and Caucasian art available through its platforms.

Thea Gvetadze
Immortal Heroes, 2014
Glazed ceramics, dimensions variable
Courtesy of Sandro Sulaberidze

Maka Batiashvili
Calling, 2014
Oil on canvas, 10 x 15 cm
Courtesy of the artist

Maka Batiashvili
Candy Cotton, 2015
Oil on canvas, 60 x 86 cm
Courtesy of the artist

Maka Batiashvili
Train Station, 2015
Oil on canvas, 40 x 60 cm
Courtesy of the artist

Maka Batiashvili
Kiss, 2015
Oil on canvas, 60 x 88 cm
Courtesy of the artist

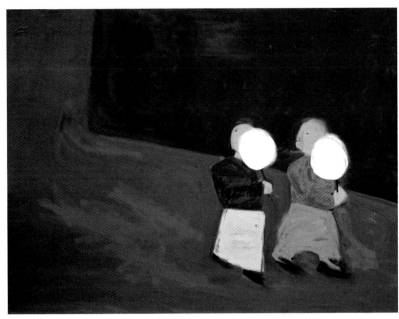

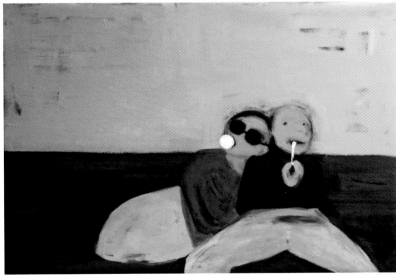

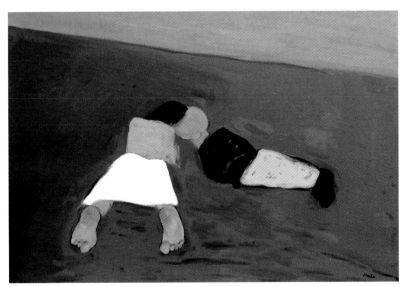

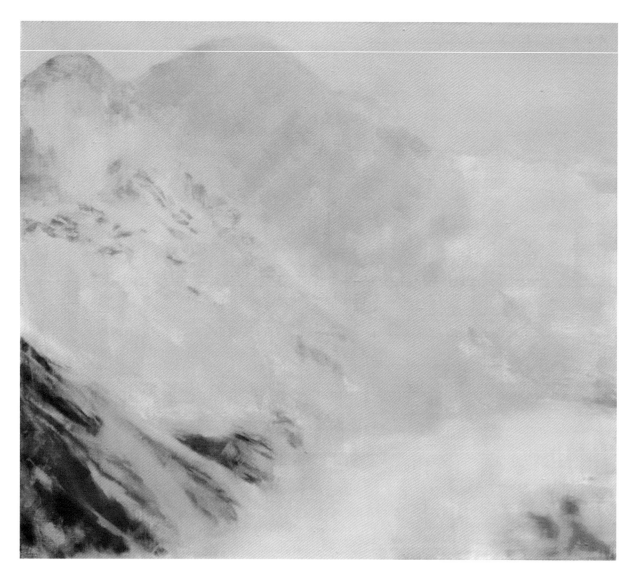

Irakli Bugiani
Untitled, 2008
Oil on canvas, 100 x 115 cm
Courtesy of the artist

Irakli Bugiani
Beyond Memory II, 2008
Oil on canvas, 40 x 50 cm
Courtesy of the artist

Irakli Bugiani
Untitled, 2009
Oil on canvas, 50 x 72 cm
Courtesy of the artist

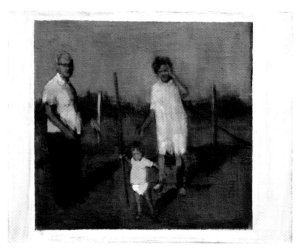

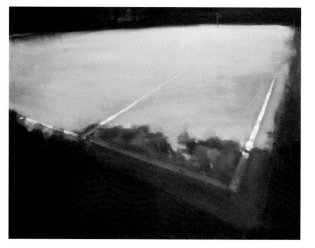

Tato Akhalkatsishvili
Conversation 08, 2014
Oil on canvas, 50 x 70 cm
Courtesy of the artist

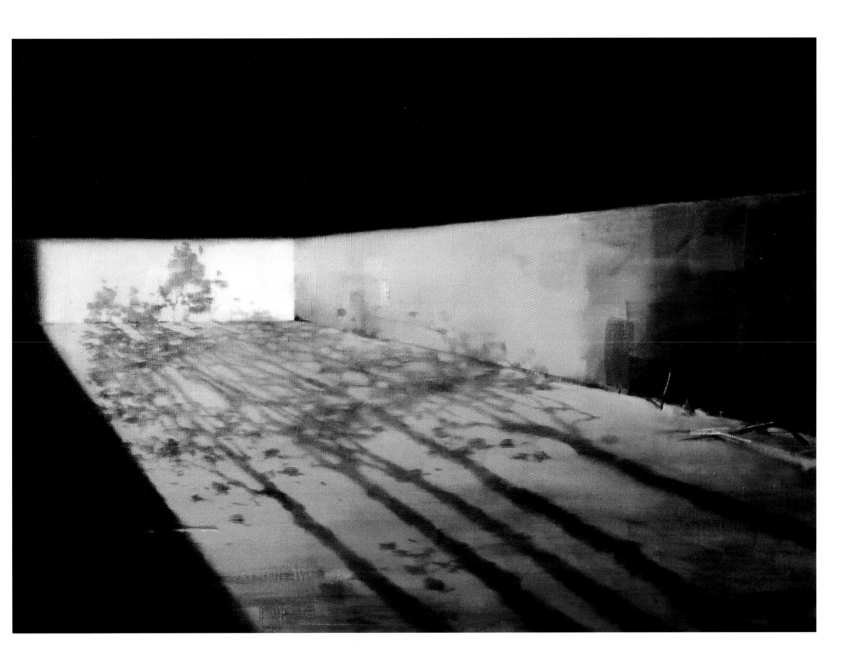

Gallery Elena Shchukina

London, UK

10 Lees Place, Mayfair
W1K 6LL London, UK
Phone +44 (0) 20 7499 6019
www.galleryelenashchukina.com
info@galleryelenashchukina.com

Directors Elena Shchukina
and Jacqueline Harvey
Established in 2013

Artists featured
Rikizo Fukao (Japan)
Alex Gough (UK)
Christoffer Joergensen (Switzerland)
Xawery Wolski (Poland/Mexico)

Artists represented
Katusha Bull (UK)
Allan Forsyth (UK)
Rikizo Fukao (Japan)
Alex Gough (UK)
Luke Jerram (UK)
Christoffer Joergensen (Denmark/
Switzerland)
Miguel Kohler-Jan (France/Uruguay)
Kyosuke Tchinai (Japan)
Xawery Wolski (Poland/Mexico)
Paul Wright (UK)
Chiang Yomei (Taiwan)

Gallery Elena Shchukina started
as a pop-up in April 2013, then later
in September the same year opened
at its current location, 10 Lees
Place, Mayfair.
We are passionate about showing
artists who, though often established
in their own countries, remain mostly
unknown within the UK. We believe in
choosing emerging artists – painters
or sculptors who display exceptional
talent, technical skill and creativity.

Rikizo Fukao
Black & Red, 2004
Acrylic on canvas, 176 x 88 cm
Courtesy of the artist

Alex Gough
Wilderness in Paint, 2011
Mixed media on paper, 24 x 34 cm
Courtesy of the artist

Alex Gough
Wilderness in Paint, 2011
Mixed media on paper, 24 x 34 cm
Courtesy of the artist

Christoffer Joergensen
Die Vereinigung, 2012
Duraclear prints, manually cut and woven,
130 x 110 cm
Courtesy of the artist

Christoffer Joergensen
Camouflage 1, 2015
C-print, diasec, 35 x 35 cm
Courtesy of the artist

Christoffer Joergensen
Autumn, 2014
C-print, diasec,
100 x 175 cm
Courtesy of the artist

Sin Sin Fine Art

Hong Kong

G/F, No. 52 Sai Street, Central,
Hong Kong
Phone 852 2858 5072
Fax 852 2764 0406
http://www.sinsinfineart.com/
info@sinsinfineart.com

Director Ms Sin Sin Man
Established in 2003

Artists featured
S. Teddy Darmawan (Indonesia)
Hanafi (Indonesia)
Muhamad Irfan (Indonesia)
Nasirun (Indonesia)
Sin Sin Man (Hong Kong)

Artists represented
Jumaldi Alfi (Indonesia)
Anusapati (Indonesia)
Fauzie As'ad (Indonesia)
Bai Xincheng (China)
I Gusti Ngurah Buda (Indonesia)
Vincent Cazeneuve (France)
Julia Nee Chu (USA)
S. Teddy Darmawan (Indonesia)
Peter Dittmar (Germany)
Fung Ming Chip (Hong Kong)
Roland Hagenberg (Austria)
Hanafi (Indonesia)
Eddie Hara (Indonesia)
Muhamad Irfan (Indonesia)
Tilo Kaiser (Germany)
Alfred Ko (Hong Kong)
Lee Man Sang (Hong Kong)

Youri Leroux (France)
Jessie Leung (Hong Kong)
Joey Leung (Hong Kong)
Rick Lewis (USA)
Lie Fhung (Indonesia)
Maria Lobo (USA)
Hervé Maury (France)
Nasirun (Indonesia)
Pablo Posada Pernikoff (France)
Eddi Prabandono (Indonesia)
Antoinette Rozan (France)
Kokok P. Sancoko (Indonesia)
Tisna Sanjaya (Indonesia)
Dwi Setianto (Indonesia)
Abdi Setiawan (Indonesia)
Sun Guangyi (China)
Putu Sutawijaya (Indonesia)
Pande Ketut Taman (Indonesia)
Wong Tong (Hong Kong)
Wong YanKwai (Hong Kong)
Bob "Sick" Yudhita (Indonesia)

Sin Sin Fine Art is the first and main
force in Hong Kong to bring
Indonesian artworks to Hong Kong
and open new windows for them to the
international art scene. Sin Sin Fine
Art focuses on contemporary art that
is spiritual and inspiring, cultivating a
collection of works by selected
international artists. Sin Sin Fine Art's
founder and owner Ms Sin Sin Man
considers herself a risk taker, in the
sense that her choices of artists are
based not on their market value but
on a genuine appreciation of their
vision and talent. This sincere
approach proved to be fruitful with
many of the artists she has shown and
who later received recognition on an
international level.

Sin Sin Man
10 YEARS AFTER, 2013
Hand-tufted carpet, wool and dull silk,
150 x 200 cm
Courtesy of the artist and Sin Sin Fine Art

Nasirun
Cool Contemporer, 2013
Mixed media, 143 x 53 x 56 cm
Courtesy of the artist and Sin Sin Fine Art

Muhamad Irfan
Top Secret, 2015
Iron, 145 x 43 x 42 cm
Courtesy of the artist and Sin Sin Fine Art

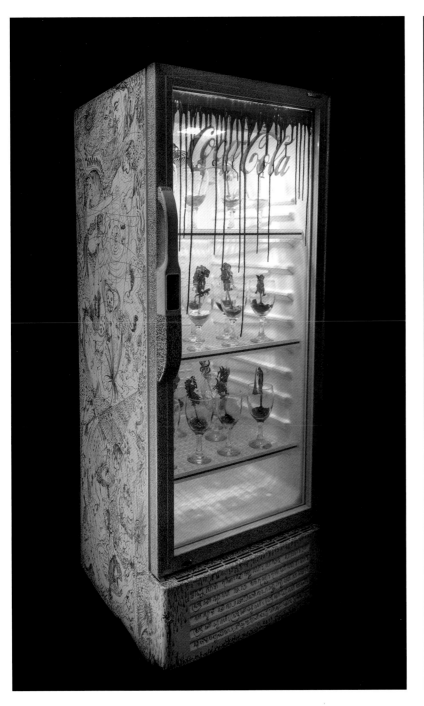

Sin Sin Man
NEST, 2015
Teak wood, 48 x 31.5 x 9 cm
Courtesy of the artist and Sin Sin Fine Art

Sin Sin Man
HOME, 2015
Teak wood, 39 x 35 x 9 cm
Courtesy of the artist and Sin Sin Fine Art

Sin Sin Man
SANCTUARY, 2015
Teak wood, 43 x 32 x 9 cm
Courtesy of the artist and Sin Sin Fine Art

Sin Sin Man
BARONG KET, 2014
A handcrafted ring, 925 sterling silver,
24K gold, emerald, 2.2 x 4.7 x Ø 2 cm
Courtesy of the artist and Sin Sin Fine Art

Sin Sin Man
GANESHA, 2014
A handcrafted ring, 925 sterling silver,
24K gold, emerald, 3.2 x 2.8 x Ø 2 cm
Courtesy of the artist and Sin Sin Fine Art

Sin Sin Man
LIGHT I, 2014
A handcrafted pendant, 925 sterling silver,
18K gold, 14 x 5.2 x 0.2 cm
Courtesy of the artist and Sin Sin Fine Art

Sin Sin Man
SUBALI, 2014
A handcrafted ring, 925 sterling silver,
24K gold, emerald, 2.3 x 4.4 x Ø 2 cm
Courtesy of the artist and Sin Sin Fine Art

Sin Sin Man
BOMA, 2014
A handcrafted ring, 925 sterling silver,
24K gold, emerald, 2 x 4.4 x Ø 2 cm
Courtesy of the artist and Sin Sin Fine Art

S. Teddy Darmawan
FLOATING, 2010
Polyester and acrylic on canvas,
80 x 100 x 20 cm
Courtesy of the artist and Sin Sin Fine Art

Hanafi
In the Drawer, 2013
Wood, paper, acrylic and transparent
screws, 63 x 55 x 32 cm
Courtesy of the artist and Sin Sin Fine Art

SKIPWITHS

London, UK

17 Clifford Street
W1S 3RQ London, UK
Phone +44 (0) 20 3239 9883
http://www.skipwiths.com
contact@skipwiths.com

Director Grey Skipwith
Established in 2014

Artists featured
Kwang Young Chun (South Korea)
Kang-So Lee (South Korea)
Richard Moon (UK)
Hyojin Park (South Korea)
Yun-Hee Toh (South Korea)
Philip Michael Wolfson (USA)

Artists represented
Kwang Young Chun (South Korea)
Kang-So Lee (South Korea)
Richard Moon (UK)
Hyojin Park (South Korea)
Yun-Hee Toh (South Korea)
Philip Michael Wolfson (USA)

Founded by Grey Skipwith and Heejin No in January 2015, Skipwiths brings together expertise in Korean and Asian artists such as as Kwang Young Chun, Kang-So Lee, Xing Danwen and Hyojin Park, and introduces their work to European audiences. Heejin established her own international art project company in 2006 after completing her Master at Sotheby's Institute, and Grey ran his own IT company for many years before returning to his roots in the art world, which he started working in at the tender age of 13. Since they started working together three years ago, they have been curating shows for galleries and public institutions as well as managing artists at different needs and stages in their careers. Recent projects include co-producing of *Korean Art: The Power of Now*, published by Thames and Hudson in 2013.Their forthcoming project is a solo presentation of Kwang Young Chun at Dovecot Foundation as part of the Edinburgh International Art Festival, from late July 2015.

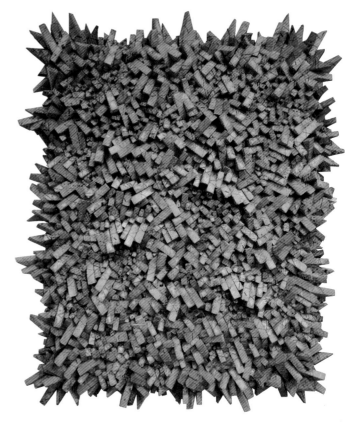

Kwang Young Chun
Aggregation14-DE069, 2014
Mixed media with Korean mulberry
paper,130 x 110 cm
Courtesy of SKIPWITHS

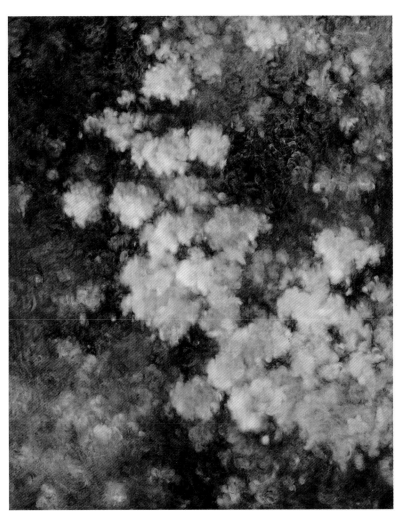

Yun-Hee Toh
Night Blossom, 2014
Oil on canvas, 162 × 130 cm
Courtesy of SKIPWITHS

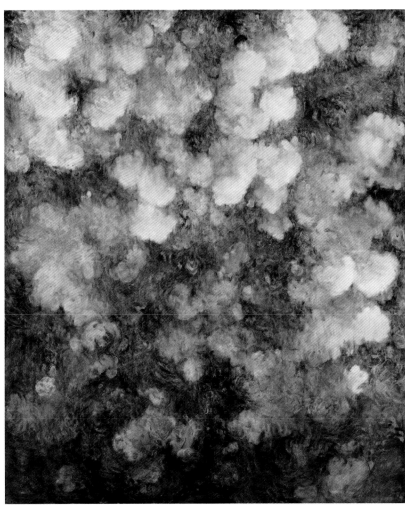

Yun-Hee Toh
Night Blossom, 2014
Oil on canvas, 162 × 130 cm
Courtesy of SKIPWITHS

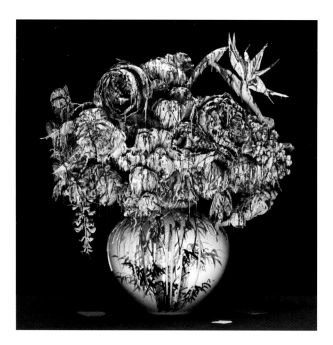

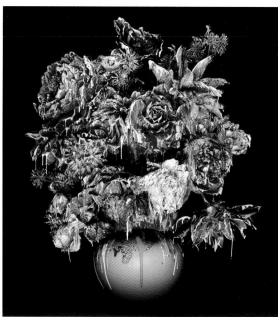

Hyojin Park
Hope, 2015
Pigment print, 110 x 110 cm
Courtesy of SKIPWITHS

Hyojin Park
Temptation, 2015
Pigment print, 110 x 102 cm
Courtesy of SKIPWITHS

Philip Michael Wolfson
Twisted – Stool, 2008
Hi-Macs Acrylic Stone (white), bronze
mirror glass, functional sculpture,
44 × 60 × 60 cm
Courtesy of SKIPWITHS

Richard Moon
Relic, 2015
Oil on canvas, 55 x 55 cm
Courtesy of SKIPWITHS

Richard Moon
Aristocrat, 2015
Oil on wood, 30 x 20 cm
Courtesy of SKIPWITHS

Kang-So Lee
Becoming-08112, 2008
Acrylic on canvas, 72.7 × 91 cm
Courtesy of SKIPWITHS

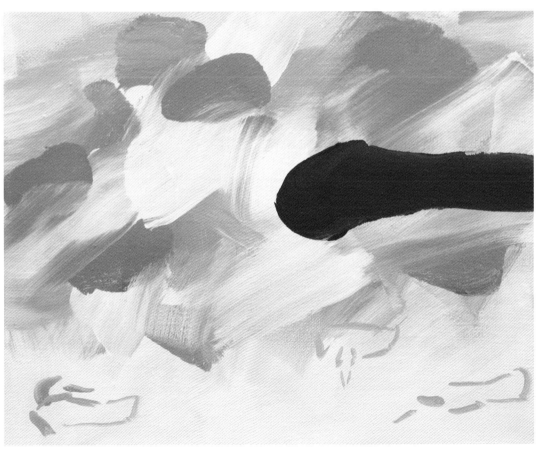

SODA gallery
Bratislava, Slovakia

Školská 9, SK
811 07 Bratislava, Slovakia
Phone +421907853562
www.soda.gallery
gallerysoda@gmail.com

Director Tomas Umrian
Established in 2010

Artists featured
Josef Bolf (Czech Republic)
Andrej Dúbravský (Slovakia)
Július Koller (Slovakia)
Ilona Németh (Slovakia)
Lucia Tallová (Slovakia)

Artists represented
Josef Bolf (Czech Republic)
Cristina Fiorenza (Italy/Austria)
Jiří Franta & David Bohm
(Czech Republic)
Viktor Frešo (Slovakia)
Július Koller (Slovakia)
Ilona Németh (Slovakia)
Jan Šerých (Slovakia)
Adam Štech (Czech republic)
Lucia Tallová (Slovakia)
Jana Želibská (Slovakia)

SODA gallery is one of the leading Bratislava–based galleries. It deals exclusively in critically acclaimed, important works of contemporary art produced by very young, emerging and high-calibre artists from Austria, Germany, the Czech Republic and Slovakia. SODA gallery is a contemporary art space whose exhibition activities are mainly focused on the creation of a new generation of domestic as well as foreign artists. Representing ten artists, SODA gallery is active in both the primary and secondary markets. Since opening its doors in 2010, it has been home to innovative, singular and pioneering exhibitions across a variety of media and genres. The gallery has helped foster the careers of some of the most influential artists working today, and has maintained long-term representation of a wide-ranging, international group of artists.

Lucia Tallová
from the *Paper stories series*, 2013–14
Acrylic and spray on old found photographs
and handmade paper, 40 x 30 cm each
Courtesy of the artist and SODA gallery

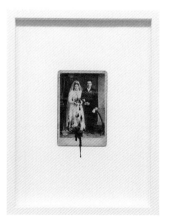 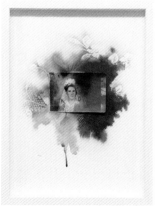 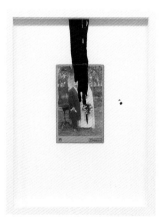

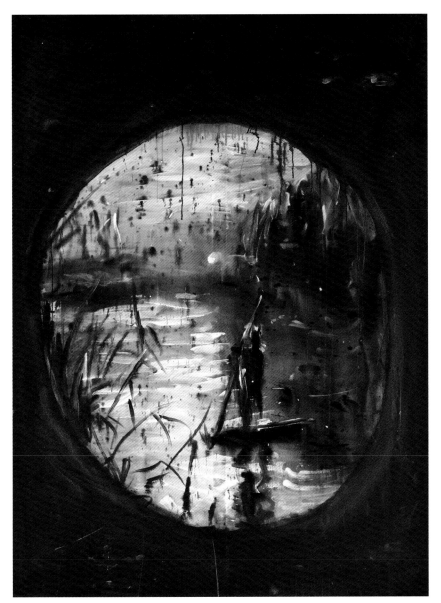

Andrej Dúbravský
Excitement from the Cave, 2015
Acrylic on canvas, 180 x 130 cm
Courtesy of the artist and SODA gallery

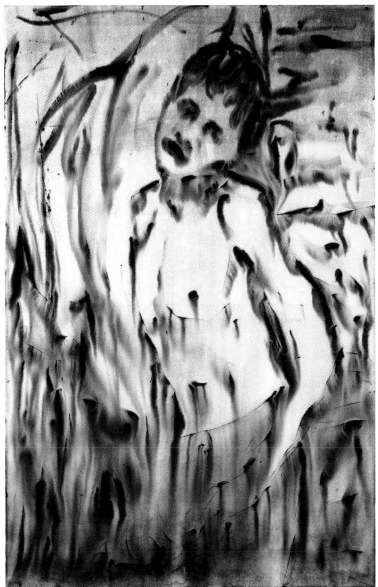

Andrej Dúbravský
Untitled (Rate me), 2015
Acrylic on canvas, 150 x 90 cm
Courtesy of the artist and SODA gallery

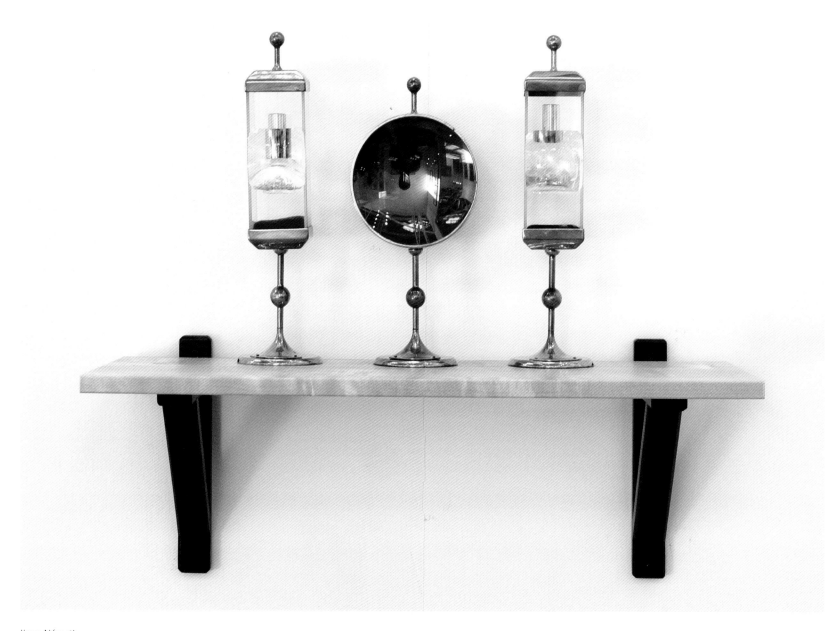

Ilona Németh
*Reliquary I–III (Artist's Relics
from 2000)*, 2012
2000 metal objects, glass, organic
materials, dimensions variable
Photo by József Rosta

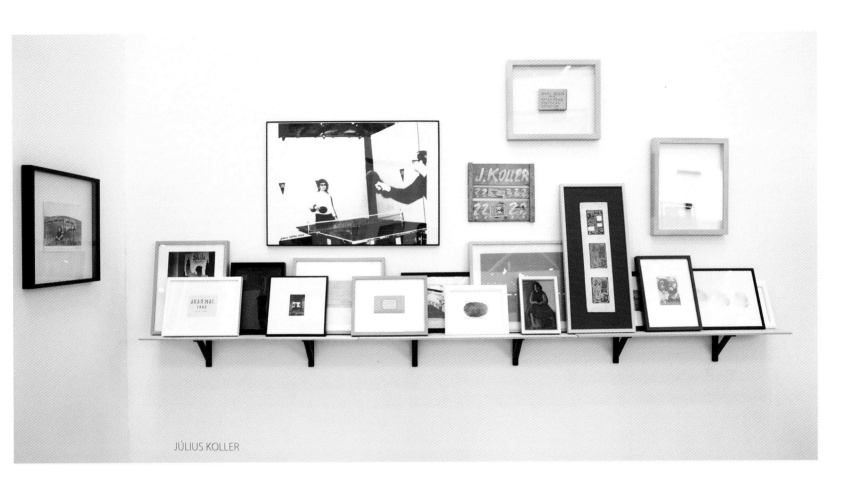

JÚLIUS KOLLER

Július Koller
Installation
Medium variable, dimensions variable
Courtesy of the artist and SODA gallery

Július Koller
1979, 2000
Photograph, 70 x 85.5 cm
Exhibited at Fundació Joan Miró, Barcelona

Július Koller
Question marks with sign, 1969
Latex on wood, framed, 33 x 39 cm
Courtesy of the artist and SODA gallery

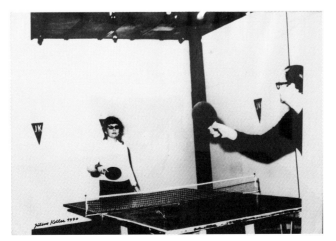

Studio Pivot – Art Hunting & Counseling

Rome, Italy

Via Nicotera 29, 00195, Rome, Italy
Phone +39 338 82 33 812
info@s-pivot.com

Directors Vittoria de Petra, Elisa
Gavotti Basilj, Beatrice Roccetti
Campagnoli and Carolina Zavanella
Established in 2012

Artists featured
Veronica Della Porta (Italy)
Chiara Lupi (Italy)
Mario Rossi (Italy)
Tindar (Italy)

Artists represented
Vittorio Asteriti (Italy)
Simone Cametti (Italy)
Giuliano Cardella (Italy)
Veronica Della Porta (Italy)
Francesco Ermini (Italy)
Francesco Liggieri (Italy)
Chiara Lupi (Italy)
Ilaria Meli (Italy)
Mario Rossi (Italy)
Tindar (Italy)

Studio Pivot – Art Hunting and
Counseling takes an alternative
approach to exhibiting and marketing
art, curating a programme of
shows, cultural events and initiatives
in unconventional spaces across
Rome. From its inception in 2012,
the association has promoted and
supported young contemporary
artists, reviving public interest
in contemporary art in the process.
Inspired by the French "pivot",
meaning hinge, the Studio places
an emphasis on the collaborative
steps that make up artistic projects.
Founded by four specialists from
the fields of art history, writing,
architecture and events
administration, Studio Pivot offers
a strong commitment to art in
Italy's capital city.

Chiara Lupi
Esercito femminile (Women Army), 2014
Mixed media on print with printed press,
124 x 230 cm
Courtesy of Studio Pivot

Chiara Lupi
Weightless 3, 2013
Printed press, 156 x 124 cm
Courtesy of Studio Pivot

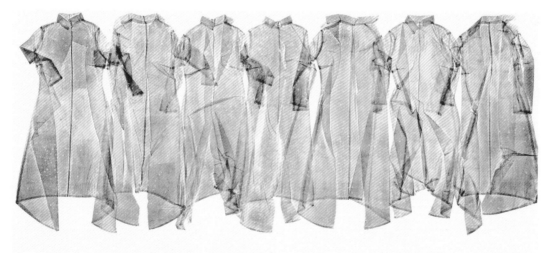

Veronica Della Porta
SOFFITTO (Ceiling) #2, 2013
Fine art inkjet print on bamboo paper,
120 x 91,5 cm
Courtesy of Studio Pivot

Veronica Della Porta
SOFFITTO (Ceiling) #6, 2014
Fine art inkjet print on bamboo paper,
100 x 82 cm
Courtesy of Studio Pivot

Tindar
Shadow (1), 2015
Ink on paper, 20 × 15 cm
Courtesy of Studio Pivot

Tindar
Shadow (2), 2015
Ink on paper, 25 × 15 cm
Courtesy of Studio Pivot

Mario Rossi
Travelers, 2013
Digital print, diasec, 100 x 93 cm
Courtesy of Studio Pivot

Mario Rossi
3 x 3, 2013
Digital print, diasec, 100 x 93 cm
Courtesy of Studio Pivot

Gallery Sumukha
Bangalore, India

24/10 BTS Depot Road
Wilson Garden
560027 Bangalore, India
Phone +918022292230
www.sumukha.com
gallery@sumukha.com

Director Premilla Baid
Established in 1996

Artists featured
Ravikumar Kashi (India)
Riyas Komu (India)
Baiju Parthan (India)
Vivek Vilasini (India)

Artists represented
Karl Antao (India)
Laxma Goud (India)
Ravikumar Kashi (India)
Riyas Komu (India)
Naveen A Kumar (India)
Paresh Maity (India)
Baiju Parthan (India)
Ravinder Reddy (India)
Vivek Vilasini (India)

Gallery Sumukha is based in Bangalore. During its existence, the gallery has grown up and travelled a long way in showcasing contemporary art, both nationally and internationally. Sumukha, which is currently housed in the largest private gallery space in South India, supports artists in terms of commissions and relevant spaces to exhibit their conceptual thinking. Important Indian contemporary artists are showcased to an international audience and, conversely, works of artists from outside India reach the local. The gallery has presented several established artists and curators and has brought out new talents, becoming a platform for showcasing all forms and media inhabiting contemporary art. In the past few years Gallery Sumukha has participated in a large number of international art fairs.

Ravikumar Kashi
Vision Coat, 2014
Cast cotton pulp and wood,
50.8 x 39.4 x 22.9 cm
Courtesy of the artist

Ravikumar Kashi
Cross Talk, 2014
Paper made from Daphne pulp,
76.2 x 203.2 cm
Courtesy of the artist

Vivek Vilasini
Between one Shore & several others, 2015
Photograph on archival paper,
91.4 x 91.4 cm
Courtesy of the artist

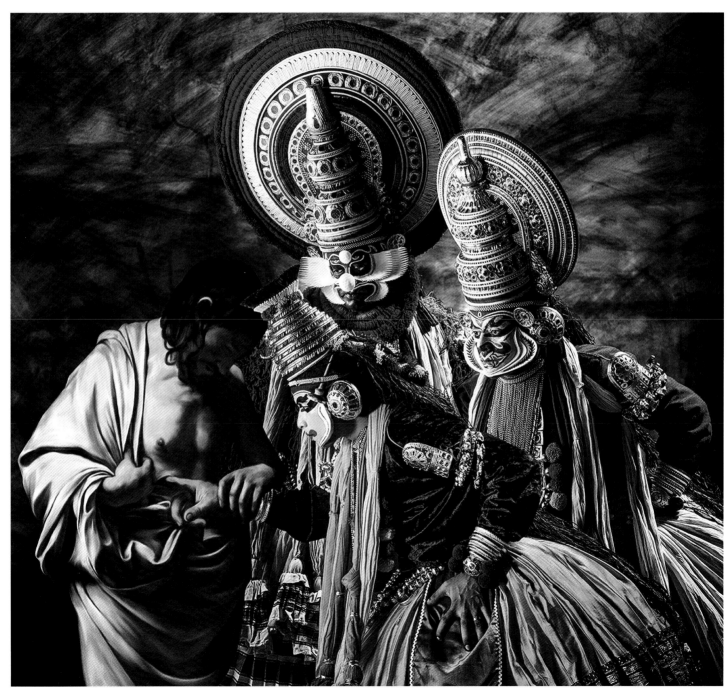

Baiju Parthan
Aniso Interfect, 2015
Lenticular 3D print, 91.4 x 91.4 cm
Courtesy of the artist

Baiju Parthan
Anisoptera Metallicis, 2015
Lenticular 3D print, 91.4 x 91.4 cm
Courtesy of the artist

Baiju Parthan
Lapido Ignis, 2015
Lenticular 3D animated print,
91.4 x 91.4 cm
Courtesy of the artist

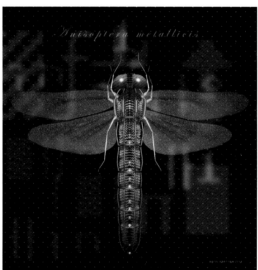

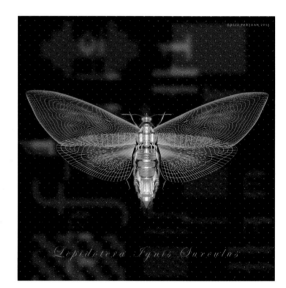

Riyas Komu
Indian Footballer, 2012
Oil on canvas, 213.4 x 152.4 cm
Courtesy of the artist

Riyas Komu
Untitled, 2012
Oil on canvas, 91.4 x 121.9 cm
Courtesy of the artist

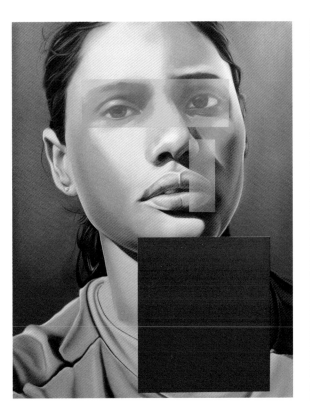

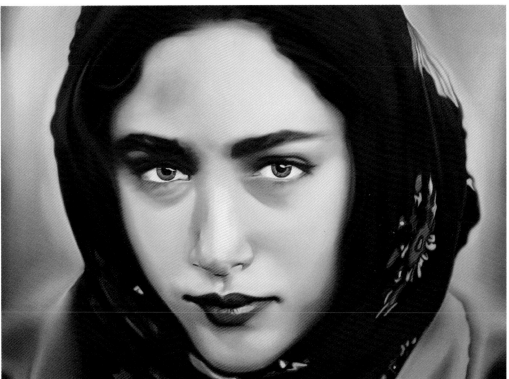

Tamar Dresdner Art Projects

Tel Aviv, Israel

16 Sharabi Street
6514761 Tel Aviv, Israel
Phone +972 544 600293
Fax +972 3 5162537
https://www.facebook.com/pages/
Tamar-Dresdner-Art-Projects/
648700061930468?fref=ts
tamari21@gmail.com

Director Tamar Dresdner
Established in 2006

Artists featured
Batia Shani (Israel)

Artists represented
Yair Barak (Israel)
Gil Desiano Biton (Israel)
Tsibi Geva (Israel)
Gaston Ickowicz (Israel)
Batia Shani (Israel)

Tavi Dresdner Gallery operated from a space on Achva Street in Tel Aviv from 2006 to 2011, after which it became Tamar Dresdner Art Projects. Tamar Dresdner Art Projects acts as a pop-up gallery, exhibiting Israeli and international artists who work in diverse media. Its exhibitions take place in museums, alternative art spaces, art fairs and photography festivals. Tamar Dresdner Art Projects is the curator of the art collection at The Norman Hotel in Tel Aviv, which consists of 150 works by emerging and established contemporary Israeli artists.

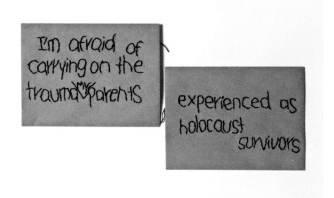

Batia Shani
I'm afraid of carrying on the trauma my parents experienced as holocaust survivors, 2015
Embroidered envelopes, 12 x 16.5 cm each
Courtesy of the artist and Tamar Dresdner Art Projects

Batia Shani
Untitled, 6 embroidered envelopes back side, 2015
Embroidered envelopes, 12 x 16.5 cm each
Courtesy of the artist and Tamar Dresdner Art Projects

Batia Shani
Installation view, 2015
Mixed media and army uniforms,
125 x 400 x 32 cm
Courtesy of the artist and Tamar
Dresdner Art Projects

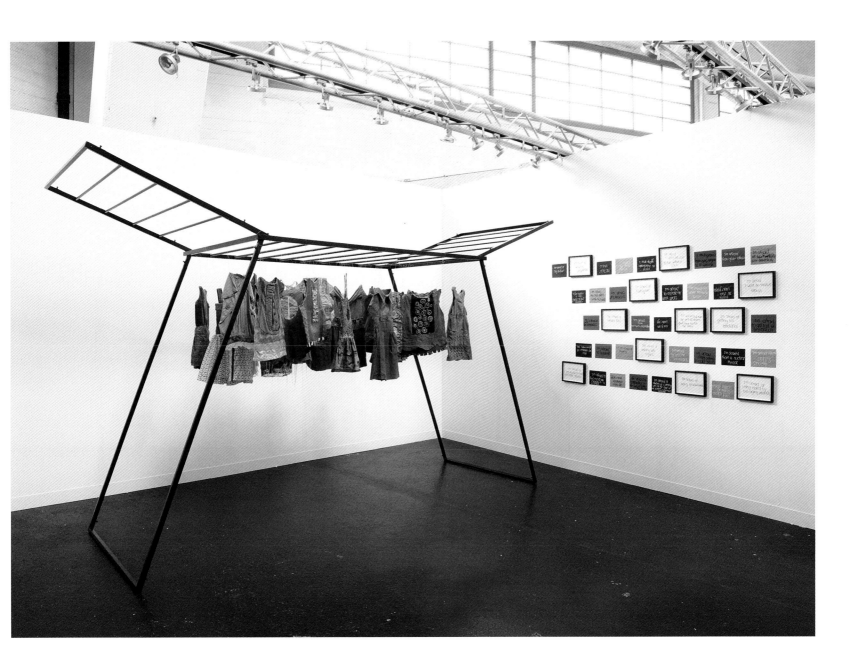

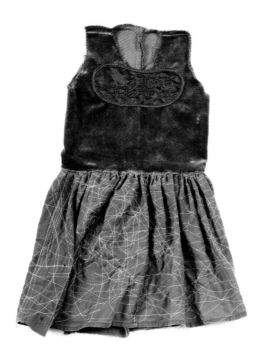

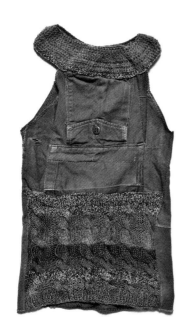

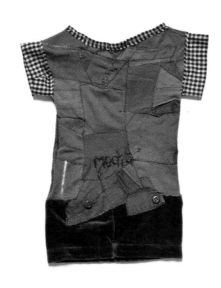

Batia Shani
Untitled Dress 4, 2014
Mixed media on army uniform,
78 x 45 cm
Courtesy of the artist and
Tamar Dresdner Art Project

Batia Shani
Untitled Dress 1, 2014
Mixed media on army uniform,
57 x 39 cm
Courtesy of the artist and
Tamar Dresdner Art Project

Batia Shani
Untitled dress 3, 2014
Mixed media on army uniform,
56 x 32 cm
Courtesy of the artist and
Tamar Dresdner Art Project

Batia Shani
Media, 2014
Mixed media on army uniform,
45 x 36 cm
Courtesy of the artist and
Tamar Dresdner Art Project

Batia Shani
Longing, 2014
Mixed media on army uniform,
50 x 48 cm
Courtesy of the artist and
Tamar Dresdner Art Project

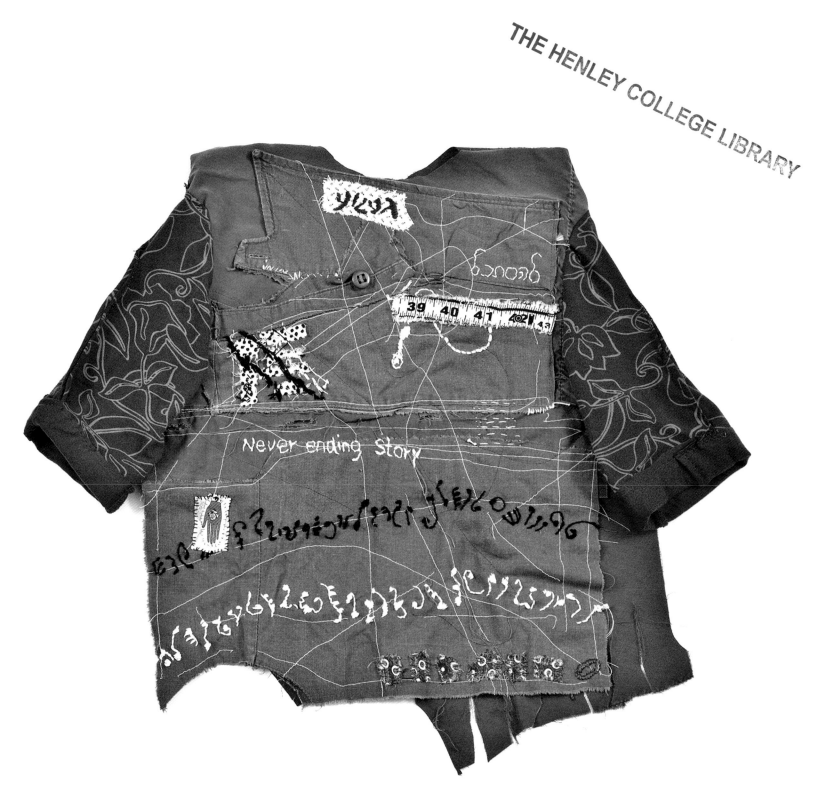

VILTIN
Budapest, Hungary

Vasvári Pál út 1
H-1061 Budapest, Hungary
Phone +36 1 787 5866
www.viltin.hu
hello@viltin.hu

Director Krisztina Dián
Established in 2008

Artists featured
Tibor iski Kocsis (Hungary)
Attila Kovács (Hungary/Germany)

Artists represented
Zsolt Asztalos (Hungary)
Mária Chilf (Hungary)
Áron Galambos (Hungary)
Pál Gerber (Hungary)
Gábor Kerekes (Hungary)
János Megyik (Hungary/Austria)
Jari Silomäki (Finland)
Tamás Szvet (Hungary)
Zsolt Tibor (Hungary)
Kata Tranker (Hungary)

VILTIN gallery opened in November 2008 with the aim to present a subjective overview of contemporary Hungarian art regardless of age-related priorities, exhibiting emerging and mid-career artists with a marked conceptual orientation and a special dedication to the medium of paper. Our artists and their high-quality works with typical Central European reference have already merited their place at international fairs and shows by now. Our portfolio reflects our professional commitment and is completed by the representation of foreign artists in Hungary.

Tibor iski Kocsis
LUNA 4 – 12th December, 1972, 2014
Charcoal on paper, diptych, 170 x 280 cm
Courtesy of the artist and VILTIN

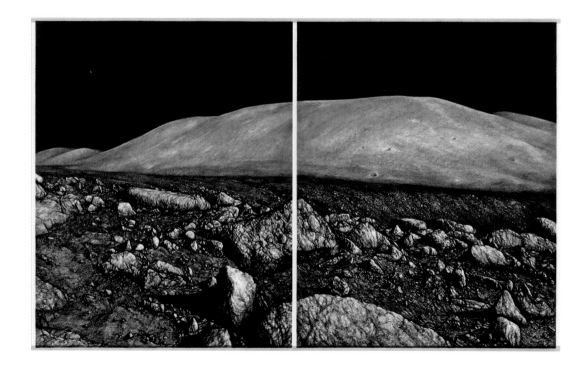

Tibor iski Kocsis
LUNA 5 – 12th December, 1972, 2014
Charcoal on paper, 140 x 170 cm
Courtesy of the artist and VILTIN

Tibor iski Kocsis
LUNA 2 – 12th December, 1972, 2013
Charcoal on paper, 70 x 99 cm
Courtesy of the artist and VILTIN

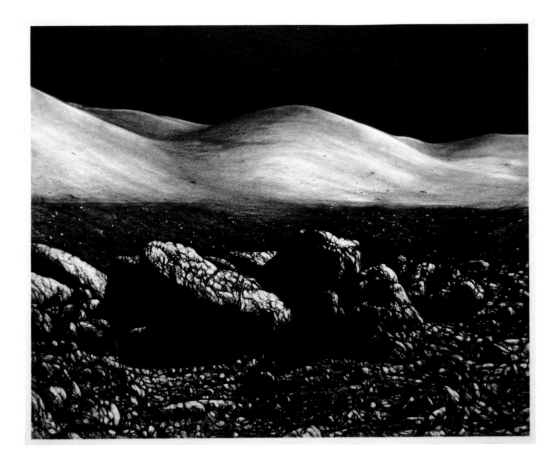

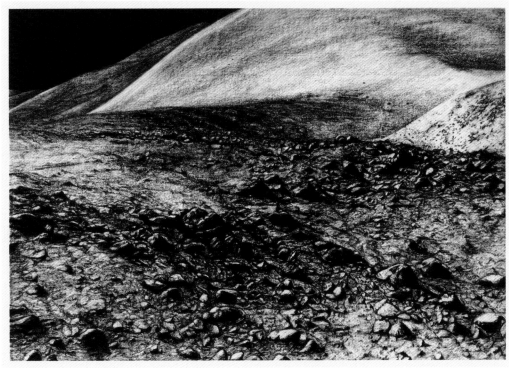

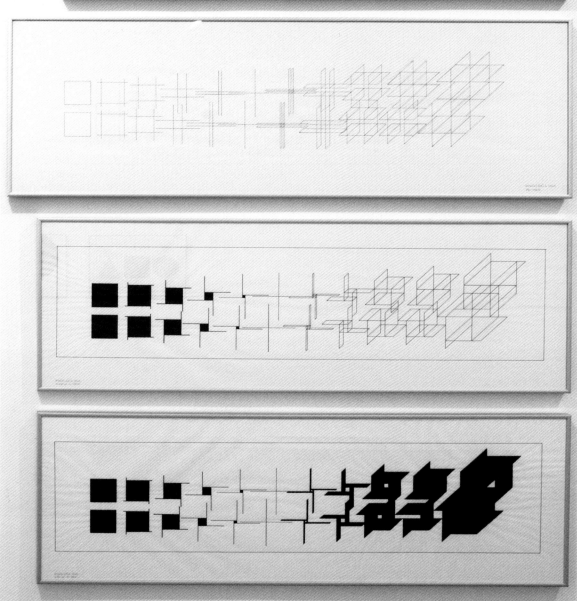

Attila Kovács
Transmutation, 1969
Ink and graphite on tracing paper,
4 pieces, different sizes
Courtesy of the artist and VILTIN

Attila Kovács
Frame of Reference A4-B8, 1973–76 (1984)
Acrylic on canvas and wooden board,
60 x 60 cm
Courtesy of the artist and VILTIN

Attila Kovács
Regressive Meta-Quadrat, 1973–79 (1983)
Acrylic on canvas and wooden board,
60 x 40 cm
Courtesy of the artist and VILTIN

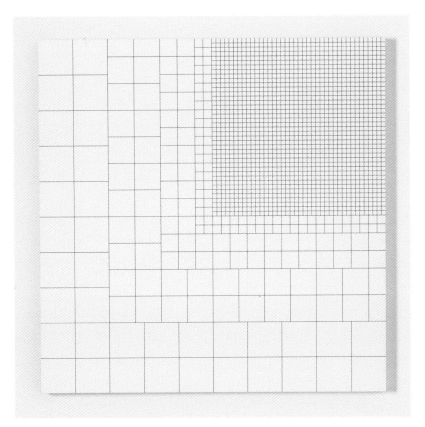

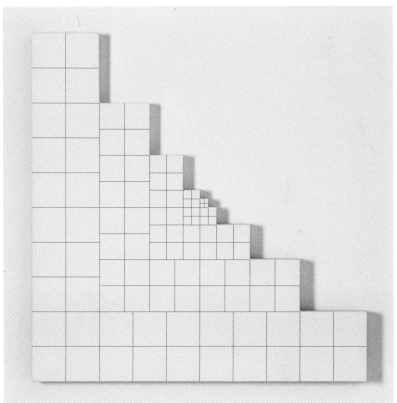

This Is Tomorrow

Farhad Gavzan

Iran

Dastan's Basement
#6 Beedar Street, Fereshteh Street
Tehran, Iran
Phone +982122023114
dastangallery.com
h@dastangallery.com

Director Hormoz Hematian
Established in 2012

Artists represented
Fereydoun Ave (Iran)
Morteza Ghasemi (Iran)
Mohammad Hossein Gholamzadeh
(Iran)
Sahand Hesamiyan (Iran)
Amin Montazeri (Iran)
Houman Mortazavi (Iran)
Lucien Murat (France)
Bahareh Navabi (Iran)
Mamali Shafahi (Irani)
Nima Zaare Nahandi (Iran)

Dastan's Basement was established
in 2012 in Northern Tehran and is
dedicated to exhibiting the artworks
of the new generation of Iranian
emerging artists. Dastan's Basement
is also devoted to research on Iranian
visual arts and regularly hosts
documentary film screenings and
book launches. Since 2014, the gallery
has extended outside the Basement in
order to reach a wider audience and to
break the confines of a single gallery
space. These ventures operate under
the framework of "Dastan Outside the
Basement"; the current project
outside the Basement is *Sam Art* –
a 150-metre pop-up gallery dedicated
to showcasing the artwork of Iranian
masters and established artists in
the heart of Tehran.

Farhad Gavzan
Untitled, 2013
Ink on paper, 120 x 90 cm
Courtesy of Dastan's Basement

Farhad Gavzan
Untitled, 2014
Graphite on paper, 150 x 50 cm
Courtesy of Dastan's Basement

Farhad Gavzan
Untitled, 2014
Graphite on paper, 150 x 50 cm
Courtesy of Dastan's Basement

Farhad Gavzan
Untitled, 2013
Installation views
Graphite on paper, 1000 x 150 cm
Courtesy of Dastan's Basement

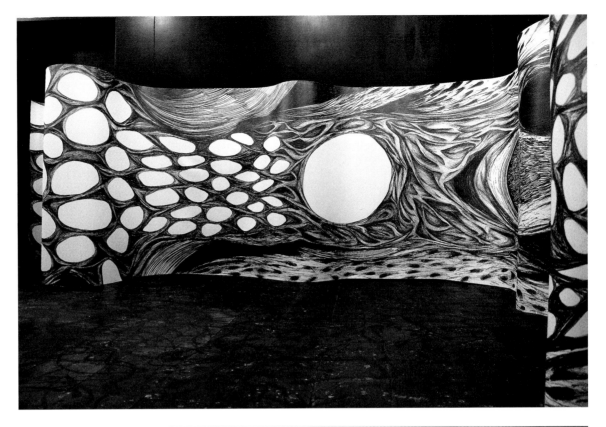

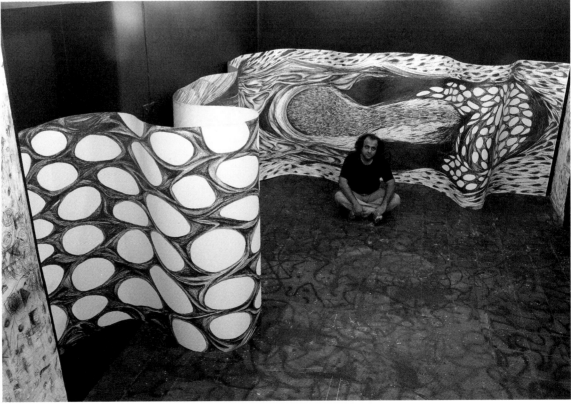

Jonny Green
UK

CARTER presents
59 Old Bethnal Green Road
E2 6QA London, UK
Phone +44 (0)7828 553 080
www.carterpresents.org
carterpresents1@gmail.com

Director Jamie Robinson
Established in 2005

Artists represented
Monica Biagioli (Spain)
Paul Brandford (UK)
Thomas Draschan (Austria)
Jonny Green (UK)
Hilary Jack (UK)
Daniel Jackson (UK)
Jay AR (UK)
Brian Reed (UK)
Jamie Robinson (Australia)
Dallas Seitz (Canada)
Colin Smith (UK)
Kate Waters (Canada)
Mark Wright (UK)

CARTER presents is an independent gallery founded in 2005 in Hoxton London and currently located in Bethnal Green East London. Our directive is to facilitate and work with emerging artists, enabling them to develop, realize and exhibit experimental and newly created art works. Carter also presents work by established artists with an international profile on curated projects and events.

Jonny Green
Blood Shod, 2015
Oil on canvas, 49.5 x 75 cm
Courtesy of the artist and CARTER presents

Jonny Green
Don't Let Your Youth Go to Waste, 2014
Oil on canvas, 122 x 158 cm
Courtesy of the artist and CARTER presents

Jonny Green
The First Cut, 2014
Oil on canvas on board, 88 x 122 cm
Courtesy of the artist and CARTER presents

Jonny Green
Ghost, 2015
Oil on canvas, 62.5 x 50 cm
Courtesy of the artist and CARTER presents

Jonny Green
Babel, 2013
Oil on canvas, 145 x 122 cm
Courtesy of the artist and CARTER presents

Jonny Green
Jazz Hands, 2015
Oil on canvas, 50.5 x 55 cm
Courtesy of the artist and CARTER presents

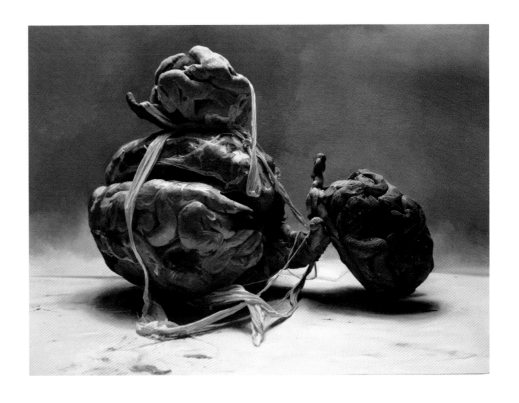

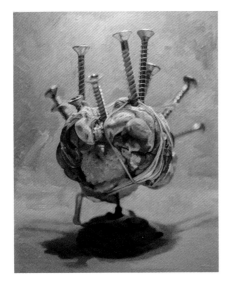

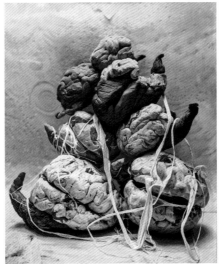

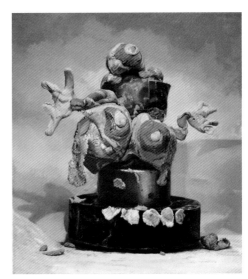

Rae Hicks

UK

CANAL
60 De Beauvoir Crescent
N1 5SB London, UK
Phone +44 (0)207 923 9211
www.canalprojects.info
info@canalprojects.info

Director Monika Bobinska
Established in 2013

Artists represented
Rae Hicks (UK)

CANAL is an independent gallery founded in 2012 that exhibits both emerging and established artists working in a deliberately wide variety of media and formats. The aim is to present a stimulating, high-quality and flexible programme within an informal and welcoming environment. Exhibitions have included solo shows by Andrew Cross, Rae Hicks, Adam King, Laura Morrison and Alex Pearl, as well as the presentation of applied arts and an archive exhibition of the 1980s alternative comedy movement, with a live programme of stand-up performance. The gallery is located on the Haggerston Riviera, an association of venues, bars and cafes on the Regent's Canal at Haggerston, East London. CANAL is a new project by Monika Bobinska, developing from the original gallery in East London.

Rae Hicks
Untitled (drills), 2015
Oil on linen, 185 x 160 cm
Courtesy of the artist

Rae Hicks
Untitled (box), 2015
Oil on canvas, 175 x 130 cm
Courtesy of the artist

Rae Hicks
Los Simpsons, 2015
Oil on sack, 152 x 122 cm
Courtesy of the artist

Rae Hicks
Sign Language, 2015
Oil on canvas, 180 x 150 cm
Courtesy of the artist

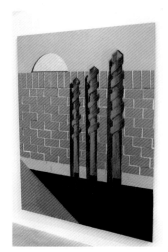
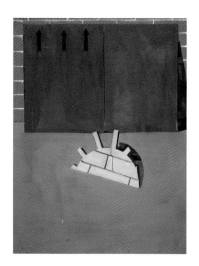
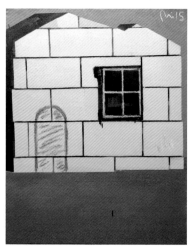
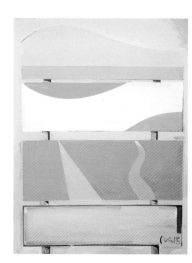

Rae Hicks
City Slickers, 2014
Oil on canvas, 150 x 200 cm
Courtesy of the artist

Rae Hicks
Manoeuvres II, 2014
Oil on canvas, 130 x 150 cm
Courtesy of the artist

Rae Hicks
Floor Wall, 2015
Oil on canvas, 160 x 210 cm
Courtesy of the artist

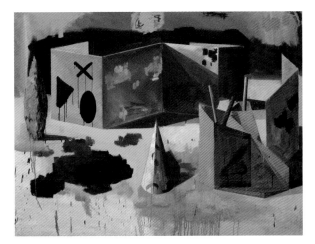
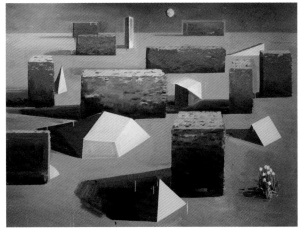

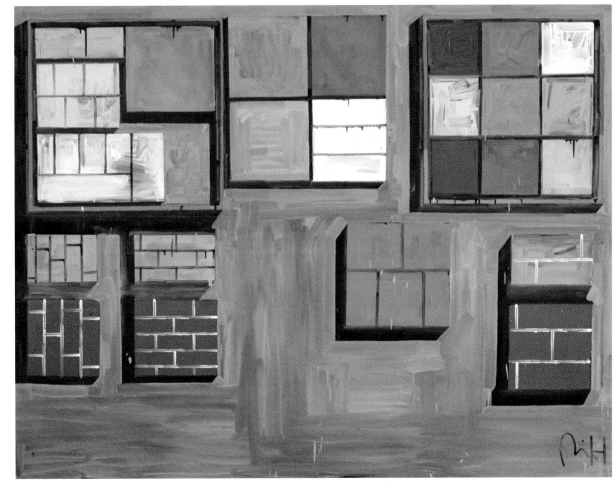

Vay Hy

UK

CHRISTINE PARK GALLERY
Gallery: 35 Riding House Street
W1W 7EA London, UK
Office: Office 3, 12 Carlton
House Terrace, The ICA,
SW1Y 5AH London, UK
Phone +44 (0) 207 930 9865
www.christinepark.net
info@christinepark.net

Director Christine Park
Established in 2014

Artists represented
Patrik Aarnivaara (Sweden)
Dan Hays (UK)
Vay Hy (UK)
Hangjun Lee (South Korea)
Vangelis Pliarides (Greece)
Jessica Rayner (UK)

CHRISTINE PARK GALLERY exhibits works by both established and emerging international contemporary artists. Located in the heart of London's Fitzrovia, the gallery is dedicated to the discovery of new, locally emerging talents, whilst also exhibiting works from internationally acclaimed artists. The extensive programme of solo shows, conceptually curated group exhibitions and special installations of new art projects is intended to expand the boundaries of the current contemporary art scene. Aiming to build a fresh and dynamic platform for contemporary art, CHRISTINE PARK GALLERY encourages cross-cultural exchange with the audience, in addition to being a commercial space that artists can use as a canvas to realize their projects and present their new works to the public.

Vay Hy
1411-05, 2014
Ink and acrylic on paper, 140 x 100 cm
Courtesy of CHRISTINE PARK GALLERY

Vay Hy
1411-76, 2014
Ink and acrylic on paper, 140 x 100 cm
Courtesy of CHRISTINE PARK GALLERY

Vay Hy
L13-001, 2013
Ink and acrylic on paper, 150 x 198 cm
Courtesy of CHRISTINE PARK GALLERY

Vay Hy
L13-003, 2013
Ink and acrylic on paper, 150 x 214 cm
Courtesy of CHRISTINE PARK GALLERY

Vay Hy
147d-001, 2014
Ink and acrylic on paper, 150 x 204 cm
Courtesy of CHRISTINE PARK GALLERY

Kim In Kyum

South Korea

Gallery SoSo
92, Heyrimaeul-gil, Tanhyeon-myeon,
Paju-si, Gyeonggi-do, South Korea
Phone +82 31 949 8154
Fax +82 31 949 9186
www.gallerysoso.com
soso@gallerysoso.com

Director Keum Hye Won
Established in 2007

Artists represented
Chung Seung Un (South Korea)
Chung Zu Young (South Korea)
Kim Eull (South Korea)
Kim Hyung Gwan (South Korea)
Kim In Kyum (South Korea)
Kim Yun Soo (South Korea)
Haiyoung Suh (South Korea)
Yang Jung Uk (South Korea)

Gallery SoSo has organized about eight exhibitions annually starting from its opening show in May 2007 to the latest one in 2015. It exhibits works of artists that show sharp interpretation and insights on space or make their own story to tell personally or through artworks. In particular, exhibitions are held with a focus on conceptual art. Such an intention is in compliance with the style of the gallery, made of exposed concrete and cedar trees beyond a white cube so that artists could prepare for their exhibition by actively intervening in the gallery space.

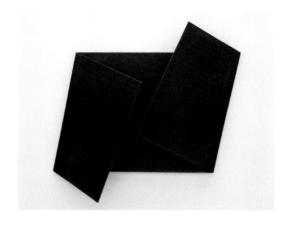

Kim In Kyum
Space of Emptiness, 2000
Steel, 67 x 50 x 15.5 cm
Courtesy of the artist and Gallery SoSo

Kim In Kyum
Revelational Space – Emptiness, 1999
Steel, front 120 x 300 x 40 cm;
back 120 x 300 x 30 cm
Exhibition view, Hall III, Gana
Art Center, Seoul
Courtesy of the artist and Gallery SoSo

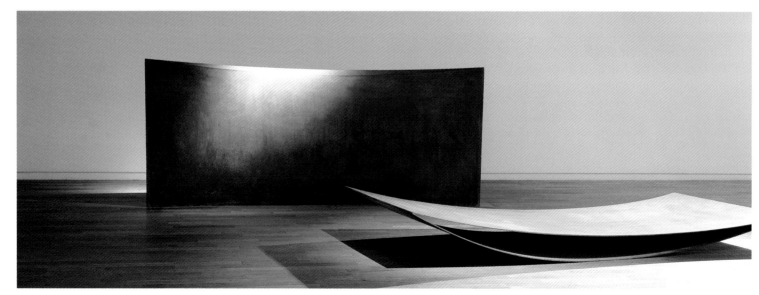

Kim In Kyum
Space-Less, 2009
Left: primer surface coating on stainless
steel, 106 x 106 x 2 cm; right: acrylic
urethane coating on stainless steel,
140 x 138 x 18 cm
Exhibition view, The Taipa Houses-Museum,
Exhibitions Gallery, Macao, China
Courtesy of the artist and Gallery SoSo

Kim In Kyum
Space-Less, 2015
Drawing, ink on paper, 79 x 109 cm
Courtesy of the artist and Gallery SoSo

Kim In Kyum
Space-Less, 2015
Drawing, ink on paper, 79 x 109 cm
Courtesy of the artist and Gallery SoSo

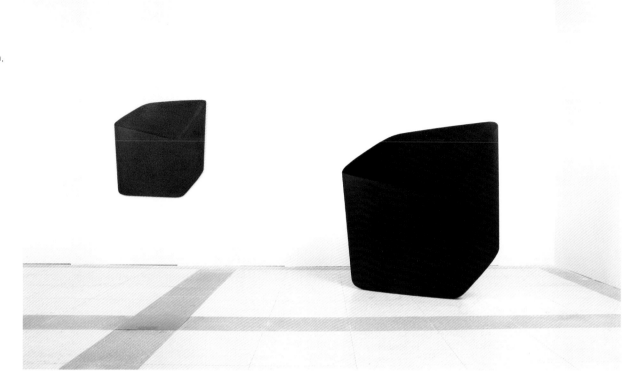

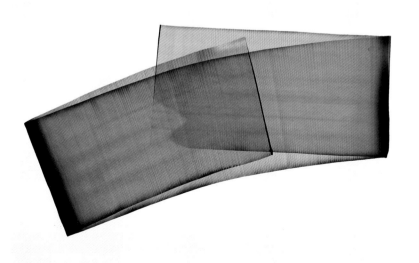

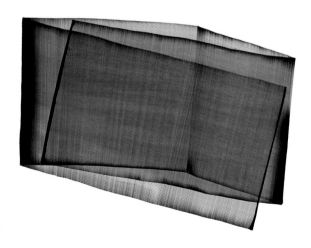

Liane Lang
UK

LOEWE CONTEMPORARY
36 Grosvenor Gardens
SW1W 0EB London, UK
Phone + 44 (0) 7973482697
http://loewecontemporary.com
catherine@loewecontemporary.com

Director Catherine Loewe
Established in 2008

Artists represented
Liane Lang (UK)

LOEWE CONTEMPORARY is a London-based art advisory and platform for innovative curatorial projects held in a variety of locations and contexts with a focus on current theories and practices. The company promotes emerging to mid-career artists in collaboration with artist-led, commercial, public, corporate and charitable organizations. Since its inception, over fifty international contemporary artists working across all media have been exhibited.

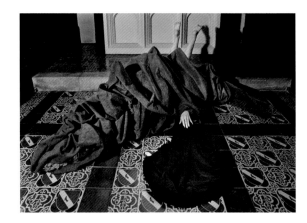

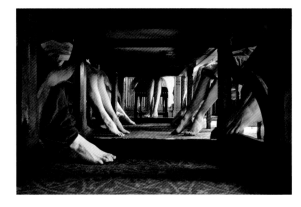

Liane Lang
St Margaret Escaping the Dragon, 2014
Analogue photographic handprint,
40 x 60 cm
Courtesy of the artist

Liane Lang
Ursula and her Virgins, 2014
Analogue photographic handprint,
40 x 60 cm
Courtesy of the artist

Liane Lang
Agatha, 2014
Analogue photographic handprint,
40 x 60 cm
Courtesy of the artist

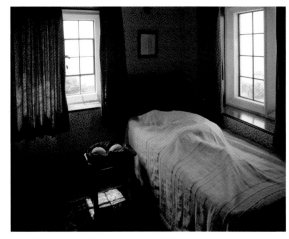

Liane Lang
Mary Lady in the Mantle, 2014
Analogue photographic handprint,
150 x 125 cm
Courtesy of the artist

Liane Lang
Agnes in the Hair Shirt, 2014
Analogue photographic handprint,
60 x 40 cm
Courtesy of the artist

Liane Lang
Benedict, 2014
Analogue photographic handprint,
60 x 40 cm
Courtesy of the artist

Liane Lang
Luminous Lucy, 2014
Analogue photographic handprint,
60 x 40 cm
Courtesy of the artist

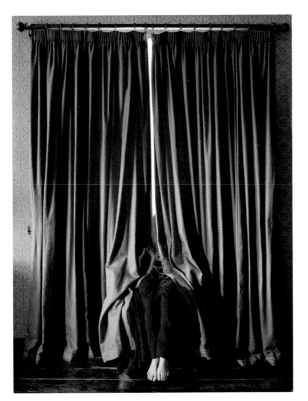
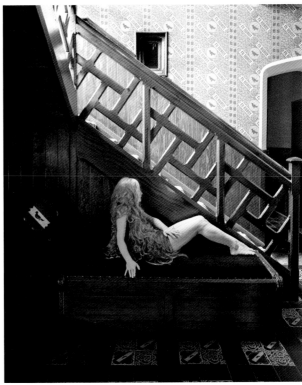
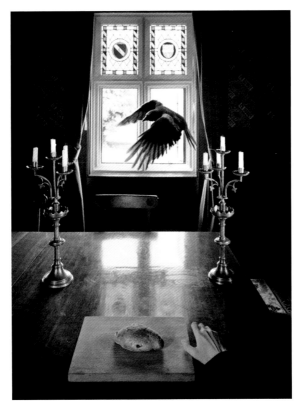

Myungil Lee
South Korea

Gallery H.A.N.
#23-4, Insadong 10-gil, Jongno-gu
Seoul, South Korea
Phone 0082 2 737 6825
Fax 0082 2 930 2111
www.gallery-han.com
hangallery55@naver.com

Director Sungwon Lee
Established in 2006

Artists represented
Eungki Kim (South Korea)
Kim Youngwon (South Korea)
Koo Sangmo (South Korea)
Rhee Kyung-Ja (South Korea)
Joonyoung Suh (South Korea)
Yang Kyeongsig (South Korea)

Gallery H.A.N. was established in January 2006. Focusing on contemporary Korean art, Gallery H.A.N. unearths gifted Korean artists working in a variety of media and styles and introduces their works to art-lovers around the world.

Myungil Lee
To Exist, or To Sustain?, 2015
Acrylic on canvas, 162 x 112 cm
Courtesy of the artist and Gallery H.A.N.

Myungil Lee
To Exist, or To Sustain?, 2014
Acrylic and stainless steel on canvas,
70.3 x 49.3 cm
Courtesy of the artist and Gallery H.A.N.

Myungil Lee
To Exist, or To Sustain?, 2015
Acrylic on canvas, 162 x 112 cm
Courtesy of the artist and Gallery H.A.N.

Myungil Lee
To Exist, or To Sustain?, 2015
Acrylic on canvas, 162 x 112 cm
Courtesy of the artist and Gallery H.A.N.

Namsa Leuba
Switzerland

Art Twenty One
1415 Adetokunbo Ademola Street,
Kuramo Waters, Victoria Island,
Lagos, Nigeria
Phone + 234 1 460 6100, ext 2558
www.art21lagos.com
info@art21lagos.com

Director Caline Chagoury Moudaber
Established in 2013

Artists represented
Olu Amoda (Nigeria)
Namsa Leuba (Switzerland)
Abraham Oghobase (Nigeria)
Gérard Quenum (Benin)

Art Twenty One is a 600 sqm space and platform dedicated to contemporary art in Lagos, Nigeria. Located at the Eko Hotels & Suites in Victoria Island, Art Twenty One is intended to contribute to and solidify the growing art scene in Lagos, as well as position the city as a major player in the international art world. An unprecedented and unique set up in Lagos, the space is designed to make art accessible to a large and growing audience who will be able to engage with a rich and diverse range of contemporary art, cultural practice, and educational art programmes.

Namsa Leuba
Untitled I (Cocktail series), 2011
Archival pigment print, 60 x 43.81 cm
Courtesy of the artist and Art Twenty One

Namsa Leuba
Untitled IV (Cocktail series), 2011
Archival pigment print, 60 x 43.81 cm
Courtesy of the artist and Art Twenty One

Namsa Leuba
Untitled V (Cocktail series), 2011
Archival pigment print, 60 x 43.81 cm
Courtesy of the artist and Art Twenty One

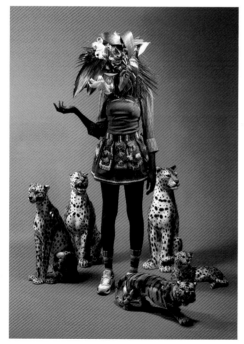

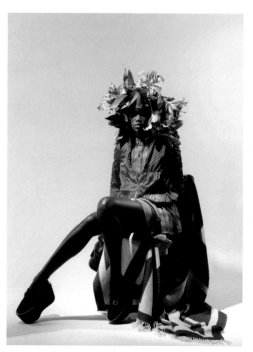

Namsa Leuba
Untitled II (*The African Queens* series), 2012
Archival pigment print, 84.1 x 59.4 cm
Courtesy of the artist and Art Twenty One

Namsa Leuba
Untitled III (*The African Queens* series), 2012
Archival pigment print, 84.1 x 59.4 cm
Courtesy of the artist and Art Twenty One

Namsa Leuba
Untitled IV (*The African Queens* series), 2012
Archival pigment print, 84.1 x 59.4 cm
Courtesy of the artist and Art Twenty One

Namsa Leuba
Untitled V (*The African Queens* series), 2012
Archival pigment print, 84.1 x 59.4 cm
Courtesy of the artist and Art Twenty One

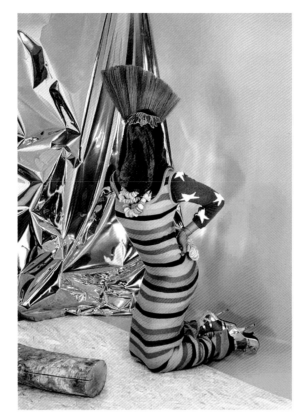

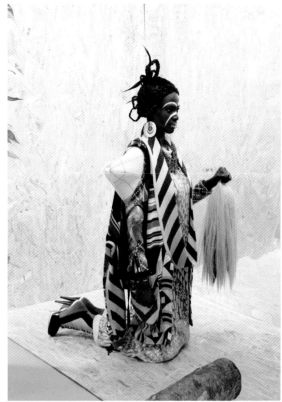

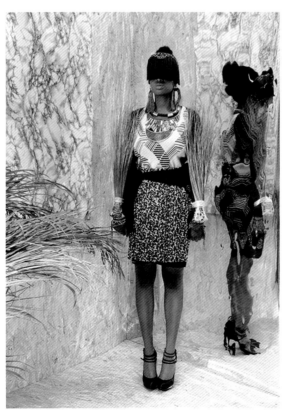

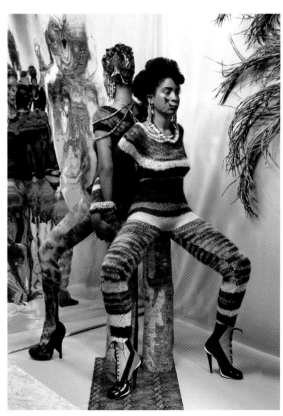

Nomusa Makhubu

South Africa

ErdmannContemporary
84 Kloof Street Gardens
Cape Town 8001, South Africa
Phone +27 21 422 2762
www.erdmanncontemporary.co.za
www.thephotographersgalleryza.co.za
photogallery@mweb.co.za
galleryinfo@mweb.co.za

Director Heidi Erdmann
Established in 2001

Artists represented
Nomusa Makhubu (South Africa)

This director-run gallery, launched in 2001 in Cape Town, is committed to the development of successful and sustainable careers. To this end it has attracted the attention of both local and international collectors, museum directors and curators. The gallery's exhibition schedule over the past fourteen years is testimony to its commitment of hosting historically relevant and content-rich exhibitions by both local and selected international artists.

Nomusa Makhubu
Inquietude I, 2009
Digital print on archival paper,
60 x 100 cm

Nomusa Makhubu
Inquietude III, 2009
Digital print on archival paper,
60 x 100 cm

Nomusa Makhubu
Inkosikazi (Queen), 2007
Digital print on archival Litho paper,
100 x 70 cm

Nomusa Makhubu
Lover, 2007
Digital print on archival Litho paper,
106 x 72 cm

Nomusa Makhubu
Ntombi (Young Girl), 2013
Digital print on archival Litho paper,
100 x 70 cm

Nomusa Makhubu
Ubuhle (Beauty), 2013
Digital print on archival Litho paper,
106 x 72 cm

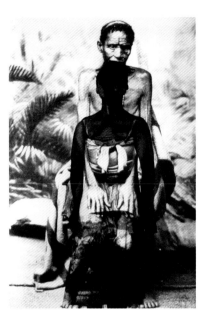
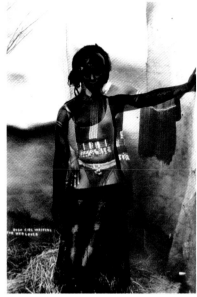
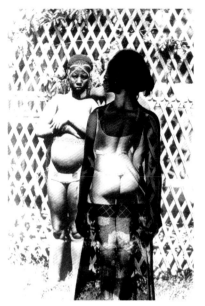
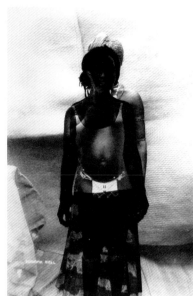

Nomusa Makhubu
Nyembezi V, 2013
Colour photograph on Hahnemühle
cotton rag paper, 60 x 79 cm

Nomusa Makhubu
Nyembezi IV, 2013
Colour photograph on Hahnemühle
cotton rag paper, 60 x 79 cm

Nomusa Makhubu
Nyembezi II, 2013
Colour photograph on Hahnemühle
cotton rag paper, 60 x 79 cm

Nomusa Makhubu
Nyembezi VII, 2013
Colour photograph on Hahnemühle
cotton rag paper, 60 x 79 cm

Pala Pothupitiye

Sri Lanka

Hempel Galleries
30/3 Barnes Place, Colombo 7,
Sri Lanka
Phone +94 777 907 321
www.hempelgalleries.com
info@hempelgalleries.com

Director Annoushka Hempel
Established in 2004

Artists represented
Pala Pothupitiye (Sri Lanka)

Hempel Galleries (HG) was founded by Annoushka Hempel in the ancient Unesco protected Dutch Galle Fort in Sri Lanka, set up to provide a platform for Sri Lankan contemporary artists. Currently the gallery runs two spaces, one in the heart of central Colombo's Cinnamon Gardens and one in Galle Fort, which represent developing and emerging artists as well as senior prize winners.
In 2009 Hempel Galleries director founded the Colombo Art Biennale (CAB), which has since run three editions and is currently regarded as one of the foremost contemporary cultural manifestations in the region. The majority of Sri Lanka's most prominent artists have exhibited either at Hempel Galleries or CAB, and CAB 2012 and 2014 hosted the largest number of artists participating in one single international art event in the country.

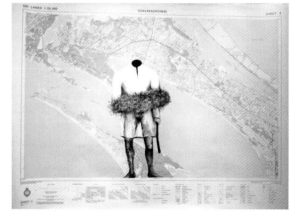

Pala Pothupitiye
Jaffna Map, 2010
Pen and ink on map, 66 x 91.5 cm
Courtesy of Hempel Galleries

Pala Pothupitiye
Chavakachcheri, 2011
Pen and ink on map, 65 x 90 cm
Courtesy of Hempel Galleries

Pala Pothupitiye
Map Underpants, 2013
29 x 21 x 19 cm
Courtesy of Hempel Galleries

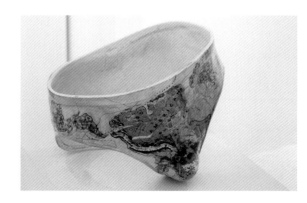

Pala Pothupitiye
Two-Legged Lion Head, Mannaya, 2015
Copper, iron, acrylic and readymade
knives, 15 x 43 cm each
Courtesy of Hempel Galleries

Pala Pothupitiye
Knife triptych with Permanent Shadows,
2015
Readymade knives, metal sheets of tar
barrels, acrylic and jack tree wood,
14 x 47 x 4 cm each
Courtesy of Hempel Galleries

Pala Pothupitiye
Keththna with Snake-Lion-Venom, 2015
Readymade Mannaya, metal sheets of tar
barrels, copper, brass, bicycle chain and
acrylic, 16 x 88 x 18 cm
Courtesy of Hempel Galleries

Pala Pothupitiye
Dagger with Saffron Venom, 2014
Acrylic on archival paper, 16 x 12 cm
Courtesy of Hempel Galleries

Pala Pothupitiye
Power & Pride, Venom & Violence 04, 2015
Archival ink and colour pencil on acid free
archival watercolour paper, 77 x 56 cm
Courtesy of Hempel Galleries

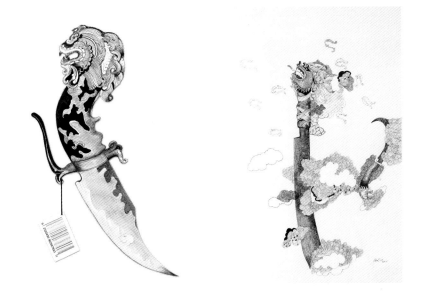

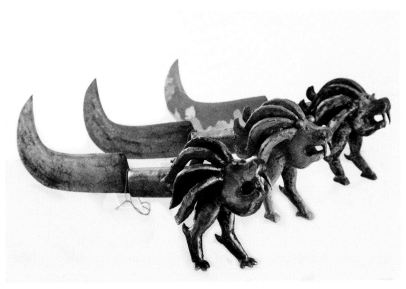

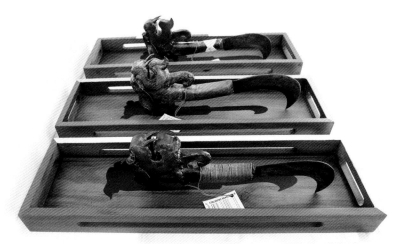

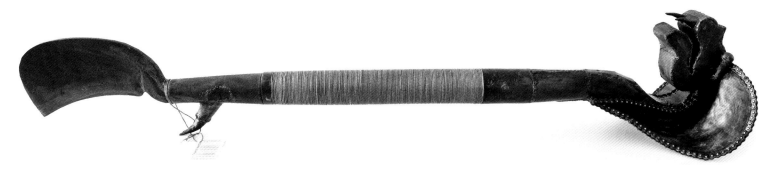

Hannah Quinlan Anderson & Rosie Hastings (@Gaybar), featuring Holly White, Ann Hirsch

UK

Arcadia Missa
Unit 6 Bellenden Road Business
Centre, 108–110 Bellenden Road
London, UK
www.arcadiamissa.com
info@arcadiamissa.com

Director Rozsa Farkas
Established in 2011

Artists represented
Maja Cule (Hungary/USA)
Jesse Darling (UK)
Ann Hirsch (USA)
Harry Sanderson (Germany/UK)
Amalia Ulman (Spain/USA)

Arcadia Missa is focused on art with intent, showcasing critical artists who are situated "after the Internet". Arcadia Missa began as a self-organized space in 2011, programming and publishing integral emerging artists and conversations. As the space evolved, and after much national and international acclaim, last year Arcadia Missa began to represent artists.

Hannah Quinlan Anderson
& Rosie Hastings
If These Fossils Could Talk They Would Tell You Who Got Fucked And Who Didn't, 2015
Laser etched toughened glass,
59.4 x 84.1 cm
Installation view, 2015
Courtesy of the artists and Arcadia Missa

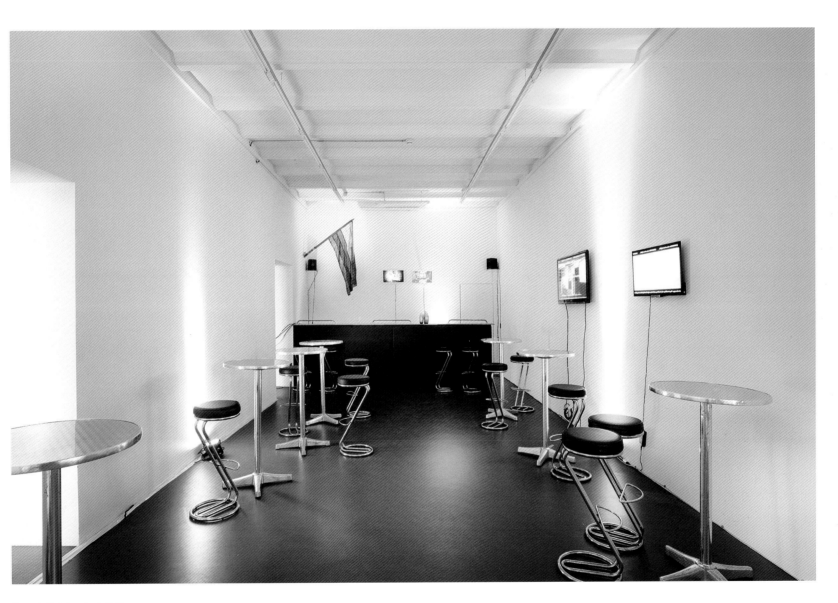

Hannah Quinlan Anderson
& Rosie Hastings
Cruising Extinction @Gaybar, 2015
HD videos, functional bar, bar equipment
and furniture, dimensions variable
Installation view, 2015
Courtesy of the artists and Arcadia Missa

Aida Silvestri

UK / Eritrea

Roman Road
69 Roman Road
E2 0QN London, UK
Phone +44 (0) 208 981 7075
www.romanroad.com
Info@romanroad.com

Director Marisa Bellani
Established in 2013

Artists represented
Antony Cairns (UK)
Thomas Mailaender (France)
Aida Silvestri (UK / Eritrea)

Founded in 2013 by Marisa Bellani, Roman Road is a contemporary art gallery committed to bolstering the talents of up-and-coming and mid-career artists. Located in the East End of London, the gallery endeavours to inspire its audiences to connect with emerging art today through innovative solo and group exhibitions and intriguing displays. With a focus on photography amongst other media including sculpture, painting and installation, Roman Road strives to impart and reinforce an "experience" of art in all its curated projects. In addition to internal exhibitions, the gallery conceives and achieves international pop-up shows and participates in prominent art fairs.

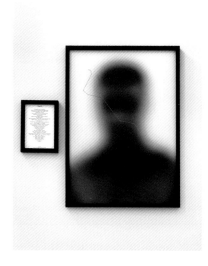

Aida Silvestri
Aman / Aman poem, 2014
Giclée print on paper, 84.5 x 60 cm
and 25 x 17.7 cm
Courtesy of Charles Hosea

Aida Silvestri
Anghesom / Anghesom poem, 2013
Giclée print on paper, 84.5 x 60 cm
and 25 x 17.7 cm
Courtesy of Charles Hosea

Aida Silvestri
Bereket / Bereket poem, 2013
Giclée print on paper, 84.5 x 60 cm
and 25 x 17.7 cm
Courtesy of Charles Hosea

Aida Silvestri
Biniam / Biniam poem, 2014
Giclée print on paper, 84.5 x 60 cm
and 25 x 17.7 cm
Courtesy of Charles Hosea

Aida Silvestri
Dawit / Dawit poem, 2013
Giclée print on paper, 84.5 x 60 cm
and 25 x 17.7 cm
Courtesy of Charles Hosea

Aida Silvestri
Henok / Henok poem, 2014
Giclée print on paper, 84.5 x 60 cm
and 25 x 17.7 cm
Courtesy of Charles Hosea

Aida Silvestri
Kidan / Kidan poem, 2013
Giclée print on paper, 84.5 x 60 cm
and 25 x 17.7 cm
Courtesy of Charles Hosea

Aida Silvestri
Rehsom / Rehsom poem, 2013
Giclée print on paper, 84.5 x 60 cm
and 25 x 17.7 cm
Courtesy of Charles Hosea

Aida Silvestri
Samrawit / Samrawit poem, 2013
Giclée print on paper, 84.5 x 60 cm
and 25 x 17.7 cm
Courtesy of Charles Hosea

Aida Silvestri
Samuel / Samuel poem, 2013
Giclée print on paper, 84.5 x 60 cm
and 25 x 17.7 cm
Courtesy of Charles Hosea

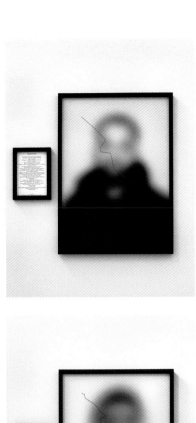
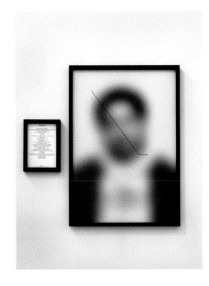
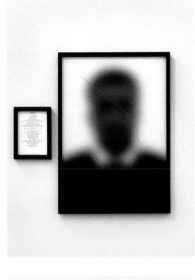
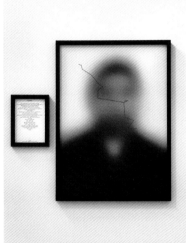
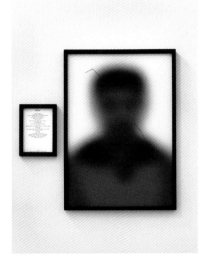
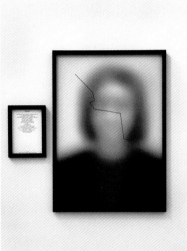
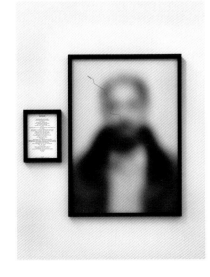
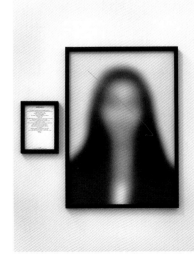
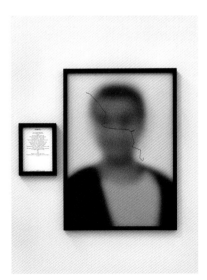

Morten Viskum

Norway

UNION Gallery
94 Teesdale Street,
E2 6PU London, UK
Phone +44 (0) 20 7730 9119
www.uniongallery.com
jari@uniongallery.com

Director Jari Lager
Established in 2003

Artists represented
Shane Bradford (UK)
Soon Hak Kwon (South Korea)
Mike Marshall (UK)
Kieran Moore (Ireland)
Matthew Stone (UK)
Rose Wylie (UK)

Jari Lager established UNION Gallery in 2003 at Teesdale Street, Bethnal Green, East London. Hosting both emerging and established artist exhibitions, the gallery maintains a commitment to both its represented artists and to the showcasing of new talent. UNION's core focus is supporting British and international artists who live and work in London, bringing together different generations who work in a variety of media, formal languages and conceptual methods.
Continuing its ambitious programming throughout 2015, the gallery has presented interactive digital works by Martelli/Gibson, paintings by Rose Wylie and the conceptual installations of Clay Arlington, with sculptural and photographic works by Brian Reed and Mike Chavez-Dawson forthcoming.

Morten Viskum
I am Charlie, 2015
Life-size silicon and resin sculpture,
three framed works on paper,
dimensions variable
Courtesy of the artist

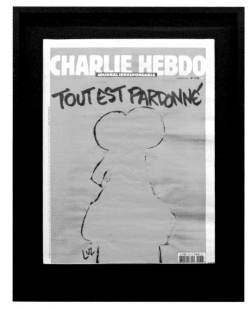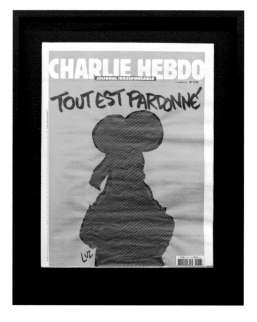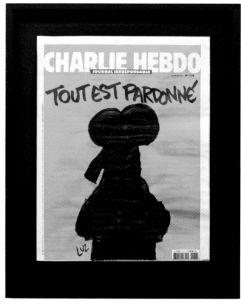

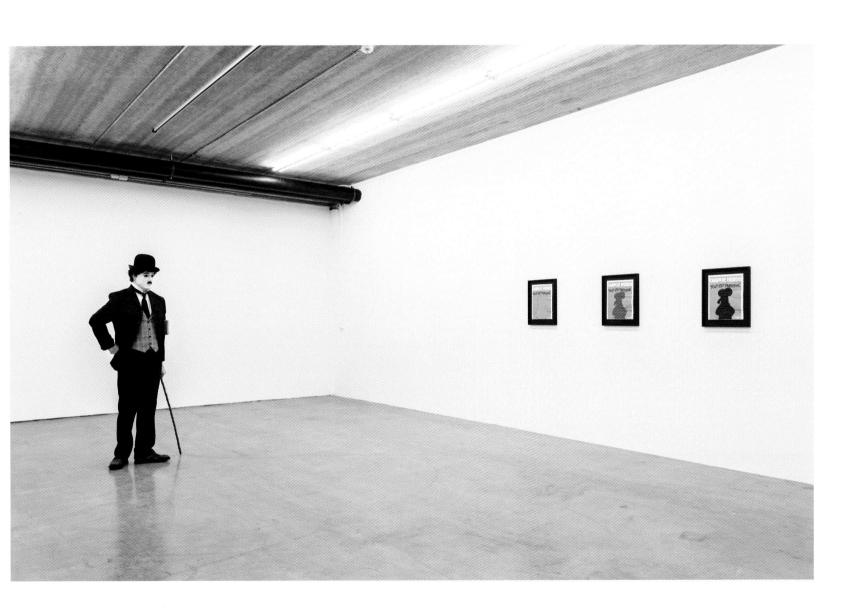

Morten Viskum

David Ben White

UK

l'étrangère
44a Charlotte Road
EC2A 3PD London, UK
Phone +44 (0) 20 7729 9707
www.letrangere.net
mail@letrangere.net

Director Joanna Mackiewicz-Gemes
Established in 2015

Artists represented
Filip Berendt (Poland)
Jyll Bradley (UK)
Małgorzata Markiewicz (Poland)
Joanna Rajkowska (Poland)
Marek Szczęsny (Poland)
Anita Witek (Austria)

Launched in 2015 by Joanna Mackiewicz-Gemes, l'étrangère is a contemporary art gallery based in Shoreditch, East London. The idea of l'étrangère addresses the philosophical, political, social and personal connotations of being a stranger in one's own country. It suggests a displacement, searching for and re-defining one's own identity, being an outsider, the "other", whilst also pointing to the strange and the uncanny.
l'étrangère works with artists who identify with these ideas through addressing issues of identity, exposing and embracing the "other", investigating and questioning the status quo, and combating the contemporary world that is described by Polish sociologist Zygmunt Bauman as a liquid modernity.

David Ben White
Indisde Outside 9, 2015
Mixed media, 123 x 123 cm
© David Ben White, courtesy of l'étrangère

David Ben White
Inside Outside 10, 2015
Mixed media, 123 x 123 cm
© David Ben White, courtesy of l'étrangère

David Ben White
Inside Outside 11, 2015
Mixed media, 123 x 123 cm
© David Ben White, courtesy of l'étrangère

David Ben White
Inside Outside 12, 2015
Mixed media, 123 x 123 cm
© David Ben White, courtesy of l'étrangère

David Ben White
Personification of an Ideal (Howardena), 2015
Mixed media, 123 x 96 cm
© David Ben White, courtesy of l'étrangère

David Ben White
Outside Inside 6, 2015
Mixed media, 122 x 80 cm
© David Ben White, courtesy of l'étrangère

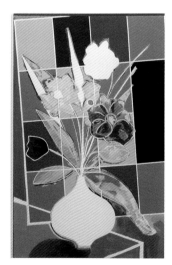

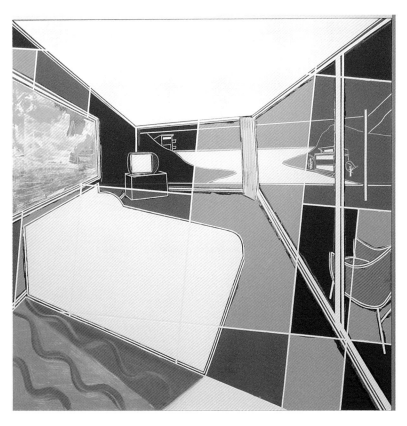
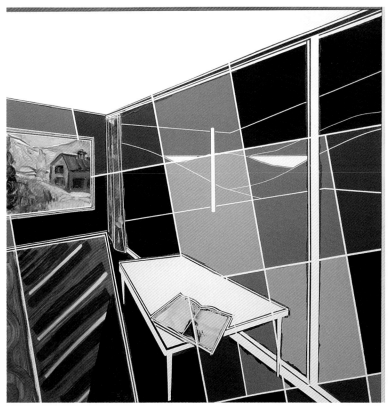
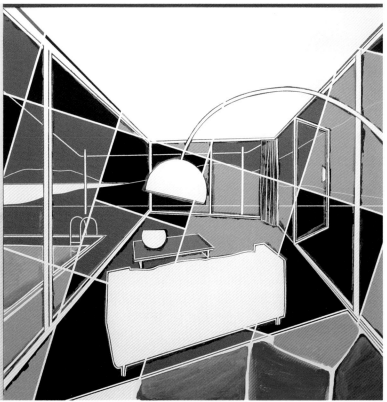
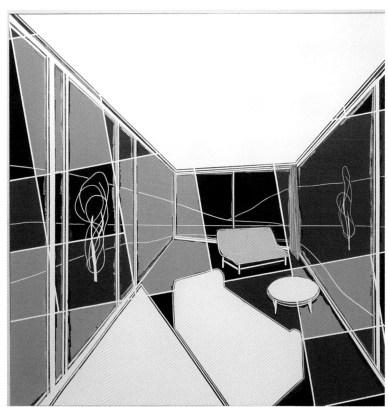

START Projects

teamLab

Tokyo, Japan

teamLab's installation in START Projects is a fully immersive environment. Within this all-encompassing environment there are three individual works.

Flowers and People, Cannot be Controlled but Live Together – A Whole Year, Dark
teamLab, 2015, interactive digital installation

This installation consists of a mirrored walkway and a large open space. Over the course of one year a seasonal year of flowers are depicted. The work is being rendered in real time, it is not a pre-recorded animation or loop. The flowers spring up, grow, bud and blossom before their petals scatter and the flowers wither and fade away. The cycle of growth and decay repeats itself in perpetuity. The viewer's behaviour (making sudden movements or standing still) affects the cycle, causing the flowers to either wither and die, or spring up and blossom. The interaction between the viewer and the installation causes continuous change in the work; previous visual states can never be replicated, and will never reoccur. What you can see right now will never be repeated again in the future. When teamLab visited the Kunisaki Peninsula in spring, many cherry trees were in blossom in the mountains, and rape was in flower in the fields. We began to wonder how many of these flowers were cultivated by people, and how many were natural. This place, which was simply overflowing with flowers, gave us great contentment. It also made us realize that this large number of flowers is an ecosystem that is subject to human intervention. The boundary between nature's work and the work of humans was unclear. In other words, nature and humans are not antagonistic concepts, but rather, a pleasant nature is an ecosystem that also includes the work of humans. Unlike today, we could say that the work of humans over many years has been based on nature's predetermined rules that humans were unable to understand or control; this has contributed to the creation of this pleasant nature. In pre-modern times, civilizations flourished and prospered along sea routes, nowadays our focus has moved inland, but we feel that hidden in secluded valleys of human habitation, there is still something left of the pre-modern relationship between humans and nature. We also began to wonder what kind of behaviour would constitute artificial behaviour toward nature, based on this premise that nature cannot be controlled, and whether these behaviours could perhaps give us a hint for the future.

Ever Blossoming Life II – Dark
teamLab, 2015, digital work, endless

This artwork is being created in real time by a computer programme. The images are not pre-recorded or played back. Flowers are born, grow and blossom in profusion before the petals scatter and the flowers wither and fade away. The cycle of birth and death repeats itself, continuing for eternity. The entire work continues to change and the same state will never be repeated again.

This artwork is an edition of 10, each work has its own life, producing different flowers, thus making it effectively a unique piece of work. The artwork is created in two versions: one with Gold background and another with Dark background. Each version is issued in an edition of 10 plus 2 APs.

Flutter of Butterflies beyond Borders
teamLab, 2015, digital work, endless

The flutter of butterflies fly across and through the other works eliminating the boundaries between them. The butterflies' flight is altered by the state of the artwork and the behaviour of the viewer. The artwork is being created in real time by a computer programme. The images are not pre-recorded or played back. The entire work continues to change and the same state will never be repeated again.

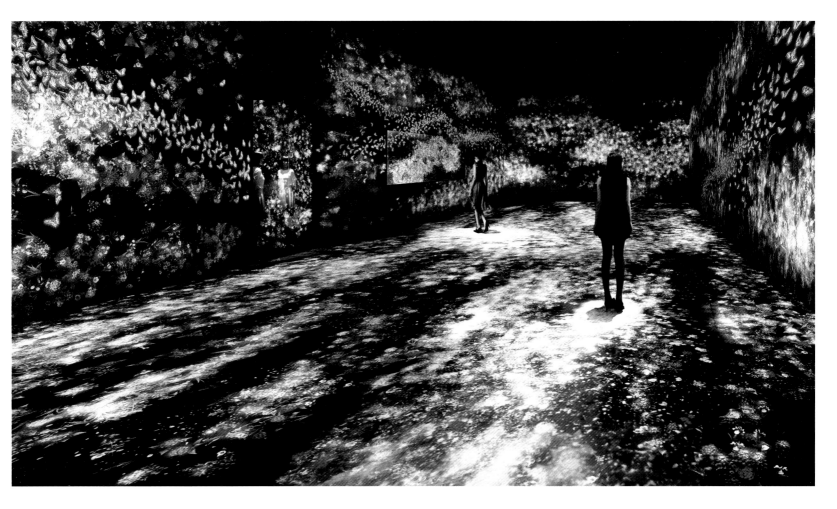

teamLab
Flutter of Butterflies beyond Borders
http://www.team-lab.net/latest/
exhibition/saatchi2015.html

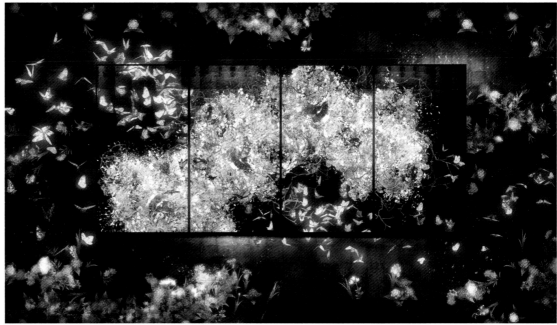

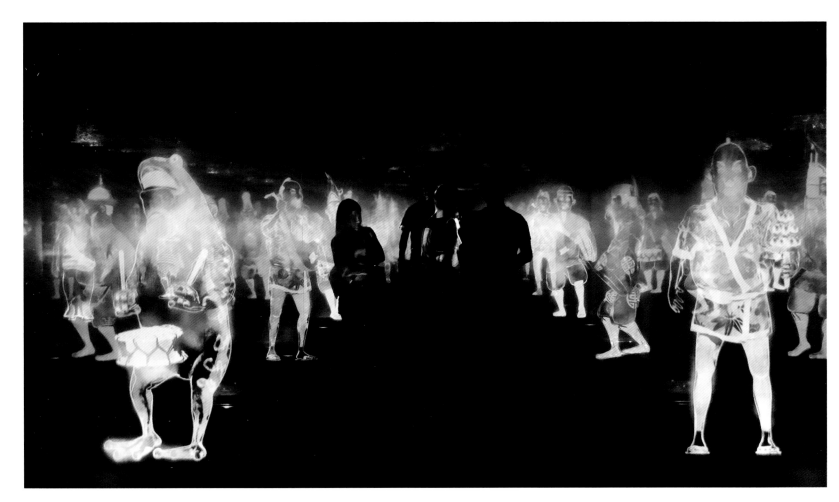

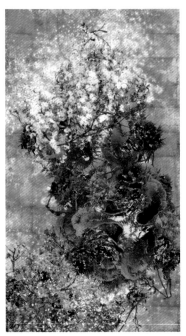

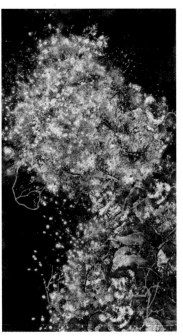

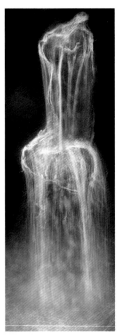

teamLab
Peace can be Realized Even without Order
http://www.team-lab.net/en/all/art/
peace_sg.html
Interactive digital installation
Sound: Hideaki Takahashi
Voices: Yutaka Fukuoka, Yumiko Tanaka
© teamLab

teamLab
Ever Blossoming Life – Gold
http://www.team-lab.net/en/all/art/
everblossominglife.html
Digital work, endless
© teamLab 2014

teamLab
Ever Blossoming Life – Dark
http://www.team-lab.net/en/all/art/
everblossominglife_dark.html
Digital work, endless
© teamLab 2014

teamLab
Universe of Water Particles
http://www.team-lab.net/en/all/
art/uowp.html
Digital work, 1920 x 5400 pixels
© teamLab 2013

teamLab
Cold Life
http://www.team-lab.net/en/all/art/
coldlife.html
Digital work, 2160 x 3840 pixels,
7'15'' (loop)
Calligraphy: Sisyu
© teamLab 2014

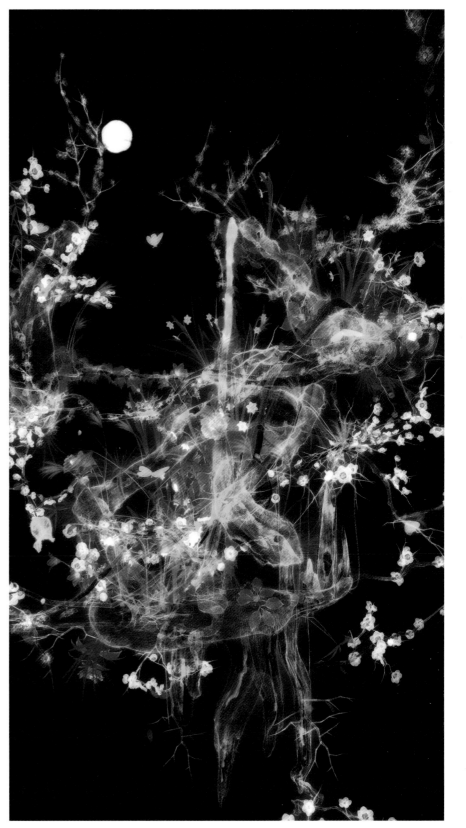

Chim↑Pom

Tokyo, Japan

Chim↑Pom is an artist collective formed in Tokyo in 2005, composed of Ushiro Ryuta, Hayashi Yasutaka, Ellie, Okada Masataka, Inaoka Motumu and Mizuno Toshinori. All the participants in the collective were in their twenties when it was formed. The group came together because they wanted to respond to the specific social and cultural realities of living in Japan at that time, using an instinctive approach to making art. Since then, Chim↑Pom has made works that intervene in contemporary society and that often carry strong social messages interweaved with a humorous, questioning mode of address. The group use video as their primary mode of making work but also create installations, whilst the performative is central to their practice and their identity as artists. They have also expanded their activities into directing art magazines and curating exhibitions.

This solo exhibition is the result of the group winning Emerging Artist of the Year at the second Prudential Eye Awards in January 2015. They also won the category for Best Emerging Artist Working with Digital and Video. The exhibition consists of works that come together through the concept of "post-Fukushima", a theme they see as being central to contemporary Japanese art. The exhibition will include *BLACK OF DEATH*, a film that features the collective herding an ever-growing crowd of crows over Tokyo's landmarks by using a stuffed crow and a megaphone that amplifies a crow's call. Originally made between 2007 and 2008, a later version filmed in 2013 was set partly in the ex-evacuation zone of Fukushima that has been uninhabited since the Great East Japan Earthquake of 2011. A related work, *REALTIMES* was filmed whilst Chim↑Pom trespassed into high-security areas of towns uninhabited due to the Fukushima nuclear accident. The group headed for a lookout point on the site of the TEPCO (Tokyo Electric Power Company) around 700 metres away from the Fukushima Daiichi Nuclear Power Station. The group stretched out a white flag, sprayed the red circle of the Japanese flag onto it before altering it to look like a radiation symbol, before finally raising it as a flag to make a "pole of inaccessibility". The concept of "post-Fukushima" has moved contemporary Japanese art away from concerns such as the post-pop, which a previous generation of Japanese artists focused on. In its place, Chim↑Pom has been more concerned with themes such as the issues related to urbanization, mass consumerism, the legacy of war and the way peace is conceptualized. Despite the weightiness of these concerns, Chim↑Pom's work is simultaneously optimistic, playful and looks to the future.

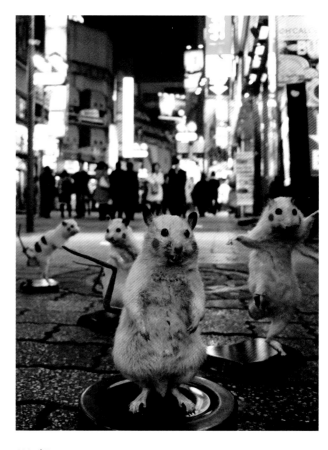

Chim↑Pom
SUPER RAT, 2006
© Chim↑Pom, courtesy of MUJIN-TO
Production, Tokyo

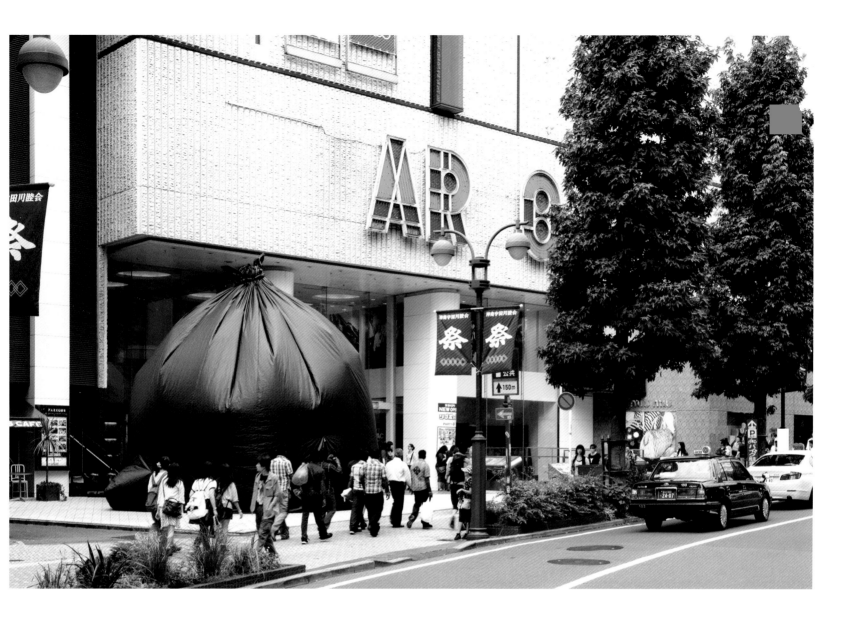

Chim↑Pom
Gold Experience, 2012
Photo Kenji Morita
© Chim↑Pom, courtesy of MUJIN-TO
Production, Tokyo

Chim↑Pom
Making the sky of Hiroshima "PIKA!", 2009
© Chim↑Pom, courtesy of MUJIN-TO
Production, Tokyo

Chim↑Pom
BLACK OF DEATH (above the Diet Building,
Nagatacho, Tokyo), 2008
© Chim↑Pom, courtesy of MUJIN-TO
Production, Tokyo

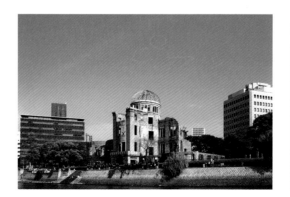
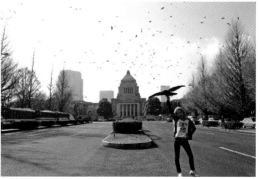

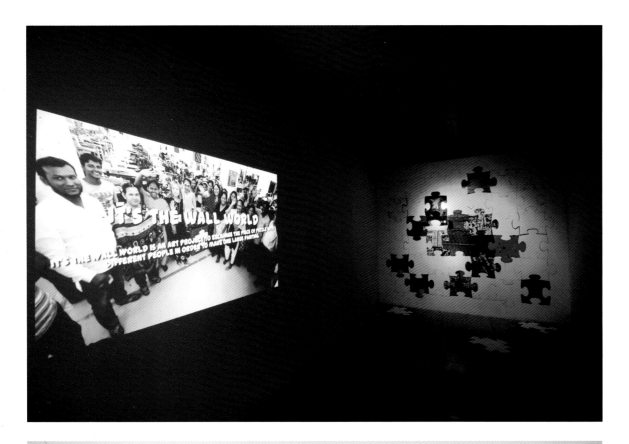

Chim↑Pom
It's the Wall World, Asia Art Biennale,
Bangladesh, 2014
© Chim↑Pom, courtesy of MUJIN-TO
Production, Tokyo

Chim↑Pom
It's the Wall World, White Rainbow Gallery,
London, 2015
© Chim↑Pom, courtesy of MUJIN-TO
Production, Tokyo

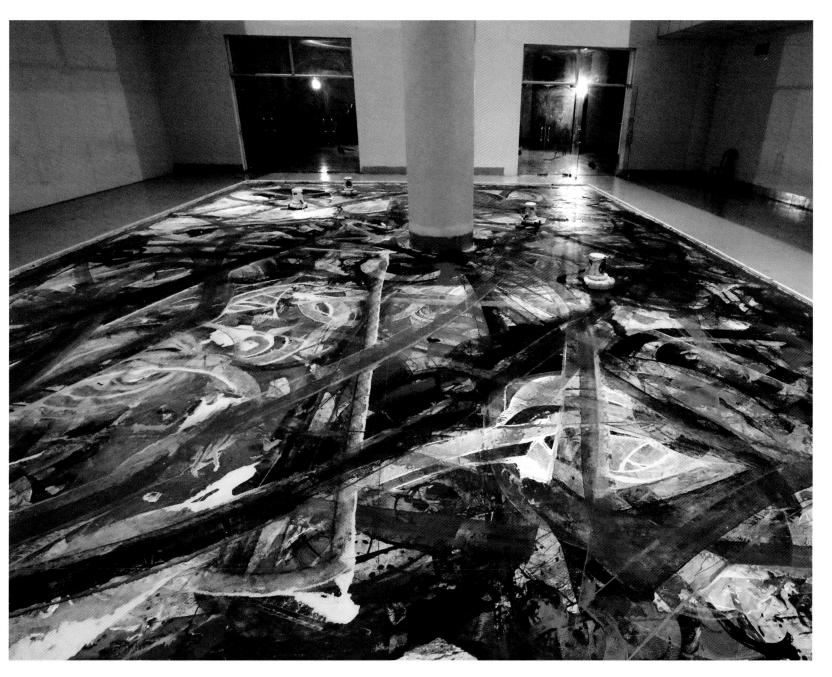

Chim↑Pom
Downtown Paradox, 2014
© Chim↑Pom, courtesy of MUJIN-TO
Production, Tokyo

Chim↑Pom
REAL TIMES, 2011
© Chim↑Pom, courtesy of MUJIN-TO
Production, Tokyo

Petroc Sesti

London, UK

"Whether one is looking into the human eye and the intricacy of the brain, questioning the creative and destructive function of Black Holes or contemplating the vastness of open space, we soon collide with the extreme complexity and the limit of our capacity to understand and comprehend such things. The Void features in my figurative sculpture, photography and painting, it acts as a kind of portal or entrance that seeks to activate the viewers' vital curiosity, heightening their awareness. Emptiness in my work pays tribute to outer space and the workings of the Universe at large, often understood as the ultimate void – they are in fact not empty at all but rich, complex and permeable."
Previous artworks have been shown at or are part of the following permanent collections: the Louis Vuitton Foundation in Paris, the Kistefos-Museet, Norway, Boghossian Foundation, Belgium, the new Qatar Foundation HQ in Doha by Rem Koolhaas, the Beyond Museum, South Korea, MONA Museum, Australia, and "Sculpture in the City", the annual outdoor public exhibition in London's financial district.

Literal Form, 2015
Perpetual movement sculpture

Literal Form by Petroc Sesti is composed of a large transparent sphere containing a swirling vortex. The sculpture bends light like a prism, refracting and inverting the light that passes through it, presenting the public with the largest spherical artwork of its kind.
Petroc Sesti is a permanent ambassador for the Prudential Eye

Programme, a member of Prudential Eye selection committee and an active supporter of their philanthropic activity. Petroc Sesti Studio has been asked to sponsor and loan *Literal Form* as a special-exhibit to START at the Saatchi Gallery. The installation seeks inspire young emerging artists. *Literal Form* will be exhibited in Singapore in January during the Prudential Eye Awards in 2016.

Timefold, "Sculpture in the City", Aviva Square, London, 2013

Inspired by Optics and Cosmology, Petroc Sesti presents us with a study of a perpetual moving void. Challenging the idea of statics in sculpture, it presents the viewer with a new form of flux, where chaos and order are in constant dialogue.

Timefold, "Sculpture in the City", Aviva Square, London, 2013

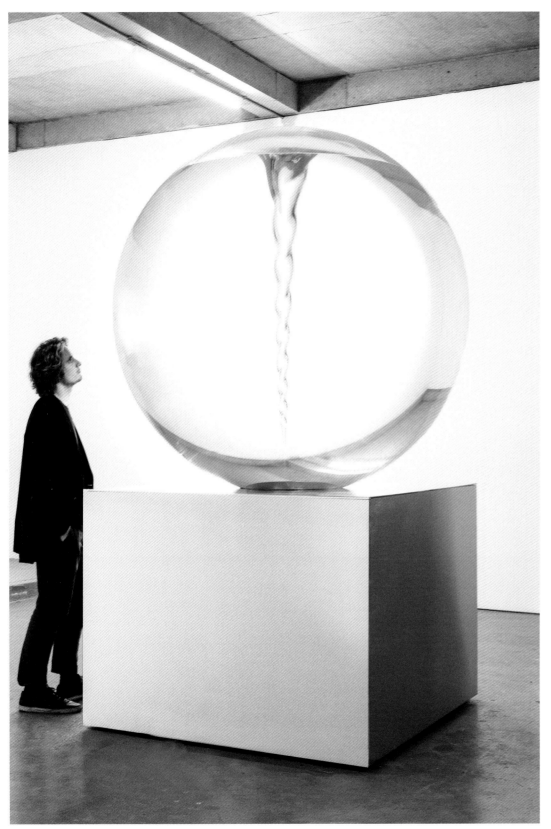

Literal Form, 2015
Aerospace sphere, optic fluid,
turbine, stainless steel plinth,
3 x 1.8 x 1.8 m

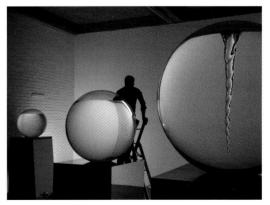

Petroc Sesti Studio, London, 2015

Sisley-L

South Korea

Brodin A. M. Gallery
45, Pangyo-ro 209 beon-gil,
Bundang-gu, Seongnam-si,
Gyeonggi-do, South Korea
Phone (82) 10 2401 3351
Fax (82) 2 790 6870
www.brodinasset.com
Bean068@naver.com

Director S. W. Kim
Established in 2008

Artists represented
Sisley-L (South Korea)

Brodin A. M. is a good example of a new way of working with artists that goes beyond the traditional gallery model, seeing itself more as a company rather than a gallery. It works to break down the barrier between art, visual culture and entertainment, seeking to re-define the category of art. In this, it exemplifies the cross-cultural approach to the arts that has been typified by recent creative output in Korea. Brodin A. M. has coined the term "Artainment" to describe their approach that focuses on not just fine art but also performance and popular culture.

Sisley-L
Portrait of a Generation, 2015
Oil on canvas, 130 x 130 cm
Courtesy of the artist

Sisley-L
A bee on the flowers (portrait of a generation), 2015
Oil on canvas, 130 x 130 cm
Courtesy of the artist

Sisley-L
A bee on a flower (portrait of a generation), 2015
Oil on canvas, 130 x 130 cm
Courtesy of the artist

Sisley-L
A bee and man (portrait of a generation), 2015
Oil on canvas, 130 x 130 cm
Courtesy of the artist

Sisley-L
A bee on the silver (portrait of a generation), 2015
Oil and acrylic on canvas, 72.7 x 90.9 cm
Courtesy of the artist

The Prince's School of Traditional Arts

London, UK

19-22 Charlotte Road
EC2A 3SG London, UK
Phone +44 (0) 20 7613 8500
www.psta.org.uk
sam.toolan@psta.org.uk

Director Dr Khaled Azzam
Established in 2004

Artists featured
Jethro Buck (UK)

Artists represented
Jethro Buck (UK)

The Prince's School of Traditional Arts was founded by HRH The Prince of Wales in 2004 as one of his core charities. As a leading education provider in the traditional arts, the School offers a range of education programmes, from full-time postgraduate degrees to one-day introductory workshops. All of the School's education programmes encourage an awareness of the holistic nature of the traditional arts, where inspiration is derived from the highest sources, and skill and dedication create masterpieces recognized as part of our world heritage.

The School continues its role as Education Partner to START. As part of this partnership, the School will showcase the work of Jethro Buck in a solo presentation at START. Buck completed an MA in Traditional Arts in 2014, during which he developed his interest in Indian miniature painting, which he infuses with a contemporary sensibility. Buck won the 2014 Ciclitira Prize and enjoyed a sell-out graduation show at the School that year. At START he will present new work that draws on a number of influences in addition to Indian miniature painting, including seventeenth-century Rajasthan Tantric Art, the tree art of the Gond people, Samuel Palmer and Henri Matisse. In Buck's words, his new works "broach the mystical yet perplexing concept of creation and the associated stories and mythologies that are inspired by it".

Jethro Buck
Bull Finch, 2015
Pigment gum and watercolour
on antique Indian paper, 21 x 20 cm
Courtesy of the artist

Jethro Buck
The Forest, 2014
Pigment, gum Arabic on Sanganir paper,
93 x 75 cm
Courtesy of the artist

Jethro Buck
Creation 1 Genesis, 2015
Pigment, gum Arabic and gold
on Sanganir paper, 72 x 55 cm
Courtesy of the artist

Jethro Buck
∞, 2015
Gilded gold and egg tempera on gesso
panel, 36 x 36 cm
Courtesy of the artist

Jethro Buck
377 Suns, 2015
Shell gold and black pigment on Wasli
paper, 20 x 20 cm
Courtesy of the artist

Eye Zone

Chen Sai Hua Kuan

Singapore

Chen Sai Hua Kuan was born in 1976
in Singapore, where he lives and
works. He graduated with a diploma in
Fine Art from LASALLE College of the
Arts and a Master in Fine Art from the
Slade School of Fine Art, University
College London. Sai's art practices
span across a range of media and
techniques including drawing, film,
performance, photography, sculpture,
sound and installation. The exploration
of space and time in relation to
architectural issues is a recurring
interest that can be found in his
practice, and his work is often
subversively and whimsically
assembled and deconstructed out
of everyday objects such as earth,
travelling fans and toys.

Chen Sai Hua Kuan
Bottles and Fans, 2010
Sound installation, dimensions variable
Courtesy of the artist

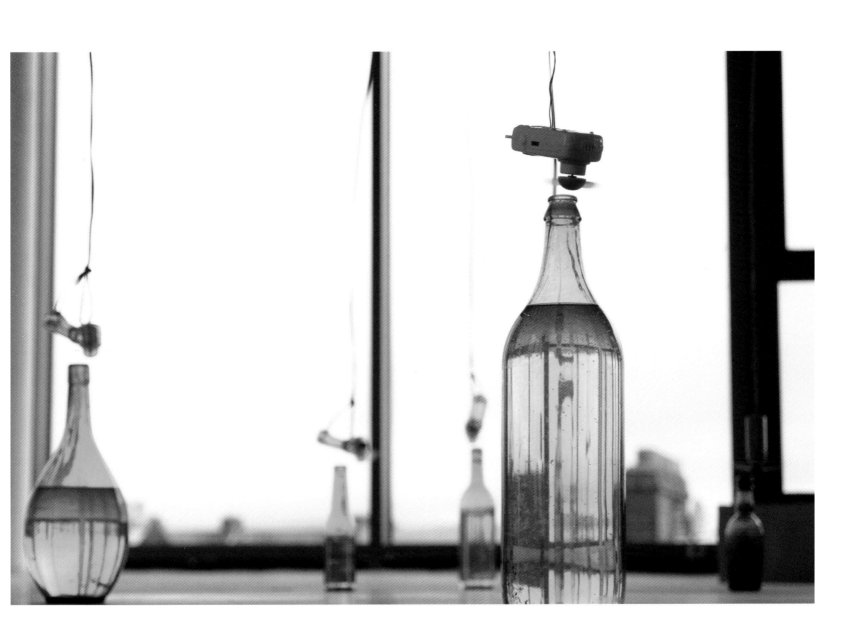

Chia Ming Chien

Singapore

"*Wires* and *Architecture* explore the 'being of seeing': how one's being affects what one sees. The 'chaos of wires', synonymous with many Asian cities today, is criticized by residents as despoiling the cityscape. But with a different set of eyes, the mundane is transformed. This begs the question: what do we preserve when transforming an old city into a modern one? Architecture searches for the 'poetry' in a building. My approach is that of a photojournalist: photograph what you see in-situ without manipulating the image. The 'decisive moment' when a subject transforms from mundane to remarkable occurs in the mind."

Chia Ming Chien
Wires – Abstract #1, 2010
Photograph, 76.2 x 50.8 cm
Courtesy of the artist

Chia Ming Chien
Wires – Abstract #2, 2010
Photograph, 76.2 x 50.8 cm
Courtesy of the artist

Chia Ming Chien
Wires – Highway #3, 2010
Photograph, 76.2 x 50.8 cm
Courtesy of the artist

Chia Ming Chian
Wires – Chaos #3, 2010
Photograph, 42 x 59.4 cm
Courtesy of the artist

Chia Ming Chien
Wires – Abstract Construction, 2010
Photograph, 50.8 x 76.2 cm
Courtesy of the artist

Chia Ming Chien
Wires – Connection #1, 2010
Photograph, 50.8 x 76.2 cm
Courtesy of the artist

Chia Ming Chien
Wires – Chaos #3, 2010
Photograph, 50.8 x 76.2 cm
Courtesy of the artist

Jane Lee

Singapore

"I am interested in discovering the true meaning of a painting: from what constitutes a painting to how paintings can be constructed and how the medium's essence and real meaning can be extracted. I believe paint has a life of its own, the materiality has stories to tell. It's like a crying child trapped behind the picture's surface for a long period of time, waiting for his or her abilities and potential to be discovered and unleashed – to reveal what's possible rather than being purely a medium."

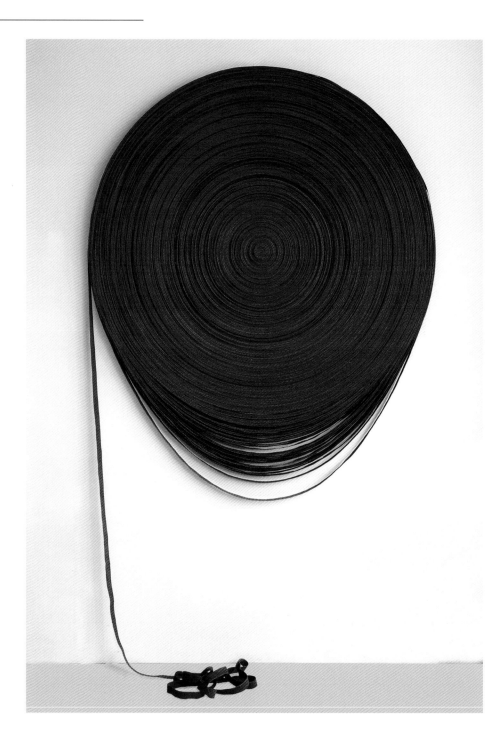

Jane Lee
Turned Out I, 2009
Cut-out canvas, dimensions variable
Courtesy of the artist

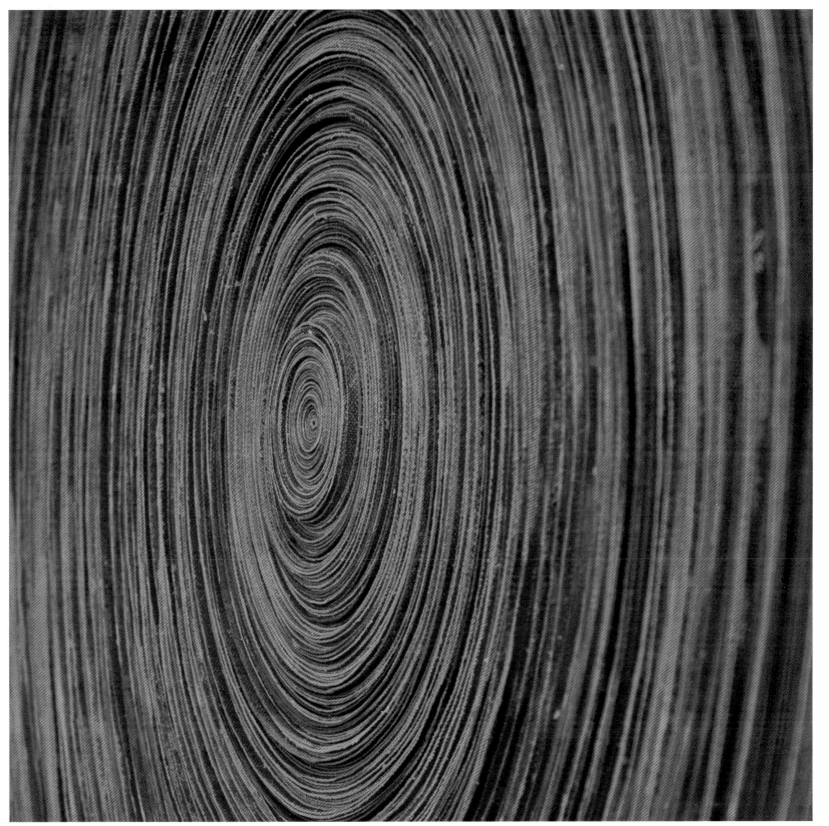

Sean Lee

Singapore

Since 2010, I have been routinely choreographing performances and situations between my father, my mother and me. I used to think I knew what I was doing with the making of these images, but as time passed I became less certain. At times they seem to speak to me about the dreams and nightmares of childhood; more often, however, they make me wonder about the strangeness of being a human organism and the mystery of being a family, of belonging to a lineage. I continue to photograph my parents because they are the only people who occur to me without my own choosing."

Sean Lee
Shauna Series 010, 2007–09
Photographic print, dimensions variable
Courtesy of the artist

Sean Lee
Shauna Series 008, 2007–09
Photographic print, dimensions variable
Courtesy of the artist

Sean Lee
Shauna Series 002, 2007–09
Photographic print, dimensions variable
Courtesy of the artist

Sean Lee
Shauna Series 038, 2007–09
Photographic print, dimensions variable
Courtesy of the artist

Sean Lee
Shauna Series 021, 2007–09
Photographic print, dimensions variable
Courtesy of the artist

Sean Lee
Shauna Series 026, 2007–09
Photographic print, dimensions variable
Courtesy of the artist

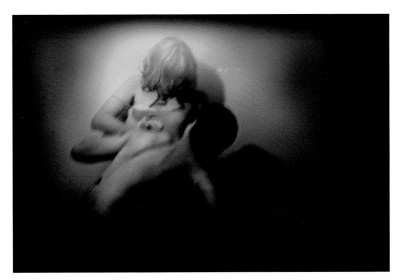 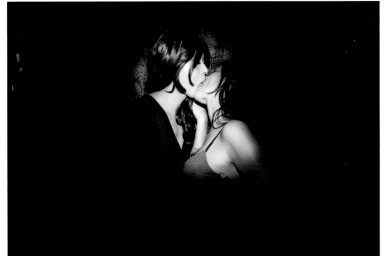

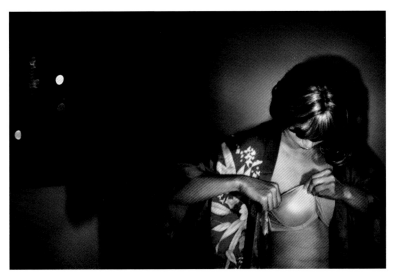 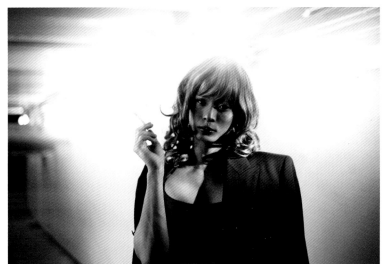

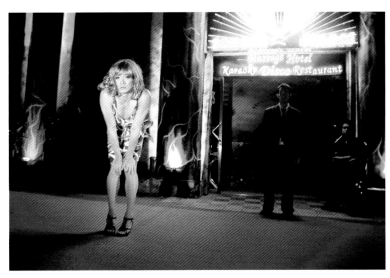 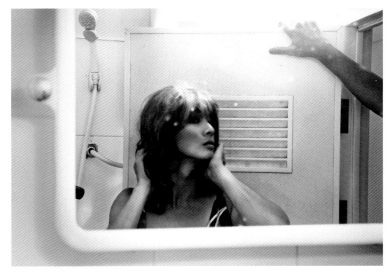

Lee Wen

Singapore

"To me, my work is basically about
making images and I see myself as
an image maker. Walter Benjamin
talks about how all of us are actually
image makers, image being the word
for imagination. We make images in
order to communicate to each other.
Even when we use words we are at the
same time composing images for
others to see. Even in a performance,
I see myself making images with my
body, the objects I use and the space
I walk around. Of course, the Chinese
language is literally that, because
every single word is an image."

Lee Wen
Ping Pong Go-Round, 2013
Performance and mixed media installation,
76 x Ø 580 cm
Courtesy of iPRECIATION

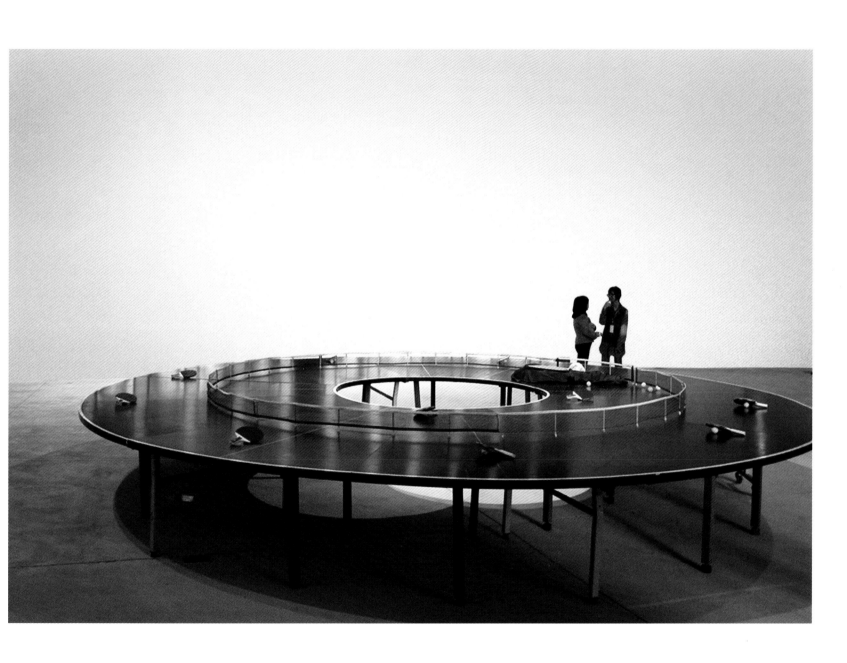

Gerald Leow

Singapore

Gerald Leow uses found objects from
the cultural landscape and reworks
them to shed light on the problematic
nature of authenticity, culture and
identity. His interests include
anthropology and the study of material
cultures. Gerald was included in
The Singapore Show: Future Proof, the
Singapore Art Museum at 8Q, 2010,
and has been The Substation's
Associate Artist for 2014.

Gerald Leow
The Decline of the Western Civilisation,
2010
Sculpture, 101.6 x 274.3 x 7.6 cm
Courtesy of the artist

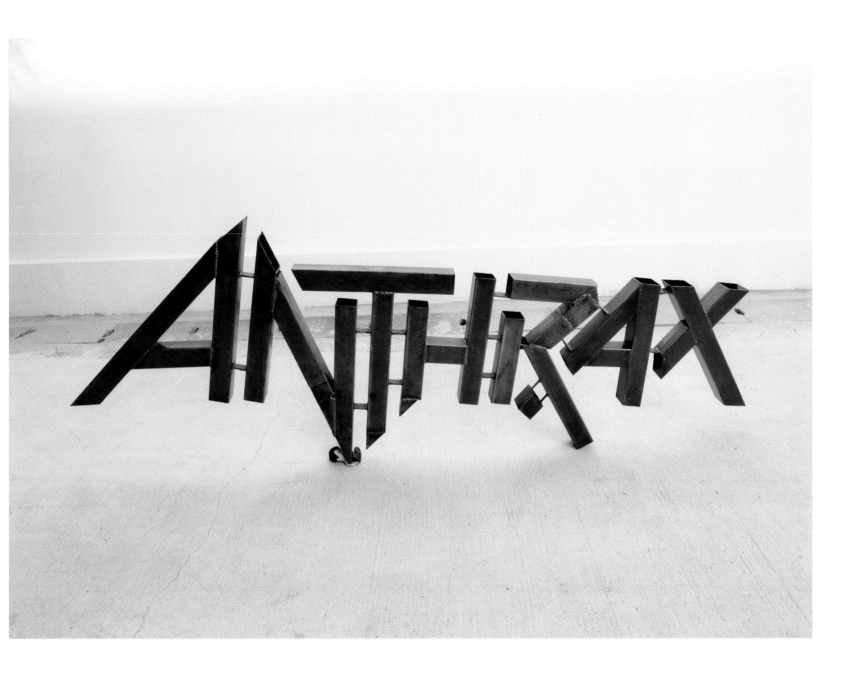

Charles Lim

Singapore

Charles Lim sees Singapore like no other artist. As a former professional sailor, his senses are keenly attuned to environments we rarely see. This unique viewpoint marks an oeuvre that makes visible, with stunning clarity, a physical reality that lies hidden around us every day. His *SEA STATE* series features photographic and video works, as well as audio materials, drawn from the artist's ongoing exploration of Singapore's maritime geography and history. Issues of space and natural resources are especially worrying on this diminutive and densely populated island. Lim offers a compelling exposure of humanity's impact on its physical environment, highlighting the interplay between the natural and the man-made, between land and sea, between actions and reactions. From the state's monumental sculpting of land and sea, to bodies adrift at the mercy of tidal currents, and to the echoes of an abandoned waterfront home, Lim performs an automatic tracing of the nation's political and psychological contours.

Charles Lim
SEA STATE 2: Goryo 6 Ho, 2012
Diasec print, 74 x 46 cm
Courtesy of Future Perfect Gallery

Charles Lim
SEA STATE 2: Barge, 2012
Diasec print, 74 x 37 cm
Courtesy of Future Perfect Gallery

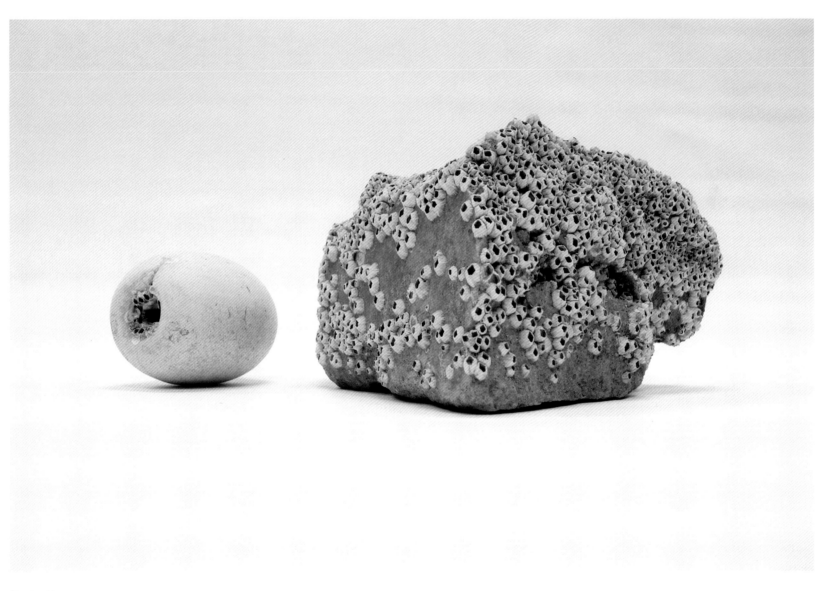

Charles Lim
SEA STATE 3: adrift, aground, 2013
Flotation device, stone (found), barnacles,
dimensions variable
Courtesy of Future Perfect Gallery

Justin Loke

Singapore

Exploring ideas of framing and composition, as well as medium specificities, Justin Loke has created an installation based on scenes from the period movie *Barry Lyndon* (1975) by Stanley Kubrick. Moving between painting, sculpture and film, the artist plays with different strategies of framing to highlight the relationship between these media. The exhibition space will be transformed to reflect the scenes depicted in these oil paintings, which are in turn taken from certain key sets from the film.

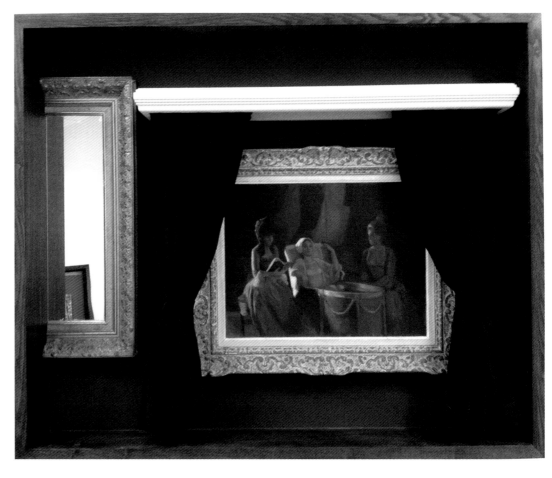

Justin Loke
Lady Lyndon in Tub, 2013
Oil on canvas, emulsion, wood, wax, lacquer, fabric and mirror, 150.5 x 171 x 10.5 cm
Courtesy of RKFA SG

Justin Loke
Lady Lyndon on Harpsichord, 2013
Oil on canvas, emulsion, wood, wax, lacquer and mirror, 162 x 15 x 122 cm
Courtesy of RKFA SG

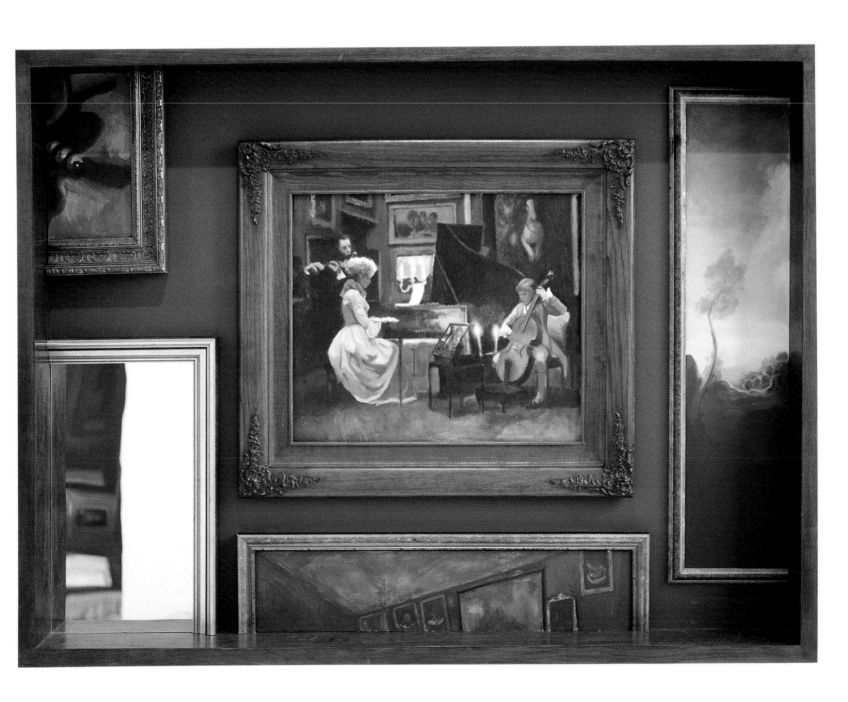

Donna Ong

Singapore

"I promised myself as a child, Never to
forget what it felt like to be a child.
To dream and invest in the imaginary,
the fantastic, the impossible...
My work is about trying to keep that
promise."

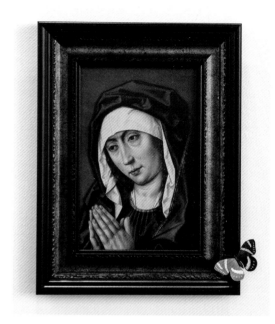

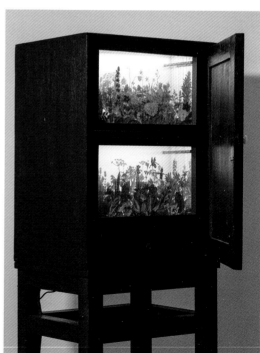

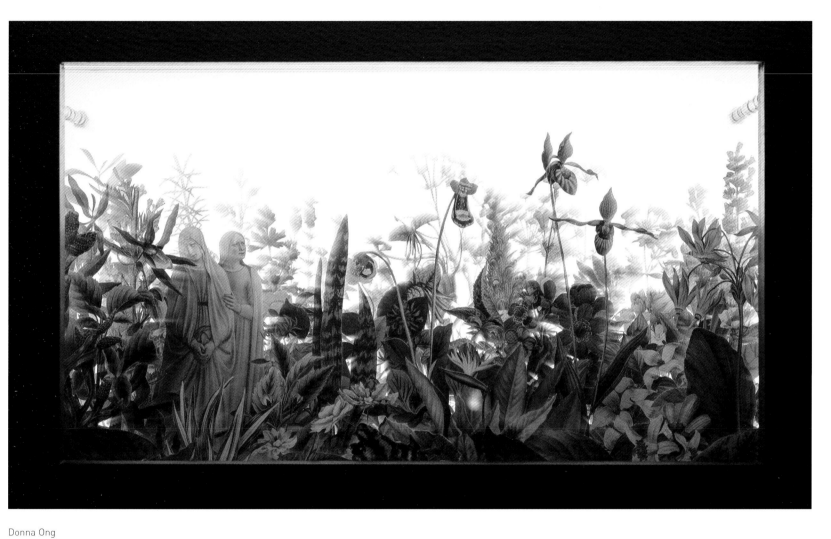

Donna Ong
And We Were Like Those Who Dreamed,
2013
Installation, dimensions variable
Courtesy of the artist

Jeremy Sharma

Singapore

Jeremy Sharma works primarily as a conceptual painter but his body of work encompasses video, photography, drawing and installation. He is also a sometimes-musician, having performed, collaborated and recorded for albums, gigs, theatre and radio. He was also a founding member of rock band Tiramisu and art collective Kill Your Television (KYTV). He obtained his Master of Art at the LASALLE-SIA College of the Arts / The Open University, United Kingdom in 2006, and his Bachelor of Art with High Distinction from the Royal Melbourne Institute of Technology, Australia in 2003. He has participated in numerous exhibitions in Singapore, Malaysia, Thailand, Hong Kong, South Korea, Bangladesh, Italy, Switzerland, England and the United States. Jeremy Sharma's current practice investigates the notion of art as the reflection of a conscious life that observes it in the age of mechanical, industrial and digital reproduction and interconnectivity, addressing our relationship to modernity and our place in time and space in an increasingly fragmented and artificial reality.

Jeremy Sharma
Lilith, 2014
High-density polystyrene foam, robotic
milled, unique, 244 x 122 x 25 cm
Courtesy of Michael Janssen Gallery

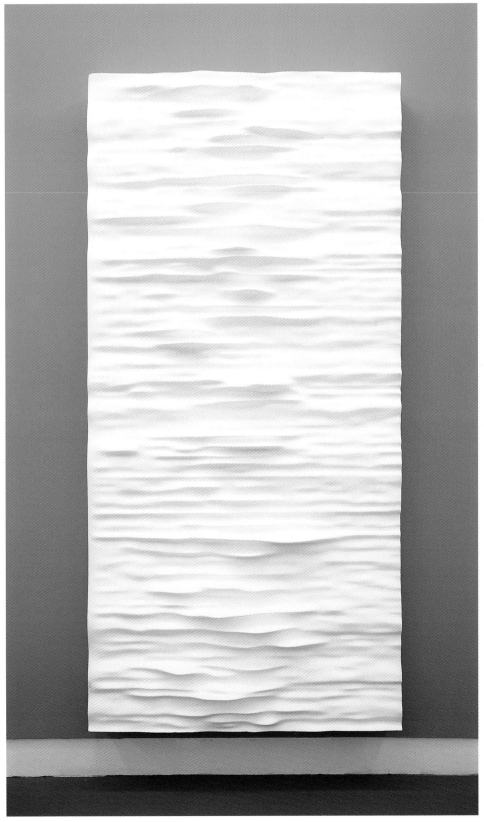

Biographies of the Artists

Chen Sai Hua Kuan

Born in 1976 in Singapore.
Lives and works in Singapore.

Selected solo exhibitions
• 2014
Space Drawing, Osage Gallery, Hong Kong.
• 2012
Everything that Has a Point Makes a Circle, Yavuz Fine Art, Singapore.
• 2009
Drawing between Nothing, The Slade School of Fine Art, London, UK.

Selected group exhibitions
• 2014
Follies for É Birds, National Museum of Singapore.
Countershadows (Tactics in Evasion), Institute of Contemporary Arts, Singapore.
Quo Vadis: The last drawing show, The University of New South Wales Galleries, Sydney, Australia.
Unearthed, Singapore Art Museum, Singapore.
Moving Image New York 2014, New York.
Performing Art Festival, Chang Theatre, Bangkok, Thailand.
Nameless Forms, The Latent Spaces, Haw Par Villa, Singapore.
To Beat the Butterfly's Wings, 222 Artspace, Singapore.
Media at Large, Singapore Art Museum, Singapore.
DAW, Platoon Kunsthalle, Seoul, South Korea.
• 2013
If the World Changed, Singapore Biennale 2013, Singapore Art Museum, Singapore.
Winds of Artist in Residence 2013 – Part 1, Fukuoka Asian Art Museum, Fukuoka, Japan.
Young Overseas Chinese Invitational Exhibition, He Xiangning Art Museum, Shenzhen, China.
Currency Crisis, Whitespace Gallery, Bangkok, Thailand.
The Realm in the Mirror, the Vision Out of Image. Singapore Contemporary Art Exhibition, Suzhou Jinji Lake Art Museum, Suzhou, China.
Arte Laguna Prize, Finalist Artists Exhibition, Arsenale, Venice, Italy.
Drawing Now Paris / Le Salon du Dessin Contemporain, Carrousel du Louvre, Paris, France.
PARALLAX – Between_Borders: Singapore_China, Institute of Contemporary Arts, Singapore.
Airs and Graces, Art Stage Singapore, Millenia Walk, Singapore.
Eyes to Think, Light & Space Contemporary, Quezon City, The Philippines.
• 2012
Panorama: Recent Art from Contemporary Asia, Singapore Art Museum, Singapore.
Mirror of Otherness, Gaodi Gallery, Shenyang, China.
13 Steps, Concourse, Esplanade, Singapore.
CologneOFF 2012. BEFF06 – Bangkok Experimental Film Festival, Goethe Institute, Bangkok, Thailand.
Itsaphase, Brighton, UK.
• 2011
Animal Talk, Jendela Visual Arts Space, Esplanade – Theatres on the Bay, Singapore.
Luleå Art Biennial, Luleå, Sweden.
Alternative Now, 14th Media Art Biennale WRO 2011. Wroc aw, Poland.
Intimacy, Yavuz Fine Art, Singapore.
ARTchSO Video Festival 2011 – Asia, Rennes, France.
CologneOFF 2011 – Arad, Art Museum, Arad, Romania.
CologneOFF 2011 – Finland, a collaboration with Live Herring 2011, Jyväskylä, Finland.
Attraction of the Opposites, International Film Festival Rotterdam, The Netherlands.
CologneOFF 2011 – Ukraine, Kiev, Ukraine.
• 2010
Moscow International Biennale for Young Art, Moscow, Russia.
Whitstable Biennale 2010, Whitstable, UK.
EV+A, Limerick, Ireland.
Royal Academy of Arts: Summer Exhibition 2010, London, UK.
MOVES10: Framing Motion, The Bluecoat, Liverpool, UK.
Green for Something, Mara Gallery, Bucharest, Romania.
Shelf, London, UK.
Busan International Short Film Festival, Busan, South Korea.
Fundada Artists' Film Festival 2010, Square Chapel, Halifax, UK.
Singapore Short Film Awards 2010, The Substation Gallery, Singapore.
AIAF – AsoloInternationalArtFestival, Asolo, Italy.
Experimental Film & Video Festival, Seoul, South Korea.
CologneOFF 2010 – Wilfried Agricola de Cologne, Cologne, Germany.
DÉRAPAGE 10, Montreal, Canada.
Oslo Screen Festival 2010, Oslo, Norway.
Salon Video Art Prize 2010, London, UK.
Simultan Festival, Timisoara, Romania.
• 2009
International Festival for Arts and Media Yokohama 2009, Yokohama, Japan.
Singapore Art Exhibition, Singapore Art Museum, Singapore.
Salon 09, Matt Roberts Arts Project Space, London, UK.
Tower Kronprinz: Second Advent, National Centre for Contemporary Art, Kaliningrad, Russia.
Jam: Cultural Congestions in Contemporary Asian Art South Hill Park, Bracknell, UK.
Green for Something, Area Privata, Perugia, Italy.
Szpilman Show Schöfferhof, Frankfurt am Main, Germany.
Frontier, La Roche-sur-Grane, France.
CUBEOpen 09, Centre for the Urban Built Environment, Manchester, UK.
Spinning Tongues, Rotoreliefs at Vibe, London, UK.
Pantheon International Xperimental Film & Animation Festival, Pantheon Cultural Association, Cyprus.
VIDEOEX Experimental Film & Video Festival, Zurich, Switzerland.
• 2008
Szpilman Award 2008, Esplanade – Theatres on The Bay, Singapore.
Vacanza/Du Jia, Toffia, Italy.
Art and Neuroscience, The Dolphin Gallery, Wantage, UK.
All About Him photography show, open-air exhibition in front of the Ivan Vazov National Theatre, Sofia, Bulgaria.
La terre comme temoin, La Roche-sur-Grane, France.
• 2007
Left Right, The Art Museum of Sichuan University, Chengdu, China.
Detours: Histoires, Mémoires et Stratégies, Art-in-Situ, Crest, France.
Space Drawing, Woburn Square, Slade Research Space, University College, London, UK.
Worm Book, Plastic Kinetic Worms, Singapore.

Awards
• 2013
Best Artwork, Young Overseas Chinese Invitational Exhibition, He Xiangning Art Museum, Shenzhen, China.
The People's Choice Award, Mostyn Open 18, Wales, UK.
• 2011
The Asian Short Film Awards Top 10 Finalists, ScreenSingapore2011, Singapore.
Best of WRO, 14th Media Art Biennale WRO 2011, *Alternative Now*, Wroc aw, Poland.
Project Award, Singapore International Foundation, Singapore.
• 2010
Special mention, Asolo International Art Festival, Asolo, Italy.
Best film of FAFF2010, Fundada Artists' Film Festival, Wakefield, UK.
• 2009
Winner of International Competition, *Tower Kronprinz: Second Advent*, National Centre for Contemporary Art, Kaliningrad, Russia.
Runner-up, CUBEOpen 09, Centre for the Urban Built Environment, Manchester, UK.
• 2007
Julia Wood Award, The Slade School of Fine Arts.
Project Awards, The Slade School of Fine Arts.
Slade Bursaries, Slade School of Fine Arts, London, UK.
• 2006–07
Overseas Bursary, National Arts Council, Singapore.
• 2005–07
Boise Scholarships, Slade School of Fine Arts, London, UK.

Public collections
He Xiangning Art Museum, Shenzhen.
Singapore Zoo.
Singapore Art Museum.
Vehbi Koç Foundation, Istanbul.

Chia Ming Chien

Born in 1957 in Singapore.
Lives and works in Singapore.

Selected solo exhibitions
• 2012
Intimate Moments 1: ICONS, Fullerton Heritage Gallery, Singapore.
WIRES, Institute of Contemporary Arts, Singapore.

Selected group exhibitions
• 2014
The Wires Project. VIVID Sydney Festival 2014, Seymour Centre, Sydney, Australia and Melbourne Jazz Festival, Melbourne, Australia.
• 2013
The Wires Project, Urbanscapes Arts Festival, Kuala Lumpur, Malaysia.

Chim↑Pom

Formed in 2005 in Tokyo, Japan by Ryuta Ushiro, Yasutaka Hayashi, Ellie, Masataka Okada, Motomu Inaoka and Toshinori Mizuno. Chim↑Pom operates in Tokyo, Japan.

Nationality
Japanese.

Selected solo exhibitions
• 2014
YAJIRUSHISOVIETORU Chim and Pom's Paradox, MUJIN-TO Production, Tokyo, Japan.
The Electrical Parade Never was a Satisfaction to Me, hiromiyoshii roppongi, Tokyo, Japan.
• 2013
Hiroshima!!!!!, Former Bank of Japan Hiroshima Branch, Hiroshima, Japan. Pavilion, Taro Okamoto Memorial Museum, Tokyo, Japan.
• 2012
Parco Museum, Tokyo, Japan.
• 2011
LEVEL 7 Feat. Hiroshima!!!!, Maruki Gallery for The Hiroshima Panels, Saitama, Japan.
Chim Pom (screening), MoMA PS1, New York.
K-I-S-S-I-N-G, The Container, Tokyo, Japan.
Survival Dance, MUJIN-TO Production, Tokyo, Japan.
Real Times, MUJIN-TO Production, Tokyo, Japan.
• 2010
Imagine, MUJIN-TO Production, Tokyo, Japan.
• 2008
Becoming Friends, Eating Each Other or Falling Down Together. BLACK OF DEATH, curated by MUJIN-TO Production, hiromiyoshii, Tokyo, Japan.
Japanese Art is 10 Years Behind, NADiff a/p/a/r/t, Tokyo, Japan.
• 2007
Thank You Celeb Project I'm BOKAN, MUJIN-TO Production, Tokyo, Japan.

Oh My God!, MUJIN-TO Production, Tokyo, Japan.
• 2006
SUPERRAT, MUJIN-TO Production, Tokyo, Japan.

Selected group exhibitions
• 2015
DAS HYBRIS PROJEKT, HALLE 14, Leipzig, Germany.
by the mountain path, white rainbow, London, UK.
TAKAHASHI COLLECTION: Mirror Neuron, Tokyo Opera City Art Gallery, Tokyo, Japan.
Don't follow the wind, inside the evacuated, radioactive exclusion zone surrounding the Fukushima Daiichi Nuclear Power Plant owned by TEPCO, Fukushima, Japan.
Prudential Eye Awards, ArtScience Museum, Singapore.
The Radiants, BORTOLAMI X GREEN TEA GALLERY, New York, NY.
• 2014
Duality of Existence – Post Fukushima: A group exhibition of Contemporary Japanese Art, Friedman Bendam, New York.
Tomorrow Comes Today, Digital Ark at the National Taiwan Museum of Fine Arts, Taichung, Taiwan.
Takahashi Collection 2014 Mindfulness!, Nagoya City Art Museum, Nagoya, Japan.
• 2013
global aCtIVISm, ZKM | Zentrum für Kunst und Medientechnologie Karlsruhe, Germany.
Atomic Surplus, Muñoz Waxman Galleries at the Center for Contemporary Arts, Santa Fe, New Mexico.
adidas Originals PRESENTS BETTER NEVER THAN LATE, Kodachi Seisakujo, Tokyo, Japan.
Now Japan. Exhibition with 37 contemporary Japanese Artists, Kunsthal KAdE, Amersfoort, The Netherlands.
inToAsia: Time-based Art Festival 2013 – MicroCities, Stephan Stoyanov Gallery, New York.
MOT Collection: From Me to You – Close but Distant Journeys, Museum of Contemporary Art, Tokyo, Japan.
All You Need Is LOVE: From Chagall to Kusama and Hatsune Miku, Mori Art Museum, Tokyo, Japan.
• 2012
Artists and the Disaster – Documentation in Progress, Contemporary Art Gallery, Art Tower Mito, Ibaraki, Japan.
9th Shanghai Biennale: REACTIVATION, Shanghai Museum of Contemporary Art, Shanghai, China.
Project Daejeon 2012: Energy, Daejeon Museum of Art, Daejeon, South Korea.
Son et Lumière, et sagesse profonde, 21st Century Museum of Contemporary Art, Kanazawa, Japan.
Get Up, Stand Up, SAM Seattle Art Museum, Seattle, Washington.

The Angel of History – I Love Art 12 Photography, Watari-um Museum, Tokyo, Japan.
Turning Around, curated by Chim↑Pom, Watari-um Museum, Tokyo, Japan.
Double Vision: Contemporary Art from Japan, MMoMA Moscow Museum of Modern Art, Moscow, Russia; travelled to Haifa Museum of Art, Haifa, Israel.

Public collections
Mori Art Museum, Tokyo.
Museum of Contemporary Art, Tokyo.
The Japan Foundation, Tokyo.
21st Century Museum of Contemporary Art, Kanazawa.
Asia Society Museum, New York.
Queensland Art Gallery, Brisbane.
MOMAT The National Museum of Modern Art, Tokyo.

Awards
• 2007
New Art Competition 2007, Hiroshima City Museum of Contemporary Art Award.

Jane Lee

Born in 1963 in Singapore.
Lives and works in Singapore.

Selected solo exhibitions
• 2014
Jane Lee: 100 Faces, Sundaram Tagore Gallery, Singapore.
• 2013
Jane Lee: Secret Garden, Mizuma Gallery, Tokyo, Japan.
• 2012
Jane Lee: Beyond, Sundaram Tagore Gallery, New York.
• 2011
Jane Lee: Prélude à l'après-midi d'un faune, Osage SoHo, Hong Kong.
• 2009
Jane Lee, Osage Gallery, Singapore.
• 2006
Transformation / Process, TAKSU, Singapore.

Selected group exhibitions
• 2014
Medium at Large, Singapore Art Museum, Singapore.
Southeast Asia Platform, Art Stage Singapore, Marina Bay Sands, Singapore.
• 2013
Squaring the Circle: Contemporary Art from Singapore, Indonesia, Malaysia and the Philippines, One East Asia, Gallery 8, London, UK.
To Be a Lady, Sundaram Tagore Gallery, Singapore.
Painting in Singapore, Equatorial Art Project, Singapore.
The Realm in the Mirror, the Vision Out of Image. Singapore Contemporary Art

Exhibition, Suzhou Jinji Lake Art Museum, Suzhou, China.
Landscape Memories, Espace Louis Vuitton, Singapore.
• 2012
Encounter, Experience and Environment, Gillman Barracks, Singapore.
Panorama: Recent Art from Contemporary Asia, Singapore Art Museum, Singapore.
• 2011
Fabrication, Museum of Art and Design, Manila, The Philippines.
Celeste Prize Exhibition, The Invisible Dog, New York.
Jane Lee, Donna Ong, Wilson Sheih, Eslite Gallery, Taipei, Taiwan.
Collectors Stage, Singapore Art Museum, Singapore.
Remaking Art in the Everyday, Marina Bay Sands Convention Centre, Singapore.
• 2010
Popping Up: Revisiting the Relationship between 2D and 3D, Hong Kong Arts Centre, Hong Kong.
The Burden of Representation: Abstraction in Asia Today, Osage Kwun Tong, Hong Kong.
• 2009
Code Share: 5 Continents, 10 Biennales, 20 Artists, The Contemporary Art Centre, Vilnius, Lithuania.
• 2008
Wonder. Singapore Biennale 2008, Singapore.
Coffee, Cigarettes, Pad Thai: Contemporary Art in South East Asia, Eslite Gallery, Taipei, Taiwan.

Awards
• 2011
Winner, Celeste Prize for Painting, New York.
• 2007
Winner, International Residency Art Prize, Singapore Art Exhibition.
Finalist, The Sovereign Art Prize 2007, Hong Kong.
• 2005
Juror's Choice, Philip Morris Singapore Art Award, Singapore.
• 2003
Finalist, Singapore – ASEAN Art Award.

Public collections
Singapore Art Museum.
National Heritage Board, Singapore.

Sean Lee

Born in 1985 in Singapore.
Lives and works in Singapore.

Selected solo exhibitions
• 2012
Chan Hampe Galleries, Singapore.
• 2011
Emergent Lleida Festival, Lleida, Catalunya, Spain.

Galeria TagoMago, Barcelona, Spain.
Le Petit Endroit, Paris, France.
Objectifs – Centre for Photography and Filmmaking, Singapore.
• 2008
Singapore Month of Photography, Singapore.

Selected group exhibitions
• 2013
Singapore Biennale 2013, Singapore Art Museum, Singapore.
Guizhou Photo Festival, Guizhou, China.
Group exhibition at Gallery Tanto Tempo, Kobe, Japan.
• 2012
Gallery 360, New Delhi, India.
• 2011
Delhi Photo Festival, Delhi, India.
The Empire Project, Istanbul, Turkey.
New York Photo Festival, New York.
• 2010
Beyond LKY, Valentine Willie Fine Art, Singapore.
• 2009
Phnom Penh Photo Festival, Phnom Penh, Cambodia.
Arles Photo Festival – Discovery Award, Arles, France.
• 2008
Singapore International Photography Festival, Singapore.
Angkor Photo Festival 2008, Siem Reap, Cambodia.

Awards
• 2011
Winner, ICON de Martell Prize.
Unanimous Decision, Reflexions Masterclass.
• 2010
Nomination, Paul Huf Award, Foam Fotografiemuseum Amsterdam, The Netherlands.
Best Portfolio Prize, Singapore International Photography Festival.
• 2009
Prix Decouverte, Arles Photo Festival, Arles, France.
• 2007
Special Jury Prize, Angkor Photo Festival.

Public collections
Singapore Art Museum.
Sandor Family Collection.

Lee Wen

Born in 1957 in Singapore.
Lives and works in Singapore.

Selected solo exhibitions
• 2014
Lee Wen at Art Basel Hong Kong 2014, Art Basel Hong Kong.
• 2012
Lucid Dreams in the Reverie of the Real, Singapore Art Museum, Singapore.

• 2008
Anthropometry Revision, Soo Bin Art Gallery, Singapore.
• 2007
Freedom of Daydreams, Mothers of Imagination, Your Mother Gallery, Singapore.
• 2004
Unframed 7, p-10 Art Space, Singapore.
• 2003
Strange Fruits, The Substation Gallery, Singapore.
• 2002
Everybody Should Be Happy, Utterly Art Exhibition Space, Singapore.
• 1996
Hand-Made Tales, The Black Box, TheatreWorks, Singapore.
• 1995
Neo-Baba, VA-nishiogi Gallery, Tokyo, Japan.
• 1993
Journey of a yellow man no. 3: DESIRE, The Substation Gallery, Singapore.

Selected group exhibitions
• 2013
Cascadence: Singapore Redux, iPRECIATION, Singapore.
• 2012
Venice International Performance Art Week, Venice, Italy.
• 2011
R.I.T.E.S. Rooted in the Ephemeral Speak #01/2011, The Substation Gallery, Singapore.
This Is Performance Art, Aberdeen and Glasgow, UK.
Negotiating Home, History and Nation: Two Decades of Contemporary Art from Southeast Asia, 1991–2011, Singapore Art Museum, Singapore.
Future of Imagination 7, Goodman Arts Centre, Singapore.
• 2010
National Review of Live Art 2010, Glasgow, UK.
Future of Imagination 6, Sculpture Square, Singapore.
The Winds Project. Encontro internacional da performance, Teatro TUCA, São Paulo, Brazil.
Performance Platform Lublin 2010, Lublin, Poland.
BONE 13 – Festival für Aktionskunst, Bern, Switzerland.
• 2009
International Performance Show-Ceramic Passion, 5th World Ceramic Biennale, Icheon, South Korea.
Infr'Action '09 – Festival International d'Art Performance, Paris, France.
Rasa Aksi-4 Artists From Singapore, Lublin and Warsaw, Poland.
Live Action Göteborg 09, Gothenburg, Sweden.
Momentum – Platform for Performance-Art, Brussels, Belgium.
Drawing as Form, Sculpture Square, Singapore.
10th OPEN International Performance Art Festival, Beijing, China.
LIVE International Performance Art Biennale, Vancouver, Canada.

• 2008
Small East Co-prosperity, Restaurant 08, Tokyo, Japan.
Intervene! Interrupt! Rethinking Art as Social Practice, University of California, Santa Cruz CA.
Ket Noi: Vietnam–Singapore Performance Art Dialogue, Singapore Art Museum, Singapore.
Performatica '08, Four Artists From Singapore, 26cc, Rome and La Casa Verde, Foligno, Italy.
Blow!5 – Performance Art Meeting between Singapore and Germany, Hildesheim and Ilsede, Germany.
The Artists Village: 20 Years On, Singapore Art Museum, Singapore.
• 2007
National Review of Live Art 2007, Glasgow, UK.
IX Medzynarodowy Festiwal Sztuki Akcji Interakcje 2007, Piotrkow Trybunalski, Bielsko-Bia a, Poland.
Made in China, Louisiana Museum of Modern Art, Humlebæk, Denmark.
Future of Imagination 4, TheatreWorks 72-13, Singapore.
LONG'ACTION 07 rencontres franco-chinoises d'art performance, Sète, France.
• 2006
The Future of Imagination #2, The Substation Gallery, Singapore.
TROUBLE #2, halles de schaerbeek, Brussels, Belgium.
acción!06MAD. III Encuentro Internacional de Arte de Acción, Madrid, Spain.
4th DaDao Live Art Festival, Beijing, China.
*7a*11d International Festival of Performance Art*, Toronto, Canada.
DEFORMES, Primera Bienal de Performance, Santiago, Chile.
• 2005
National Review of Live Art – 2005, Glasgow, UK.
Crossing Time International, Dartington College of Arts, Totnes, Devon, UK.
3 Encuentro Internacional de Performance, Institut Valencià d'Art Modern (IVAM), Valencia, Spain.
National Review of Live Art – MIDLAND 05, Perth, Australia.
Situations, Museum of Contemporary Art, Sydney, Australia.
REACH OUTLYING 2005 TipAlive Taiwan International Performance Art Festival, Taipei, Taiwan.
Spaces and Shadows: Politics of fun, House of World Culture, Berlin, Germany.
Self-portrait Performativ, langaut, Golberode, Dresden, Germany.
BLURRR 5 biennial of performance art, Tel Aviv, Israel.
Bone 8, Schlachthaus Theater, Bern, Switzerland.
• 2004
130 Bank Gallery, 10th Anniversary Commemoration Exhibition, Kitakyushu, Japan.
National Review of Live Art – 2004, Glasgow, UK.
2nd DaDao Live Art Festival, Beijing, China.
Giving Water an Image, Hanoi University of Fine Arts, Hanoi, Vietnam.

Sea Art Festival, Busan Biennale 2004, Busan, South Korea.
Sustainable, Tokyo National University of Fine Arts and Music, Tokyo, Japan.
The Future of Imagination #2, Sculpture Square, Singapore.
• 2003
Aciones en Ruta, Mexico City and Encuentro internacional de Performance Yucatán, Mérida, Mexico.
The Future of Imagination, The Substation Gallery, Singapore.
• 2002
Alter-Native Dialogues (video-performance with James Luna), Tokyo, Japan.
Recontre international d'art performance de Quebec 2002, LELIEU, Quebec, Canada.
• 2001
EXIT International Festival for Unusual Live Performances, Cable Factory, Helsinki, Finland.
2nd Open Art Festival, Pengshan, Leshan and Chengdu, Sichuan, China.
• 2000
Critical Response, Ivan Dougherty Gallery, University of New South Wales, Sydney, Australia.
Expo 2000 (performance with Black Market International), Hanover, Germany.
TransEuropa – Theatre Festival 2000, Hildesheim, Germany.
Artists Investigating Monument – AIM projects, Raffles Landing Site, Singapore.
• 1999
Rånd, Festival der Regionen, Zuckerfabrik Enns, Austria.
3rd Asia Pacific Triennial of Contemporary Art, Queensland Art Gallery, Brisbane, Australia.
Nokia Singapore Art 1999, Singapore Art Museum, Singapore.
• 1998
Construction in Process VI – The Bridge, The Artists Museum, Melbourne, Australia.
Sub-Fiction, Werkleitz Biennale 1998, Tornitz and Werkleitz, Germany.
3rd Asian Performance Art Series, Tokyo, Japan.
Asiatopia, Bangkok, Thailand.
ZUG. Flexible: X, Performance Art Operation Work, Dresden, Germany.
• 1997
Simposio Internacional de Escultura México-Japon, Tuxtla Guttierez, Chiapas, Mexico.
Sexta Bienal de La Habana, Havana, Cuba
SeptFest Art Conference. Multi-culturalism, The Substation Gallery, Singapore.
• 1996
Recontre International d'art Performance et Multi-media 1996, Quebec, Canada.
Between the Visible and Invisible, Lahore International Arts Workshop, Lahore, Pakistan.
• 1995
2nd Nippon International Performance Art Festival, Tokyo and Nagano, Japan.
Castle of Imagination, 3rd International Artists Meeting, Bytow, Poland.
Gwangju Biennale, Gwangju, South Korea.

MA: East West Study Project, Düsseldorf and Darmstadt, Germany.
Chiang Mai Social Installation, Chiang Mai, Thailand.
• 1994
The 4th Asian Art Show, Fukuoka Asian Art Museum, Fukuoka and Setagaya Art Museum, Tokyo, Japan.
• 1993
5th Fukui International Video Biennale, Tawara, Fukui City, Japan.
Sense Yellow, Concrete House, Nonthaburi, Thailand.
• 1992
International Sculpture Symposium, Gulbarga, Karnataka, India.

Awards
• 2014
Artist/Scholar/Activist Award, Board of Performance Studies International.
• 2005
Cultural Medallion, Singapore.

Public collections
Fukuoka Asian Art Museum.
Queensland Art Museum, Brisbane.
Singapore Art Museum.

Gerald Leow

Born in 1984 in Singapore.
Lives and works in Singapore.

Selected solo exhibitions
• 2014
Teenage Dreams, Queensland College of Art, Griffith University, South Bank, Australia.

Selected group exhibitions
• 2013
Dialogue the promise, Singapore–Thailand Chiang Mai University Art Centre, Chiang Mai, Thailand.
Lit Up, Progression, The Aliwal Arts Centre, Singapore.
• 2012
The Singapore Show: Future Proof, Singapore Art Museum, Singapore.
• 2011
'Alternatives, The Substation Gallery, Singapore.
• 2010
Artriangle 2010, House of Matahati, National Gallery, Kuala Lumpur, Malaysia.

Charles Lim

Born in 1973 in Singapore.
Lives and works in Singapore.

Selected solo exhibitions
• 2014
SAFE SEA, presented as part of Singapore

HeritageFest 2014, National Museum of Singapore.
SEA STATE 3: Inversion, Future Perfect, Singapore.
• 2013
In search of Raffles' Light, NUS Museum, Singapore.
• 2012
SEA STATE 2: as Evil Disappears, Future Perfect, Singapore.

Selected group exhibitions
• 2014
The Part in the Story Where a Part Becomes a Part of Something Else, Witte de With Center for Contemporary Art, Rotterdam, The Netherlands
Unearthed, Singapore Art Museum, Singapore.
• 2013
Rendez-vous 13, Institut d'art contemporain, Villeurbanne, Rhône-Alpes, France.
• 2012
The Singapore Show: Future Proof, Singapore Art Museum at 8Q, Singapore.
• 2011
Open House 2011, Singapore Biennale, Old Kallang Airport, Singapore.
• 2009
Biennale Cuvée. Weltauswahl der Gegenwartskunst, O.K. Centrum für Gegenwartskunst, Linz, Austria.
• 2008
Translocalmotion. BARNACLE 1: it's not that I forgot, but rather I chose not to mention, Shanghai Biennale, AIVA, Japan.
• 2007
MANIFESTA 7, European Biennial of Contemporary Art, Trentino, Italy.
• 2006
Islanded: Contemporary Art from New Zealand, Singapore and Taiwan, Adam Art Gallery, Wellington, New Zealand.
• 2005
Singapore Open Nature, NTT Inter Communication Center, Tokyo, Japan.
Space and Shadow, Haus der Kulturen der Welt, Berlin, Germany.
President's Young Talents Award, Singapore Art Museum, Singapore.
• 2004
Gravity: MAAP in Singapore, Singapore Art Museum, Singapore.
• 2002
tsunamii.net at *Documenta 11*, Binding Brewery, Kassel, Germany.
The 2nd Seoul International Media Art Biennale, Media City Seoul, South Korea.

Awards
• 2014
Selected to represent Singapore in the Venice Biennale 2015.
• 2012
Experimental Innovation Award, Beijing, China.
Independent Film Festival *Best Experimental Short*, Nashville Film Festival, Nashville TN.

Silver Award, Asian New Force Category, 17th IFVA Awards, Hong Kong.
• 2011
Special Mention, Venice Film Festival Official selection in *Orizzonti* Competition.
• 2005
President's Young Talents Award.
• 2002
JCCI Arts Award.

Public collections
Singapore Art Museum.

Justin Loke

Born in 1979 in Singapore.
Lives and works in Singapore.

Selected solo exhibitions
• 2013
The Seven Scenes of Barry Lyndon, Objectifs – Centre for Photography and Filmmaking, Singapore.

Selected group exhibitions
• 2014
Painting in Motion, Arts in The Neighbourhood, National Arts Council, Singapore.
Contemporary Art from Soutneast Asia, Arter, Istanbul.
Bang Bang Wonderland!, Passion Art Festival, People's Association, Kovan-Kaki Bukit, Singapore.
Fool's Gold, iLights Marina Bay 2014, Singapore.
Passion Arts Festival @ Tampines, Singapore.
Mechanical Arm – Yang Jie, Young Curators Series of Grey Projects, Singapore.
Destruction of Readymade Everyday, Arts Apart Fair, Park Royal @ Pickering, Singapore.
• 2013
Sun Tzu's Art of War, Southeast Asia Pavilion, Beirut Art Fair, Beirut, Lebanon.
Hokkien Rhymes, Esplanade, Singapore.
Wallflowers, Gardens by the Bay Station, Thomson Line Art in Transit, Land Transport Authority, Singapore.
The Logbook of Public Ideas Vol. II, Associate Artist Research Programme, The Substation Gallery, Singapore.
The Forest, a short film supported by Media Development Authority, Singapore.
FOURPLAYS: ABCD, TheatreWorks 72-13, Singapore.
Lenin in Warsaw, Richard Koh Fine Art Booth, Artstage 2013, MBS Convention Centre, Singapore.
Worlds Apart Fair, Conrad Centennial, Singapore.
• 2012
A View with a Room, Human Scale, Hong Kong Art Centre, Hong Kong.
This is not a Demonstration (with Quelic Berga), Cultural Centre "Les Bernardes" de Salt, Fundació Atrium Artis, Girona, Spain.
Incendiary Texts II: Thirty-six Eastern Vulgarities... in Roman Letters, Richard Koh Fine Art and Umahseni AIR, Jakarta, Indonesia.

The Forest, Roundtable: Gwangju Biennale 2012, Gwangju, South Korea
This is not a Demonstration (with Quelic Berga), Goodman Arts Centre, Singapore.
Incendiary Texts II: Thirty-six Eastern Vulgaries... in Roman Letters, Richard Koh Fine Art, Art Hong Kong, 1x 8 Booth, HK Convention and Exhibition Centre, Hong Kong.
Landed Poverty, a community sculpture commissioned by People's Association, Bishan Park, Singapore.
Planting Shadows (Nocturnal), commissioned by Urban Redevelopment Authority (URA), part of *iLight at Marina Bay*, Singapore.
Incendiary Texts II: Thirty-six Eastern Vulgarities... in Roman Letters, Richard Koh Fine Art, Art Stage Singapore, Marina Bay Sands, Singapore.
Logbook of Public Ideas: Volume I, Associate Artist Research Programme, The Substation Gallery, Singapore.
• 2011
Humanity will not be Happy until... Jakarta Biennale, Indonesia.
A View with a Room, The Invisible Dog, Brooklyn, New York.
Incendiary Texts, Institute of Contemporary Arts, Singapore.
Chocolates for Blood, for Future of Imagination 7, Goodman Arts Centre, Singapore.
Dust: A Recollection, TheatreWorks, Singapore.
UnderWriter's Table, commissioned by Singapore Art Museum for The Singapore Writers Festival 2011.
Asia: Looking South, Arndt Contemporary Art, Berlin, Germany.
Postcards from Earth, Objectifs – Centre for Photography and Filmmaking, Singapore.
Open Studios, Gertrude Contemporary, Melbourne, Australia.
Armchair Philosophy, Langgeng Gallery, Art Stage Singapore, Marina Bay Sands, Singapore.
• 2010
How We Learned to Stop Worrying and Love the Bomb for Pasagüero, Mexico City, Mexico.
Simulacro Naturale, Ex Teresa Arte Actual, Mexico City, Mexico.
The Bag of Samuel Chen (La Bolsa de Samuel Chen), CONEJOBLANCO Galeria de Libros, Mexico City, Mexico.
The Garden of Forking Path for *Memories & Beyond – Kuandu Biennale* by Kuandu Museum, Taipei, Taiwan.
Flirting Point for Festival Ingravid, Figueres, Spain.
Kiam Hu for *Cheong Soo Pieng: Bridging Worlds* by The National Art Gallery, Singapore.
Now & Next, Gwangju National Museum, Gwangju, South Korea.
Space & Imagination Exhibition, Chonnam Provincial Okgwa Museum, South Korea.
Abusement Park, part of *The Night Festival 2010*, Singapore Art Museum, Singapore.
The Garden of Forking Paths, Grey Projects, Singapore.
The Colour of Money: Our Two-Dollar Education, i-AM Deciphered, Post-Museum, Singapore.

Flirting Point, Singapore Art Museum, Singapore.
• 2009
Flirting Point (with Vertical Submarine), Zoukout 09, Siloso Beach, Sentosa, Singapore.
Planting Shadows (with Vertical Submarine) for *Nature Borne – Singapore & Korea Joint Sculpture Exhibition*, Singapore Botanic Gardens, Singapore.
Analogic (with Vertical Submarine) for *Singapore Art Show 2009* at Post-Museum, SIngapore.
A View with a Room (with Vertical Submarine) for President's Young Talents 2009, Singapore Art Museum at 8Q, Singapore.
Shopping for a Personal Letter (with Kooy Siew Yen, He Yue and Vertical Submarine), Wheelock Gallery, Singapore.
• 2008
Fool's Gold (with Vertical Submarine) for Zoukout 08, Siloso Beach, Sentosa, Singapore.
Singapore Young Contemporary Artists exhibition and website launch with Vertical Submarine at Sculpture Square, Singapore.
Decomposition II: Publications is Prostitution (Vertical Submarine's inaugural solo show), part of Substation's Open Call at The Substation Gallery, Singapore.
• 2007
Foreign Talents (with Vertical Submarine) for *Raised*, a part of *Curating Lab* (coordinated by Sculpture Square) at the *Singapore Art Show 2007*, Singapore.
Shut for *Autobiobliophiles* (co-organized by the Department of Fine Arts, Chinese University of Hong Kong, with Vertical Submarine), Studio Bibliothèque, Hong Kong.
• 2006
EVERY marx NEEDS AN engels (with Fiona Koh) for *Withdrawing*, Nanyang Academy of Fine Arts, Gallery 2, Singapore.
Dead books: DEcomposition (with Vertical Submarine) for *Txtrapolis: Contemporary Text-Based Art from Singapore*, Film Center, University of Philippines Diliman, Quezon City, The Philippines.
• 2005
500 and below, a fund-raising group exhibition, Plastic Kinetic Worms, Singapore.
Spacepork (with Vertical Submarine) for *Singapore Art Show – New Works by Singapore Artists: Open Section*, Singapore Management University, Li Ka Shing Library Building, Singapore.
Dead books: DEcomposition (with Vertical Submarine) for *Txtrapolis: Contemporary Text-Based Art from Singapore*, Nanyang Academy of Fine Arts, Gallery 2, Singapore.
Gulliver's Travel for *NOMAD 2005*, Ang Mo Kio Secondary School, Singapore.
Think Pig Think Spacepork (with Vertical Submarine), tickleart series, Citylink Mall, Singapore.
• 2004
Best of Singapore Art 2004, tickleart series, Citylink Mall, Singapore.
Arts @ Tekka: Little India Arts Belt Street Festival, Plastic Kinetic Worms, Singapore.

R (A) – Rated Artistic: Artists Take On Cinema (with Vertical Submarine), The 6th Annual Worms Festival, Plastic Kinetic Worms, Singapore.
Tally-Vision (with Vertical Submarine), Windows@Wisma Atria, Singapore.
• 2001-02
Nokia Singapore Art 2001–02, Singapore Art Museum, Singapore.
• 2001
The Case (of)..., Société Générale Gallery, Alliance Française de Singapour, Singapore.

Awards
• 2012
Nominated for the 12th Straits Times Life! Theatre Awards, Best Set Design.
• 2011
Winner of Celeste Prize 2011, Installation & Sculpture Prize, New York.
• 2009 JCCI (Japanese Chamber of Commerce and Industry) Singapore Foundation Arts Award.
President's Young Talents 2009, Credit Suisse Art Residency Award (with Vertical Submarine).
• 2005
Judge's Choice (with Vertical Submarine), *Singapore Art Show 2005: New Works*.
• 2004
1st Prize – Windows – Wisma Atria creative windows display (with Vertical Submarine)
• 2000
Certificate of Merit, Della Butcher Award, Rotary Club of Orchard, Singapore.
• 1999
Certificate of Merit, Della Butcher Award, Rotary Club of Orchard, Singapore.

Donna Ong

Born in 1978 in Singapore.
Lives and works in Singapore and Berlin.

Selected solo exhibitions
• 2014
The Forest Speaks Back, Kunstlerhaus Bethanien, Berlin, Germany.
• 2013
And We Were Like Those Who Dreamed, Primae Noctis Art Gallery, Lugano, Switzerland.
• 2009
Asleep, A Room Awakens, Wada Fine Arts, Tokyo, Japan.
• 2004
Palace of Dreams, Arts House, Singapore.

Selected group exhibitions
• 2014
A Time For Dreams: Moscow Biennale for Young Art 2014, Moscow, Russia.
Das Mechanische Corps | Auf den Spuren von Jules Verne, Kunstlerhaus Bethanien, Berlin, Germany.
• 2013
Suspended Histories, Museum Van Loon, Amsterdam, The Netherlands.

Landscape Memories, Louis Vuitton Island Maison, Marina Bay Sands, Singapore.
• 2012
Home Again: 10 Artists Who Have Experienced Japan, Hara Museum, *Tokyo*, Japan.
Encounter: The Royal Academy in Asia, Institute of Contemporary Arts, Singapore.
The Singapore Show: Future Proof, Singapore Art Museum, Singapore.
The Collectors Show: Chimera, Singapore Art Museum, Singapore.
• 2011
Fatto a Mano for the Future, Fendi Boutique, Singapore.
Donna Ong, Jane Lee, Wilson Chieh, Eslite Gallery, Taipei, Taiwan.
Dust on the Mirror, Institute of Contemporary Arts, Singapore.
• 2010
Homestay, Osage Gallery, Shanghai, China.
Dust on the Mirror, Djanogly Art Gallery, Nottingham, UK.
• 2009
President's Young Talent Exhibition, Singapore Art Museum, Singapore.
Photographer Unknown, Monash University Museum of Art, Melbourne, Australia.
Night Festival, National Museum of Singapore.
AROUND Sound Art Festival, Soundpocket, Lamma Island, Hong Kong.
Live Harder, Dream Bigger, Love Deeper, JOYCE boutique, Hong Kong.
Fluid Zones: Jakarta Biennale, Jakarta, Indonesia.
Some Rooms, Osage Kwun Tong, Hong Kong.
• 2008
I have a Dream, 10 Solos by 10 Asian Artists: 2008 Kwandu Biennale, Kwandu Fine Arts Museum, Taipei, Taiwan.
Singapore Supergarden; An Ecosystem of Design Thoughts: 11. International Architecture Exhibition, Venice Architecture Biennale, Venice, Italy.
Coffee, Cigarettes and Phad Thai, Eslite Gallery, Taipei, Taiwan.
8Q-rate: School, Singapore Art Museum at 8Q, Singapore.
• 2007
Footnotes on Geopolitics, Market and Amnesia: 2nd Moscow Biennale of Contemporary Art, Moscow, Russia.
Project – Eden: Singapore Arts Festival, Singapore.
• 2006
Belief: Singapore Biennale 2006, Singapore.

Awards
• 2009
Young Artist Award, National Arts Council, Singapore.
People's Choice Award, President's Young Talents 2009, Singapore Art Museum and Credit Suisse.
• 2003
1st Prize, Sefton Open 2003 (2D Art), UK.
• 2002
Shell-NAC Scholarship, National Arts Council, Singapore.

Architecture Theory Prize, University College, London, UK.
• 1999
Singapore Undergraduate Scholarship, University College, London, UK.

Public collections
Deutsche Bank.
Tiroche-Deleon.
Singapore Art Museum.

Petroc Sesti

Born in London 1973.

Recent projects and upcoming projects
• 2015
Vanishing Point, permanent sculpture for Qatar Foundation HQ, Doha, Qatar.
• 2014
Memory of Matter in Theatre du Monde, Maison Rouge Paris, France.
TimeFold, permanently installed at The Boghossian Foundation, Brussels, Belgium.
• 2013–14
Blu Route, The Boghossian Foundation, Brussels, Belgium.
• 2013
Tsao Collection, Yuzi Sculpture Park, Guilin, China.
Turbulence 2, The Boghossian Foundation Brussels, Belgium.
Perpetual Void, Beyond Museum, Seoul, South Korea.

Selected exhibitions
• 2012
Shanghai Biennale, New Shanghai Museum of Contemporary Art, Shanghai, China.
Museum of Old and New Art, Theatre of The World, Tasmania.
• 2012
Hong Kong Art Fair, Basel, Germany and Hong Kong.
Louis Vuitton Foundation, Champs Elysées, Paris, France.
• 2011
British Art Today, Etemad Gallery, Dubai, UAE.
• 2008
FRIEZE Art Fair, Paul Kasmin – Observer "voted top 5".
Vanishing Point, Paul Kasmin Gallery, New York.
Carrie Secrist Gallery, Chicago.
• 2007
Kistefos-Museet, Oslo, Norway.
The Last Seduction, Event Horizon, Carrie Secrist Gallery, Chicago.
• 2006
Reconstruction #1 Space-Time, Sudeley Castle, UK.
• 2005
Rifle Range, Memory of Matter, Riflemaker Gallery, London, UK.

Oracle of Truth, Aeroplastics Gallery, Brussels, Belgium.
Reconstruction, Sudeley Castle: *Vertigo, Event Horizon, Succession*.
Boost in the Shell, Memory of Matter, Succession, Bruges Museum of Art, Bruges, Belgium.
• 2004
Dreamscapes, Fluid Icon, Aeroplastics Gallery, Brussels, Belgium.
• 2001
A Shot in the Head, London Water, Lisson Gallery, London, UK.
• 2000
Anableps, Medium-Gage, Stefania Michetti Gallery, Rome, Italy.
• 1999
D.U.M.B.O, Fluid Gages, Art Space, New York.
• 1998
D.U.M.B.O, Octagon Blue, Art Space, New York.
Vessel, Ace Gallery, New York.

Jeremy Sharma

Born in 1977 in Singapore.
Lives and works in Singapore.

Selected solo exhibitions
• 2014
Factum, Primae Noctis Art Gallery, Lugano, Switzerland.
Mode Change, Michael Janssen Gallery, Singapore.
• 2013
Grey Projects, Singapore.
• 2012
Apropos, Institute of Contemporary Arts, Singapore.
• 2011
Variations, Art Forum Gallery, Singapore.
• 2008
The Protection Paintings – Of Sensations and Superscriptions, Jendela Visual Arts Space, Esplanade – Theatres on the Bay, Singapore.
• 2007
Jeremy Sharma, Art Forum Gallery, Singapore.
End of a Decade, The Substation Gallery, Singapore.
• 2006
A Certain Slant of Light, The Substation Gallery, Singapore.
• 2004
The Arcane Glimpse, The Substation Gallery, Singapore.

Selected group exhibitions
• 2014
Countershadows (tactics in evasion), Institute of Contemporary Arts, Singapore.
Going, going, until I meet the tide, Busan Biennale, Kiswire Factory, Busan, South Korea.
Anthropos, Sundaram Tagore Gallery, New York.
Departure, iPRECIATION, Singapore.
MARKET FORCES – Erasure: From Conceptualism to Abstraction, Osage Gallery and City University, Hong Kong.

Materialised Time, LATENT SPACES@Haw Par Villa, Singapore.
Do You Believe in Angels?, Equator Art Projects, Singapore and Mo_Space, Manila, The Philippines.
Art Stage Singapore, Sea Platform (Michael Janssen Gallery), Marina Bay Sands Convention Centre.
• 2013
If the World Changed, Singapore Biennale, Singapore Art Museum.
Painting in Singapore, Equator Art Projects, Singapore.
Theory and Practice of the Small Painting, Equator Art Projects, Singapore.
Side-Glance, Institute of Contemporary Arts Praxis Space, Singapore.
A History of Curating in Singapore / Curating Lab: Phase 3, Goodman Arts Centre, Singapore.
New Black City / Art Stage Singapore Platform, Marina Bay Sands Convention Centre, Singapore.
• 2012
Lyrical Abstraction: Works by Jeremy Sharma & Yeo Shih Yun, Singapore Art Museum, Singapore.
Panorama: Recent Art from Contemporary Asia, Singapore Art Museum, Singapore.
Still Building: Cotemporary Art from Singapore, Selasar Sunaryo Art Space, Bandung, Indonesia.
The Same Rain, The Same Wind, Chiang Mai University Art Center, Chiang Mai, Thailand.
The Subject Shall Remain Anonymous, Giveart, Singapore.
Nine +/- 1, FASS Art Gallery, Sabancı Üniversitesi, Istanbul, Turkey.
• 2011
Foris, LASALLE College of the Arts, Earl Lu Gallery, Singapore.
The Tokyo Art Book Fair 2011, Arts Chiyoda, Tokyo, Japan.
Nine, ICAS Galleries, Institute of Contemporary Arts, Singapore.
Pantone My Art, TCC Gallery, Singapore.
• 2010
14th Asian Art Biennale Bangladesh 2010, Shilpakala Academy, Dhaka, Bangladesh.

Awards
• 2005
Recipient (with KYTV) of the JCCI Arts Award 2005 by the Japanese Chamber of Commerce and Industry.
• 2003
Finalist, Phillip Morris Singapore Arts Awards, Studio 106 Residency Award.
• 2002
The Lee Foundation Study Grant.
• 2000
First Prize (Open category), Action For Aids Award, Singapore.
• 1999
Winner of the Della Butcher Award presented by The Rotary Club of Singapore.

Public collections
Singapore Art Museum.
National Library Board, Singapore.
The Ngee Ann Cultural Centre, Singapore.
Société Générale Gallery, Alliance Française de Singapour.
The Westin Singapore.
One Farrer Pte. Ltd.
NUS Business School.

teamLab

Established in 2001 in Tokyo, Japan.
teamLab operates in Tokyo, Japan.

Selected solo exhibitions
• 2014
Infinity of Flowers, Gucci Shinjuku, Tokyo, Japan.
teamLab and Kagawa Digital Art Festa in Summer, Sun Port Takamatsu Seto Sea Pallet, Takamatsu City Museum of Art and e-topia-kagawa, Takamatsu, Japan.
teamLab: Ultra Subjective Space, Pace Gallery, New York.
teamLab and Saga Merry-go-round Exhibition, Saga Prefectural Art Museum, Saga Prefectural Kyushu Ceramic Museum, Saga Prefectural Nagoya Castle Museum, Saga Prefectural Space & Science Museum, Saga, Japan.
Audi Forum Tokyo, Omotesando, Tokyo, Japan.
• 2012
We are the Future, National Taiwan Museum of Fine Arts, Taichung, Taiwan.
• 2011
Live!, Kaikai Kiki Gallery, Taipei, Taiwan.

Selected group exhibitions
• 2014
We Love Video This Summer, Pace Gallery, Beijing, China.
mission [SPACE × ART] – beyond cosmologies, Museum of Contemporary Art, Tokyo, Japan.
Legacies of Power, Taman Budaya Yogyakarta, Indonesia.
What We Are Mapping, The Pier-2 Art Center, Kaohsiung, Taiwan.
Art Basel – Hong Kong, Hong Kong Convention and Exhibition Centre, Hong Kong.
Media Ambition Tokyo 2014, Tokyo City View, Tokyo, Japan.
Art Stage Singapore 2014, Marina Bay Sands Convention and Exhibition Centre, Singapore.
• 2013
Distilling Senses: A Journey through Art and Technology in Asian Contemporary Art, Hong Kong Arts Centre, Hong Kong.
Singapore Biennale 2013, Singapore Art Museum, Singapore.
Kagoshima Art Festa 2013, Kagoshima Prefectural Citizens Exchange Center, Kagoshima, Japan.
Show Case for 2013 Open Call for "Da Vinci Idea", Seoul Art Space_Geumcheon, Seoul, South Korea.

Brave New World – Re-Enchanting Utopia, Aomori Museum of Art, Aomori, Japan.
Dojima River Biennale 2013: Little Water, Osaka, Japan.
Parkett: 220 Artists' Editions & Collaborations + 5, Taipei Fine Arts Museum, Taipei, Taiwan.
Where is the Power, the Beauty?, 25th anniversary of the 1988 Seoul Olympic Games special exhibition, SOMA Seoul Olympic Museum of Art, Seoul, South Korea.
Art Basel – Hong Kong, Hong Kong Convention and Exhibition Centre, Hong Kong.
Flowers, Towada Art Center 5th anniversary exhibition, Towada Art Center, Aomori, Japan.
Zipangu, Takasaki City Museum of Art, Takasaki, Japan.
Art Stage Singapore 2013, Marina Bay Sands Convention and Exhibition Centre, Singapore.
• 2012
Zipangu, The Niigata Bandaijima Art Museum, Niigata, Japan.
The Experience Machine, Ikkan Art International, Singapore.
Hyper Archipelago – Light of Silence, Aomori Museum of Art, Aomori, Japan.
What a Loving, and Beautiful World, Mizuma Art Gallery, Tokyo, Japan.
Future Pass, National Taiwan Museum of Fine Arts, Taichung, Taiwan.
Art Fair Tokyo, Tokyo International Forum, Tokyo, Japan.
Roppongi Art Night 2012, Roppongi Hills, Tokyo, Japan.
Hyper Archipelago, Eye of Gyre, Omotesando, Tokyo, Japan.
• 2011
Volta 7, Basel, Switzerland
Art HK, Hong Kong Convention and Exhibition Centre, Hong Kong.

Awards
• 2014
Honorary Mention, Ars Electronica, Interactive Art category (*Peace can be Realized Even without Order*).
• 2013
Best VizSim Project, Unity Awards 2013 (teamLabBody).
• 2012
Lava Virtual ReVolution 2012, Architectural, Art and Culture Award (*What a loving, and Beautiful World*).
• 2011
The 14th Japan Media Arts Festival, Recommended Works of Review Committee (*100 Years Sea* animation diorama and *teamLab Hanger*).

Index

Bringing art to life

Making great art takes time

At Prudential, we understand the importance of long-term thinking better than most.

We have been helping people build better futures since 1848, from industrial workers in Victorian Britain to more than 24 million customers around the world today. We also have a rich heritage of championing the arts, starting with British painting in the 19th century and now contemporary artists from Asia.

We are proud to support this year's START Art Fair in bringing the arts to life.
www.prudential.co.uk

PRUDENTIAL

Sharing the passion
www.crownfineart.com

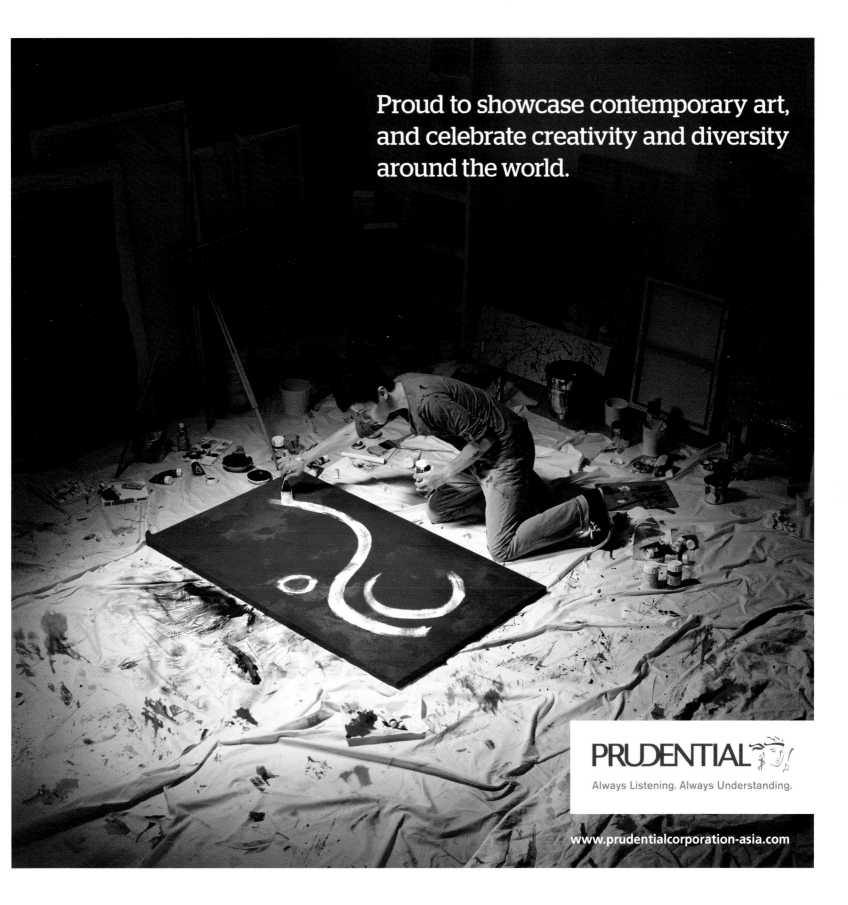

Skira Group
at the service of Art

Based in Milan, Geneva, Paris and New York, 300 new titles per year.
Visual arts, architecture, design, photography,
fashion, catalogues of major exhibitions, fiction, and essays.

● **Skira** editore ● **Skira** Genève ● **Skira** Paris ● **Skira** RIZZOLI NEW YORK

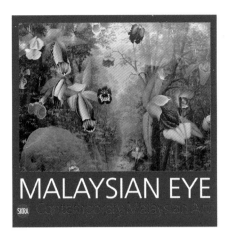

MALAYSIAN EYE
SKIRA Contemporary Malaysian Art

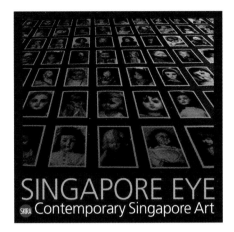

SINGAPORE EYE
SKIRA Contemporary Singapore Art

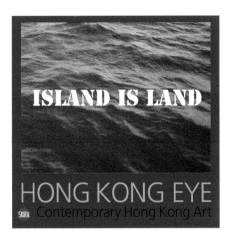

ISLAND IS LAND

HONG KONG EYE
SKIRA Contemporary Hong Kong Art

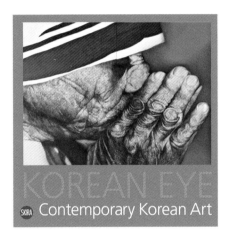

KOREAN EYE
SKIRA Contemporary Korean Art

P
C
A

Parallel
Contemporary
Art

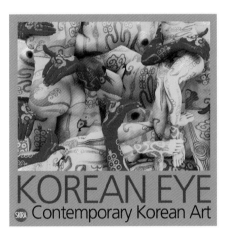

KOREAN EYE
SKIRA Contemporary Korean Art

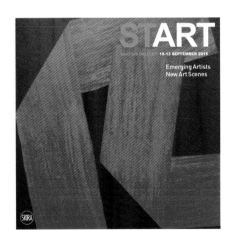

stART
SHATOR GALLERY **10-13 SEPTEMBER 2015**

Emerging Artists
New Art Scenes

SKIRA

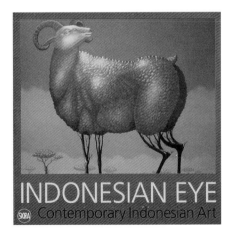

INDONESIAN EYE
SKIRA Contemporary Indonesian Art

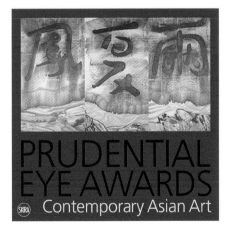

PRUDENTIAL
EYE AWARDS
SKIRA Contemporary Asian Art

YourSingapore

GET INTO

A **DIVERSITY OF TEMPLES** that are mind-blowing in their colour, decoration and sheer astonishing detail. From Hindu temples with hundreds of ornate deities and mythological beasts to the legendary Buddha Tooth Relic Temple and many more in-between. **#GETINTOSINGAPORE**

SINGAPORE

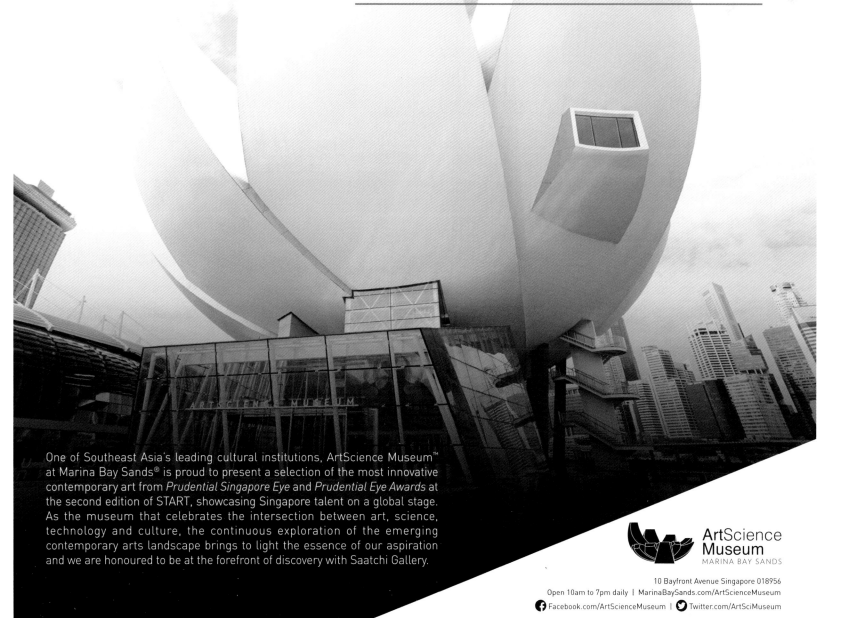

WHERE ART AND
SCIENCE MEET

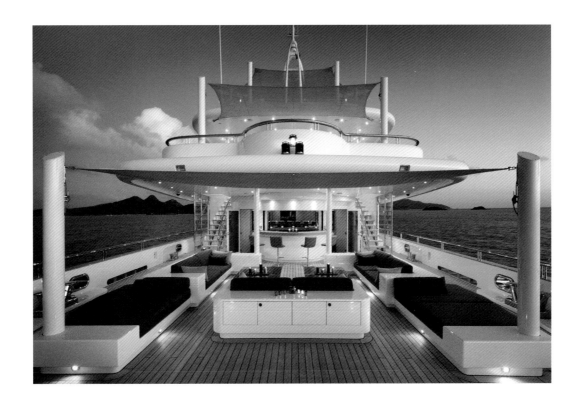

SPEY

SPEY
ROYAL CHOICE
SINGLE MALT
SCOTCH WHISKY

Historic Royal
Palaces

Bottle No. 91-03599
46% vol
70cl

Keep the secret!

ROYAL CHOICE

The finest sake from Japan

URAKASUMI

COOL ART & STUFF

www.FADmagazine.com
instagram / twitter: @FADsite

Ceremony of Superheroes (detail interieur), 2012 © Heri Dono
Courtesy of Rossi &

ELITISM FOR ALL

ART**REPUBLIK**

ASIA'S DEFINITIVE ARTS TITLE, ART REPUBLIK, SET ABOUT A QUARTERLY CYCLE,
BRINGS TOGETHER THE BEST IN THE CONTEMPORARY ART AND CULTURE. UNIFYING DYNAMIC
CONTENT AND COMPELLING CRITICAL DEBATE, ART REPUBLIK AIMS TO PROVIDE ITS READERS
WITH INFORMATIVE AND CREDIBLE FEATURES, PROFILES, ART NEWS AND REVIEWS.

ART HAS A NATION… ART REPUBLIK.

info@heart-media.com

ELITISM FOR ALL
ART**REPUBLIK** 7
THE INFLUENCE OF INDONESIA

FEAT.
HERI DONO / ENTANG WIHARSO
HANDIWIRMAN SAPUTRA
FX HARSONO / TINTIN WULIA
IRWAN AHMETT / TITA SALINA
JATIWANGI ART FACTORY / JOMPET
RUANGRUPA / NINDITYO & MELLA
PLUS: AI WEIWEI / DAVID ZWIRNER
UTE META BAUER / CHARLES LIM

C E R E A L

T R A V E L & S T Y L E

readcereal.com

Artron .Net

China's leading art platform :
a unique perspective ,
an extensive network and
data-driven expertise

2 million professional members
8 million daily views

Powerful Media + Authoritative Data + Valuable Users

China's leading professional art platform
The largest global database of Chinese artworks
The preferred platform for those seeking, buying or identifying artworks
Key resource for art collectors, investors and art lovers

Beijing Shanghai Hong Kong Shenzhen Guangzhou Hangzhou

www.artron.net

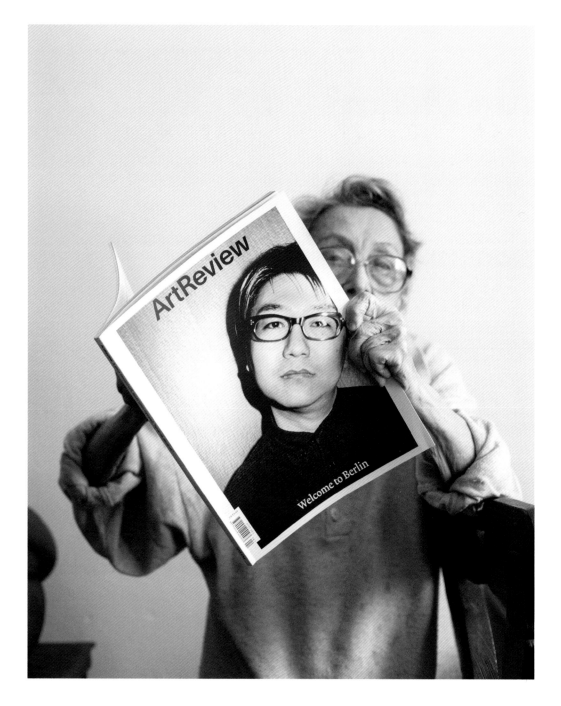

artreview.com/subscribe

ArtReview is also online at artreview.com and through the iTunes Store